# TREASURES
## OF THE
## VATICAN

# TREASURES
# OF THE
# VATICAN

ORESTE FERRARI

LONDON

THAMES AND HUDSON

Translated from the Italian by Geoffrey Webb

*First published in Great Britain in 1971 by Thames and Hudson Ltd, London*
*English translation © 1971 Thames and Hudson Ltd, London*
*Trésors d'Art du Vatican © 1970 Editions Aimery Somogy S.A., Paris*

*Printed in West Germany*

ISBN 0 500 18119 5 clothbound
ISBN 0 500 20113 7 paperbound

# CONTENTS

PART TWO: THE MONUMENTS

# PREFACE

The Vatican is unique in the length of its history and in the fact that throughout that history it has been a living force. It has, we might almost say, a personality of its own which has made a significant impact on our civilization.

There are other great monuments still with us that go much further back into the past. There are the pyramids of Egypt and Pre-Columbian America. There are the walls of Troy and of the ancient cities of Italy, palaces in Assyria, Mesopotamia, Crete and Mycenae. But all these, like the temples of Greece and Achaemenid Persia and the buildings of the Roman Empire, are only the remains of civilizations that have passed away. However long they may have lasted, they only live for us today insofar as they have influenced our culture and can still draw some response from us. Like all relics of the past, they appeal to our imagination.

The Vatican is different. It is still alive. It is not something we have to imagine. During seventeen centuries it has been not only alive, but self-renewing. And just as it has covered a long period of time, it has exercised an influence over a considerable amount of space. From its very beginning, it was not only the centre of a religion which, being Christian and catholic, presented itself as universal, but the centre of Western civilization.

To speak of the Vatican is to speak of Rome. This is as true today as it has ever been in the past. It is much more than the centre of Catholicism, because it has absorbed within itself the great heritage of the Classical world in which our own civilization still has its roots. The Vatican, like Rome of old, is in a sense *communis patria* – the universal fatherland. It has become the richer for that, and it has suffered too. It has aroused passionate enthusiasm and love, and no less passionate hatred. Even for those who do not share the Catholic faith, and have had no contact with Western civilization, the Vatican is still a symbol, and a historical reality that must be taken into account.

Therefore whatever our point of view may be, when we speak about the Vatican we have to realize its unique quality in history. We have to enter into it, to think and feel ourselves into it. Even if we consider it only as a collection of buildings and works of art (St Peter's, the Vatican Museums, and so on) we are confronted by a unifying vision of two thousand years of Western culture.

Whether we come as pilgrims or as visitors interested in art and culture, we come up against the Vatican as an artefact of history. We can see how it grew, where it was altered or destroyed, day after day and year after year. When we go into St Peter's or the papal palace, we are immediately immersed in history. The centuries speak to us, and we can touch, as it were, the point of intersection between an ancient and a modern world. And this is something that happens to everyone, irrespective of the breadth or narrowness of his cultural horizon.

This book does not claim to be a complete history of the Vatican, nor even an abridged history. Neither has it been my intention to catalogue the principal works of art that are to be seen there. It is certainly not a guide in the usual sense, and offers no itineraries. The readers I have in mind are those who have never been to the Vatican and are thinking of going there, and those who have been perhaps several times already. It may help

them to sort out their impressions, and even perhaps to re-create something of what they felt when they were there. But above all I would like to think that it may help the reader to find his way into the Vatican's extraordinary history.

Therefore I have concentrated on history, especially on the history of the Vatican's great moments, with particular reference to its art. (These moments are not of course necessarily connected with the best periods in the history of the papacy.) The creative genius of many masters, great and small, will constantly be revealed in the works we consider. They knew they had to give of their best, not only on account of demanding patrons, or because here they knew their work would be seen by everyone, but because they were so conscious of the great honour and the great responsibility that were involved.

If I propose an itinerary, it will be an itinerary in time. And even though we are basically concerned with the Vatican, we shall have to look further than its immediate boundaries, since the development of Rome, and of many other places besides, was closely connected with it.

*Numbers in square brackets [] refer to pages on which illustrations appear*

# THE BEGINNINGS OF THE VATICAN: CONSTANTINE'S BASILICA

The nucleus of what was to become the great complex of buildings that we know as the Vatican is very closely connected with the fact that the apostle Peter – Simon bar Jonah – lived and died in Rome. According to the gospel of St Matthew (16: 18,19) he was a humble Galilean fisherman who was appointed by Christ as the supreme head of the Church: 'And I say also unto thee, That thou art Peter, and upon this rock I will build my church; and the gates of hell shall not prevail against it. And I will give unto thee the keys of the kingdom of heaven; and whatsoever thou shalt bind on earth shall be bound in heaven: and whatsoever thou shalt loose on earth shall be loosed in heaven.' It was only a few days after these words were spoken that Peter's courage failed him to the extent of denying his master, after Christ had been betrayed by Judas on the Mount of Olives (Matthew 26: 70).

According to the earliest Church historians, Eusebius (260-340) and St Jerome (342-420), St Peter arrived in Rome during the reign of the Emperor Claudius, about the year AD 42, and remained there until his death, although he was probably expelled from the city with all the other Jews, even those who had become Christians, between AD 49 and 56. He was the acknowledged leader of the small community of followers of the new

faith, which was already increasing its membership not only among the Jews living in Rome, but also among the Romans themselves, even those of the nobility.

This small community was already leading a life of intense spiritual fervour when it was visited for the first time by St Paul in AD 59. It kept in close contact with the other Christian communities in Palestine and the East. But it was regarded by the authorities as a subversive sect, because it refused to recognize any moral authority in the state, or any religious authority exercised by the emperor.

In its earliest days in Rome, Christianity was considered to be just another oriental sect, along with the cults of Mithras and Isis. At first it received a measure of toleration, but under Nero it was subjected to fierce persecution. It was Nero who had a fire started in the poorest quarters of Rome, then officially put the blame on the Christians, who were already suspected of engaging in bloodthirsty and criminal rites.

Peter and Paul were both put to death during this period of persecution, which reached its height in AD 67. Paul, as a Roman citizen, was beheaded near the Via Ostiense. Peter was crucified upside down, at his own wish. As a mere disciple of Jesus he felt it was wrong for him to suffer the same fate as his master.

Like most other Christians who suffered for their faith, Peter was put to death in the circus which had been begun by Caligula (and embellished with an Egyptian obelisk from Heliopolis, which we shall meet again), and finished by Nero who liked to take part in chariot races there. The circus was on the far side of the Tiber, near the Via Cornelia, on the slope of the hill known as Mons Vaticanus. This was regarded as an unhealthy place, and was dedicated in part to the cult of the goddess Cybele.

Christians who survived the persecutions made a point of rescuing the remains of the martyrs and burying them near the Circus of Caligula. In this way a necropolis gradually came into being, and as it increased in size, it was used also for pagan

burials. A number of tombs and mausolea, some of them of patrician families such as the Valerii and the Caetennii, date from between 124 and 150. These have been excavated quite recently: they contain what are among the earliest examples of Christian art in Rome. On the vault of the tomb of the Julii, which was originally a pagan burial place, a mosaic was discovered showing Christ as Apollo or Helios, mounted on a chariot, with his head surrounded by rays of light [140]. The pagan image of the sun was taken over by the Christians to symbolize Christ as the True Light.

It was in this necropolis that St Peter's remains were buried. His tomb became an object of veneration for Christians of succeeding generations: a letter written sometime between 199 and 217 by the Roman priest Caius already speaks of it as a *tropaion,* or commemorative monument.

Recent excavations have shown that the shrine – which was probably erected at the time of Pope Anicetus, about 155-166 – was in the form of a two-storeyed aedicule, built against a wall (known as the Red Wall, from the colour-wash on the plaster) which set it apart from the rest of the cemetery. On the upper level, two colonnettes and a pediment framed a niche; below, there was an altar-like slab supported on two larger colonnettes; in the ground under this, covered by a flat stone, lay the relics of St Peter.

Cemeteries were treated with the greatest respect in ancient Rome, and thus, despite all the persecutions that befell the Christian community under Domitian, Marcus Aurelius and Diocletian, Peter's tomb remained intact for a considerable time. But even during the intervals between persecutions, when they went unmolested, the Christians still practised their religion more or less in secret, either in private houses or in the catacombs, which offered a refuge in times of danger. In the course of time these catacombs became an enormous labyrinth of tunnels of varying depth, sometimes consisting of chambers

on two or more levels. The galleries were carved out of the tufa, which gives them the appearance of some primitive architecture. Tombs and sarcophagi were ornamented with painting and sculpture of a type which, though it is close to the traditional late Roman style, clearly marks the beginning of a new and specifically Christian art.

The Christians of Rome, and indeed of the whole Empire, found their situation radically changed with the advent of Constantine, who was proclaimed emperor in 306 while he was still in Britain. According to legend, as Constantine was crossing the Alps on his return to Rome to confront his rival Maxentius, he had the vision of a cross surmounted by the words *In hoc signo vinces* – 'under this sign you shall conquer'. On the standards of his army, therefore, he placed the cross and the first two letters of the name of Christ in Greek, Christos – *chi* and *rho*. (This formed the *labarum,* the imperial standard of the reign of Constantine.)

Although he had not actually become a Christian, Constantine showed a grateful interest in the new religion when he became emperor. In 313, with the Edict of Milan, he extended toleration to all religions, and so brought state persecution to an end. He favoured the Christian community in particular: he lent his support to Pope Sylvester against the heretical Donatists, convened the first ecumenical council, which was held at Nicaea in 325, and condemned Arianism as a heresy. Finally Christianity became the official religion of the Roman Empire.

At this particular moment the church of Rome was not well organized; it was still recovering from the combined effects of Diocletian's persecution and the upheaval created by the various heresies which flourished among its members. But it was still the senior church of the Western half of the Empire and was soon able to assert its claims to pre-eminence.

In the artistic sphere, official recognition provided an incentive which the Church had thus far never known. Until this time

the Christians had simply borrowed their religious symbols from the classical repertory, more particularly from the Hellenistic tradition. But from now on, both in architecture and decoration, Christianity was to create its own original forms. All over the Empire, buildings of a specifically Christian type began to appear, some of them on an ambitious scale. There were two basic types: the longitudinal basilica, on the model of secular Roman basilicas but modified to suit liturgical requirements; and the centralized baptistery and martyrium, whose form derived from Roman baths and mausolea.

Constantine played a decisive part in this wave of new building. Hardly had he arrived in Rome when he welcomed Pope Sylvester's suggestion to build two basilicas. This was in 312. The first, which was Constantine's act of expiation for the murder of his second wife Faustina, was the basilica of the Saviour (later S. Giovanni in Laterano – St John Lateran – the cathedral of Rome). The second was St Peter's, built over the apostle's tomb.

Although he was very much occupied by his military and political enterprises in the east, the emperor continued to build. In Rome the primitive basilica of S. Croce in Gerusalemme was built to house the relics of the True Cross brought back from the Holy Land by Constantine's mother, St Helen. It was followed by the basilicas of S. Paolo, S. Agnese and S. Lorenzo, all outside the walls ('fuori le mura'). In Naples Constantine built the basilica of S. Restituto, and in Palestine the Church of the Nativity at Bethlehem, and the circular Church of the Holy Sepulchre at Jerusalem. Also circular is S. Costanza in Rome, built as the mausoleum of Constantine's daughter Constantia.

The original design for St Peter's probably amounted to little more than an improved housing for the monument already mentioned, which stood against the Red Wall of the cemetery. The *Liber Pontificalis* describes a structure consisting of porphyry pilasters and six *'columnas vitineas quas de Graecia perduxit'*, i.e.

twisted columns decorated with vines in relief. The location of the tomb, half way up a hillside, seemed to preclude anything more ambitious. The plan was soon changed, however, and it was decided that the apostle should have his own basilica. This involved the considerable task of cutting into the hill behind the tomb, so as to lay down a sufficiently large foundation.

From 322 onwards, a large flat area was made, covering much of the old cemetery. As far as we can gather from what remains of the original foundations and from written records and early illustrations, the church begun by Constantine was a simple basilica with five aisles divided by four rows of columns [23]. Most of these columns were taken from various ancient buildings, and were of different shapes and sizes. The walls of the nave, which was wider and considerably higher than the aisles, came down on to an architrave above the columns. (Only one building of this form survives in Rome, the basilica of S. Maria Maggiore.) The building had a sloping roof on wooden beams. At the end of the nave stood the shrine of St Peter, with an altar. Behind this rose a semi-circular apse, containing the throne of the bishop of Rome, who was none other than the pope himself. It is not certain whether there was a transept in the original basilica. In front of the façade was an atrium or narthex for the catechumens, who were not allowed inside the church proper until they had been baptized.

The building must have been extremely simple, but it was no doubt imposing by its very austerity. In form it was a prototype for other Christian churches, being admirably suited for the celebration of the liturgy. Its symbolic value as the resting place of the first head of the Christian community was immense.

St Peter's was built quickly. Constantine died in 337 but he saw it nearly completed, and was present at its consecration. It immediately became a centre for all the faithful living in Rome, and for pilgrims who now came from all parts to venerate the relics of St Peter.

# FROM CONSTANTINE
# TO THE RENAISSANCE

It was not long before Constantine's basilica began to be altered. Its austere structure was sumptuously decorated, and additions were made both to the interior and the exterior.

Some time before the death of Constantine the vault of the apse was covered with a mosaic representing the emperor offering his church to Christ and St Peter. Nearly all the early churches were decorated in this way, the best known surviving examples being in S. Pudenziana and SS. Cosma e Damiano.

The pontificate of Symmachus (498-514) was a time of remarkable activity in the history of the Vatican basilica. Two circular mausolea were built to the left of the church: the first was dedicated to St Andrew, while the second was built later to house the body of St Petronilla, the adopted daughter of St Peter. Symmachus' major work was in the atrium, which was enlarged and later surrounded by a colonnaded walk [22]. It was approached by a splendid staircase of thirty-five steps, where the faithful gathered and the clergy received distinguished visitors. Called *paradisum* because of its outstanding beauty, the atrium contained a handsome garden and two great fountains. One of these consisted of eight porphyry columns supporting a cupola sheathed in gilt bronze; within, a great bronze pine cone, from the nearby mausoleum of Hadrian, stood on a marble basin

*(cantharus)* filled with water for the ablutions of the pilgrims about to enter the sanctuary; four bronze dolphins, now destroyed, and four bronze peacocks completed the ensemble. (The pine cone and the peacocks survive, removed to the great niche in the Belvedere courtyard [222].) The other fountain was of a simpler design and was uncovered. The west walls of the atrium – that is to say the side next to the church, for the high altar in St Peter's is at the west, not at the east – were decorated with mosaics at this period.

St Peter's was, however, isolated outside the walls of Rome until the first residential buildings were erected by Pope Symmachus, expelled from the Lateran Palace by the anti-pope Laurence. Though they were imposingly called *episcopia,* or bishop's palace, these buildings were quite modest, and were soon pulled down.

The interior of the basilica was damaged during an earthquake and restorations were carried out under Leo I (440-461). Further alterations were made under Gregory VII the Great (590-604), who was deeply impressed by the fact that St Peter's remains had survived intact during the barbarian invasions. (Alaric had come in 410, Attila in 452, Genseric in 455, Ricimer in 472, Totila in 535, Belisarius in 553, and finally the Lombards in 568.) Gregory decided to raise the floor of the basilica to make a crypt for the shrine of St Peter (the 'Confessio'), approached by stairs at either side. Later an altar and canopy were erected over the tomb by Charlemagne.

Other outstanding additions during the Middle Ages were the central doors covered in panels of silver, the gift of Pope Honorius I (625-638), and the oratory erected by John VII (705-707). Fragments of this rich mosaic decoration survive, and show that the artists were from Constantinople. A section containing a portrait of John VII is in the crypt of St Peter's, and another showing the *Adoration of the Magi* is in S. Maria Maggiore; the complete mosaic was evidently among the finest

Byzantine works in Rome. Under Stephen III (768-772) and Adrian I (772-795) a campanile was added at the side of the atrium.

When in 800 Pope Leo III crowned Charlemagne emperor in St Peter's, the basilica and its dependencies must have been as impressive a sight as anything in Rome. By this time a loggia had been added to the façade where the pope could give his blessing to the people. Although it was well outside the city limits, St Peter's was a place of worship very much frequented by the people.

Precisely because the complex was so isolated and undefended, it was an easy prey to the Saracens, who arrived in 846. Pope Sergius II had time to make his escape, but the tomb of St Peter was destroyed and emptied of its contents.

The whole of Christendom was appalled at the sacrilege. Sergius' successor, Leo IV (847-855) had a protective wall built round the basilica: raised on the remains of the old Aurelian fortifications, it enclosed the whole of the Vatican hill behind the basilica, and extended on one side to the Tiber, and on the other to the mausoleum of Hadrian (already converted into a fortress guarding the bridge and known as Castel S. Angelo). The territory enclosed by this wall – named the 'Città Leonina' after Leo IV – is more or less that occupied by the Vatican City today.

The wall was useless, however, against the onslaught of the Normans in 1084, and succeeding popes were constantly engaged in reorganizing the defences of their domain. Further buildings were added, both for worship and to house the papal court. Innocent III (1198-1216), who is probably best known for his ability in defending the spiritual authority of the Church and creating the concept of an *ecclesia imperialis,* is outstanding among these. He was responsible for the erection of a tower to the north of the basilica, and a series of buildings of a fortified type which was very common at this time in Rome and in most of the great cities. There was now a second line of defence

within the walls of Leo IV. Innocent's buildings, though originally military in character, constitute the nucleus of the present Vatican Palace.

Nicholas III (1277-1280) was the first pope to make his permanent residence in the Vatican, leaving it only during the summer months. It was he who created the *palatium novum*, enlarging Innocent III's buildings into a complex with two main blocks. A large hall (later known as the Sala Ducale) was added on the east, connected to the larger of Innocent's buildings. Joined to it Nicholas erected another hall (the future Sala Regia) which was surmounted by several storeys, and supported by massive buttresses. This completed the residence proper. To the west, next to the tower of Innocent III (which was itself made more habitable), imposing buildings for services and stores – cisterns, granaries, and so on – were constructed. The court residence was handsomely decorated with wallpaintings, of which interesting fragments have recently been discovered.

Nicholas III had in mind an even larger rebuilding programme, but as his pontificate only lasted three years, it was never fully carried out. Work was continued by his successors during the thirteenth century with the *aulae pontificum* (residential quarters and reception rooms) and a tower *(turris scalarum)* to the south. The buildings gradually grew up around a central courtyard, later known as the Cortile del Papagallo [see plan, 270-71], and assumed the form of a rectangular palace. The side towards Rome was made into an imposing façade, with a tower at either end and a gallery running along above the buttresses. It is clear that a certain unity of style was being aimed at: but so far no architect had come forward capable of producing an ensemble that would meet the ever increasing requirements of the Curia.

The finishing touch to Nicholas III's project was a chapel dedicated to St Nicholas – *capella parva sancti Nicolai* – erected by Boniface VIII (1295-1303) in the corner between the Sala Ducale and the Sala Regia. This was an important step, for it meant that

the papal palace was no longer liturgically dependent on the basilica.

The active and in many ways dramatic pontificate of Boniface VIII interests us here particularly because of the works which he undertook in the basilica. During his reign the Church was in considerable difficulties in its relations with the Empire; a certain unease had prevailed since the abdication of Boniface's saintly predecessor, Celestine V. In an attempt to restore the Church's prestige he proclaimed the first Jubilee in 1300. Vast numbers of pilgrims came to Rome from all parts of Christendom. In the *Inferno* (Canto XVIII, 28-33), Dante describes the crowds crossing the Ponte S. Angelo:

> *come i Roman per l'essercito molto,*
> *l'anno del giubileo, su per lo ponte*
> *hanno a passar la gente modo colto,*
> *che dall' un lato tutti hanno la fronte*
> *verso 'l castello e vanno a Santo Pietro;*
> *dall' altra sponda vanno verso il monte.*

– 'just as on account of the great throng in the year of the Jubilee the Romans took measures for the people to pass over the bridge, so that all on the one side of it faced towards the Castle [Castel S. Angelo] and went to Saint Peter's and on the other they went towards the Mount [the Janiculum]' (from the translation by J. D. Sinclair, London 1958).

For the Jubilee Boniface wanted to have new monuments and decorations in the major Roman churches, and accordingly he summoned to Rome the foremost artists of the time. Giotto was brought from Florence to paint a fresco in St John Lateran depicting the pope's proclamation of the Jubilee [24]. For St Peter's, Arnolfo di Cambio was commissioned to make a new canopy for the high altar similar to those which he had already produced for the churches of S. Paolo and S. Cecilia in Traste-

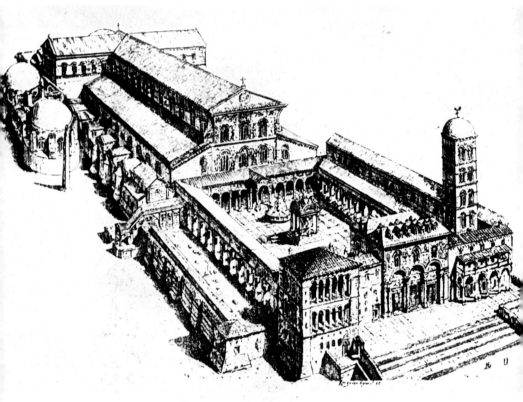

*Ideal reconstruction of Old St Peter's, with the atrium in the foreground*

vere, which still survive today. He may well also have been asked to make the magnificent bronze statue of St Peter (whose foot is kissed by the faithful), a masterly Gothic version of an idealized classical figure [116, 117]. Another of Arnolfo's works was the chapel which Boniface commissioned for his own tomb. This was later dismantled, but what remains can be seen in the crypt of St Peter's, or Vatican Grottoes.

Nearly a thousand years had elapsed since the dedication of the basilica in the days of Constantine. In the Vatican much had

been altered, and many buildings had been added, but by the beginning of the fourteenth century the old basilica and its dependencies, despite their lack of homogeneity, had a distinctive character. The reconstruction of Brewer-Crostarosa [22] gives a good idea of the appearance of St Peter's. There were two focal points, the basilica and the papal palace. The 'Leonine City' had already become relatively self-governing and independent of the city of Rome: in Boniface's time this was a source of anta-

*Interior of Old St Peter's, looking away from the altar.*
This sixteenth-century fresco, now in the Vatican Grottoes, shows the nave a few years before it was demolished.

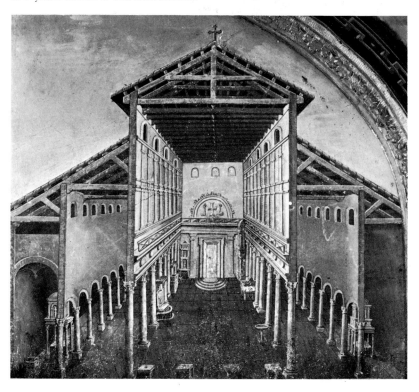

GIOTTO  *Boniface VIII proclaiming the first Jubilee in 1300*

gonism, for the feudal nobility of Rome were quick to resent any
encroachment. The papacy had in fact asserted its pre-eminence,
especially in the field of culture and the arts. The Church was by
now the chief patron of art, imposing its guidance on individual
artists and acquiring, either by commission or gift, an increasing
wealth of fine works which were eventually to be the basis of the
Vatican collections.

Boniface tried to contain and even to conceal, behind a façade of liturgical splendour, the crisis in the Church's political role. His own behaviour, however, was so tyrannical, selfish and unpredictable that the situation continued to worsen. Reviled, even by those who had been his closest friends, and finally defeated, he was forcibly detained in the town of Anagni, and ended his days virtually a prisoner in the Vatican. A few years after his death the situation reached a dramatic climax: in 1309 the new pope, Clement V, went to Avignon taking the papal court with him, where it remained until 1377.

The Avignon popes, remote from what had been for so long the centre of Christendom, now became pawns in a political game. They could scarcely envisage the possibility of ever returning to the Vatican. Italy had become largely hostile to the papacy, and Rome itself was a prey to local factions. The most that could be done from Avignon for the See of St Peter was an occasional donation towards the upkeep of the basilica and the palace.

But St Peter's was by no means neglected. During the earlier part of the Avignon period, the basilica came under the care of a man far more cultivated than any pope of his age. Cardinal Jacopo Stefaneschi had been at the Sorbonne, teaching canon law, and his feeling for the arts was remarkably up-to-date. It was due to him that Giotto undertook several new works in St Peter's. His great mosaic of the *Navicella* (little ship), depicting the calling of St Peter, was put up on the inner façade of the atrium, immediately opposite the entrance to the basilica. A date around 1310 is suggested by the style of the unrestored portions, particularly two fragments of the border containing angels, now in the Vatican Grottoes [143], and in the little church of S. Pietro Ispano at Boville Ernica near Frosinone.

Twenty years later, Cardinal Stefaneschi commissioned Giotto to paint a polyptych for the high altar [225, 226]. This magnificent and austere work was largely executed by pupils, but it

bears sure signs of Giotto's mature style – particularly in the almost classically concise expression in the central panel of *Christ in Majesty*, and in parts of the predella. The necrology of the cardinal, compiled after his death in 1343, records that Giotto was also commissioned to do five frescoes of scenes from the life of Christ for the walls of the apse. The only surviving fragments – two apostles, probably SS. Peter and Paul – are now in a private collection at Assisi.

# THE VATICAN
# DURING THE RENAISSANCE

With the papal court removed to Avignon, it became very clear in Rome that the Vatican had indeed been the leading cultural influence. The end of artistic activity there meant the end of artistic enterprise in the city. Almost the only new work of importance undertaken during the fourteenth century was the stairway to the church of S. Maria in Aracoeli, erected in 1348 by the tribune Cola di Rienzo as a thank-offering to the Virgin for having miraculously ended the plague.

Even after the return of Pope Gregory XI to Rome in 1377 the arts remained at a standstill. From 1378 to 1417 the Church was in a state of schism, with an anti-pope holding sway at Avignon. In the early fifteenth century there was even a third pope presuming to exercise authority from Pisa.

During the Schism, the only work undertaken in Rome was the decoration of the chapel of St Catherine in the church of S. Clemente, frescoed by Masolino with help from Masaccio. Between 1425 and 1428, Masolino and Masaccio painted a large polyptych for Pope Martin V, a member of the Colonna family: designed for a chapel in S. Maria Maggiore, it was the first Renaissance work of art produced in Rome. (It is now dismembered, and divided between the museums in Naples and Philadelphia and the National Gallery in London.)

The situation changed at last with the advent of Eugenius IV, a noble Venetian of the Condulmer family (1431-1447). Western Christendom was at last united. Eugenius had spent some time in Florence, where he had been greatly impressed by the intense artistic activity. He summoned to Rome a number of great artists. Pisanello was commissioned to complete the frescoes in St John Lateran which had been begun by Gentile da Fabriano; Donatello came with his pupil Michelozzo, to carve the Tabernacle of the Blessed Sacrament [119], originally intended for the chapel of the papal apartments, built by Bernardo Rossellino; and finally, the great bronze doors of the main entrance to St Peter's [108] were executed by Filarete between 1433 and 1445.

Eugenius was by no means exclusively committed to the Renaissance style. Pisanello, and to a certain extent Filarete, still followed the late Gothic tradition. But Eugenius' successor, Nicholas V (1447-1455) was clearly very much aware of the new tendencies. He came of a modest background – his father was a doctor at Sarzano in Liguria – but he was an outstanding figure both politically and culturally. One of his contemporaries, Vespasiano da Bisticci, recalled that Nicholas always said there were two things he would do if he could afford to: collect books and build walls.

In the event he realized his ambition and founded the Biblioteca Apostolica or Vatican Library, reorganizing the existing collection of books in the Vatican, and adding important ancient and modern texts, both sacred and secular. Of humanist leanings, Pope Nicholas V spent as much time as he could in his library.

Nicholas' major achievement in the sphere of art was to give a new impulse to architecture. He was a friend of Leon Battista Alberti, who dedicated to him his treatise *De re aedificatoria*. He envisaged a vast plan for altering the Vatican, with three principal objectives: the strengthening of its defences, the enlargement of the papal palace, and the rebuilding of St Peter's.

The renewal of the defences was of paramount importance. The old walls built by Leo IV, which had been restored in the thirteenth century, were totally inadequate to cope with the new fifteenth-century invention – artillery. A new system of defence was built, based in part on Leo's walls and connecting with Castel S. Angelo. The strong points were formed by four circular towers, two of which still survive, one near the Porta di S. Anna and the other now occupied by the Vatican radio station. The purpose of these defences was to protect the papal residence on its two vulnerable sides: foreign invasions invariably came from the north, while the no less dangerous threat of the Roman aristocracy and popular factions lay to the east.

The papal palace was enlarged by a new wing built parallel to the buildings of Innocent III, thus enclosing a third side of the Cortile del Papagallo. This *palatium novum* of Nicholas V was almost certainly designed and built by Bernardo Rossellino. From the outside it looks very much like the neighbouring thirteenth-century buildings, but its spacious interior shows it to be in fact a typical patrician residence of the Renaissance. It consists of a basement, ground floor and two upper storeys, each of which is divided into three rooms. The lower of these storeys was later adapted to form the Borgia Apartments [151], while the rooms on the top floor, which originally had flat ceilings and were later vaulted, eventually became the Stanze of Raphael. A third storey was also projected, but this was only completed much later, under Leo X.

Everything in Nicholas' new palace was of the highest quality, especially the painting. A very fine fresco, recently discovered in the room known as the Sala Vecchia degli Svizzeri, is in the style of Pisanello, and must have been done at the outset of Nicholas' pontificate. Fra Angelico, who had already been at work in St Peter's, was commissioned to paint episodes from the lives of St Stephen and St Laurence in a chapel at the top of the old tower of Innocent III *(capella parva superior)*. These frescoes,

executed between 1448 and 1451, are the only surviving works of Angelico in the Vatican [147, 149]. Other frescoes originally existed in the Chapel of St Nicholas (the *capella parva sancti Nicolai* built by Boniface VIII and demolished under Paul III), and in Boniface's study, of which no trace now remains.

But Nicholas had another project in mind, far more ambitious and more costly. Alberti had drawn up a detailed report on St Peter's, which showed its state to be precarious. To restore the old building would be extremely difficult. The pope therefore decided to pull it down, and to have a much finer one built on the site.

Such a decision seems incredible to us: Constantine's basilica had immeasurable symbolic significance for the Christian world, and by this time it contained a great number of outstanding works of art. Nicholas' plan met with severe criticism, but he was not afraid to take on the heavy responsibility. He commissioned Bernardo Rossellino to design a new building of Renaissance form, which would have the serene and measured spaciousness of Brunelleschi while keeping to the plan of Constantine's basilica. As before, there would be five aisles divided by arcades on columns, but there would also be a projecting transept, a dome over the Confessio of St Peter, and a deep apse with two large sacristies and some minor chapels alongside it. There was to be a new atrium, surrounded by arcades, where the old fountain with its pine cone would retain a central position. On either side of the façade there would be a tall campanile.

But Rossellino's project was never realized. The last years of Nicholas' pontificate were occupied by other problems, such as the Council of Ferrara-Florence (where a reconciliation was attempted between the Eastern and Western churches), and the fall of Constantinople to the Turks in 1453. All that was done to further Rossellino's plan was the demolition of the old apse and the *templum Probi,* or St Peter's house (a late medieval chapel built against the apse over the ruins of the Roman mausoleum of

the Anicii), and the laying of the foundations of the new apse to a height of a few yards.

The pontificate of Nicholas V thus marks a definite turning point in the artistic history of the Vatican. The Renaissance style, which had been introduced by Eugenius IV, was fully accepted. In Rome the new spirit was reflected in major works of church restoration and town planning. The aqueduct of the Acqua Vergine (which later fed such famous fountains as the Trevi) dates from this period.

Nicholas' immediate successors were unable to do much in the way of building. Clement III (1455-1458) was absorbed by the threat of a Turkish attack. Pius II (1458-1464) – perhaps better known as the great poet and humanist Aeneas Silvius Piccolomini – summoned Piero della Francesca in 1459 to paint some frescoes, since destroyed. He also had a new loggia built on the atrium façade for the ceremony of papal benediction [56]. In the palace he set up a fine doorway with his coat of arms over it, which is dated 1469 and may be the work of Giovanni Dalmata. Pius II's architectural interest was concentrated on his native town of Corsignano, near Siena, which was re-named Pienza in his honour; there both the cathedral and the Piccolomini palace are by Bernardo Rossellino.

Paul II (1464-1471) built a three-storey block between Nicholas V's wing and the old Sala Ducale, enclosing the west side of the Cortile del Papagallo. But since he preferred to live in the city, Paul had a fine residence built there for himself – the Palazzo Venezia, so named when it later became the headquarters of the Venetian embassy. During the last year of his pontificate Paul II took up Nicholas V's idea of rebuilding St Peter's, and to this end he commissioned a young and almost unknown architect, Giuliano da Sangallo, to produce a plan to replace that of Rossellino. The pope died before the plan could be put into execution, but Sangallo was destined to return to the work at a later date.

Paul II was succeeded by Sixtus IV (1471-1484), who, like Nicholas V, came from Liguria and was a devotee of literature and the arts. He belonged to the aristocratic della Rovere family, and was ambitious to associate his name with great architectural and cultural projects. His pontificate is remarkable as a period during which the arts were much encouraged. Many of the best artists were attracted to Rome, and for the first time in centuries a Roman school of painting developed, led by Lorenzo da Viterbo and Antoniazzo Romano. The statutes of a 'university of painters', housed in the little church of S. Luca on the Esquiline, were approved on 17 December 1478: this later became the famous Accademia di San Luca. Sixtus also re-opened the literary Accademia Romana, which had been founded by the humanist Pomponius Laetus but suppressed by Paul II who disapproved of it.

In Rome through the influence of Sixtus IV new churches were built, such as S. Maria del Popolo and S. Maria della Pace, and others restored (S. Pietro in Montorio and SS. Apostoli). A new bridge, known as the Ponte Sisto, was constructed near the Tiber Island; work was begun on what was to be the finest of all Renaissance palaces, the Palazzo della Cancelleria; charitable institutions were founded, such as the magnificent Hospital of S. Spirito in Sassia; and the Acqua Vergine was further extended. Virtually all this was the work of one man, Baccio Pontelli, an architect without great imagination, but with considerable practical sense and a clear and coherent style. The pope took the most active interest in all these works, even appearing in person wherever construction was in progress.

In the Vatican itself, Sixtus entrusted Pontelli with the building of a new chapel, the design for which was probably provided by Giovannino de' Dolci. Called the Sistine Chapel after its founder, it was built on the site of the thirteenth-century *capella magna* of Nicholas III next to the Sala Regia. Externally it is plain and rather military, and it stands out from the papal palace like a

great bastion. None of the Renaissance popes had envisaged the complete rebuilding of the Vatican complex: the Sistine Chapel came as yet another addition to what seemed to be an almost organically developing series of new or restored buildings.

Internally the chapel is a large rectangular hall without aisles, covered by a shallow barrel vault [48, 154]. Its dimensions, 40.23 × 13.41 metres, are exactly those of Solomon's temple at Jerusalem as given in the Bible. Sixtus IV evidently wished to give the chapel great symbolic significance, and this was intensified when the walls were later frescoed with scenes from the Old and New Testaments [156-163]. Episodes from the life of Moses and the life of Christ (echoing each other in meaning across the room) were chosen to demonstrate the continuity of that pastoral authority which rested in the pope: the lesson was made even clearer by Latin inscriptions under the scenes which left no doubt as to their meaning. The Church was going through a difficult period, and its authority had to be affirmed unequivocally.

For the decoration of his chapel, Sixtus engaged Pietro Perugino, Domenico Ghirlandaio and Cosimo Rosselli in 1481. These painters were soon joined by Botticelli, Luca Signorelli and Bartolomeo della Gatta, Pinturicchio, and also Piero di Cosimo, who assisted Rosselli. The series of idealized portraits of popes between the windows was done by Fra Diamante, and the ceiling was painted with a design of stars by Pier Matteo d'Amelia [48]. Finally Antoniazzo Romano decorated the door leading into the Sala Regia. As we look at their works in detail (below, pp. 153-63), we shall see what incredible perfection was achieved by this group of artists all working together in competition. Remarkable too is the degree of unity that they managed to achieve in the over-all design. The finishing touches were provided by an elegant marble screen and a cantoria for the choir. These are attributed to Mino da Fiesole, working with Antonio Bregno and Giovanni Dalmata.

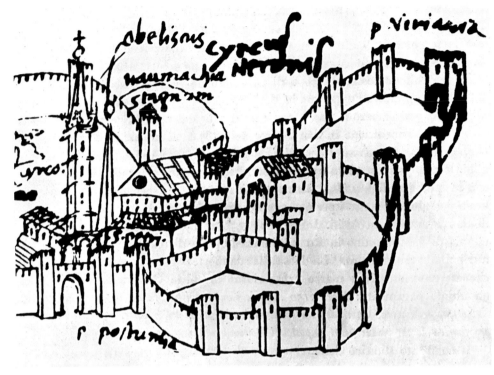

ALESSANDRO STROZZI  *The Vatican c. 1474*  Detail

The Sistine Chapel, which was to undergo amazing trans-
formations in years to come, is the chief monument to Sixtus IV,
but not the only one. Sixtus was a great humanist, and it is to his
efforts that the Vatican Library owes the acquisition of some
1,527 manuscripts. The works were arranged in sections in a very
modern way, under the care of Bartolomeo Platina, who had
been dismissed by Paul II and was re-appointed to the director-
ship of the Library in 1475.

The Library was now housed in a more suitable place, certain
apartments having been altered and enlarged to receive it. These

were splendidly frescoed with figures of ancient philosophers and Fathers of the Church, to symbolize the marriage of secular and religious culture. Some of the paintings have only recently come to light and have been attributed to Domenico and Davide Ghirlandaio. Others, such as the floral decoration in one of the rooms, were done by Melozzo da Forli and Antoniazzo Romano. Melozzo was also responsible for the fresco, painted between 1475 and 1477, representing Platina being put in charge of the Vatican Library by Sixtus IV. This can now be seen in the Vatican Gallery [235].

While all this work was going on in the palace, little was done in St Peter's. Alterations were made to the canopy over the shrine of St Peter, and the roof and the mausoleum of S. Petronilla were restored. Sixtus also gave orders for the arrangement of Paul II's tomb, carved by Mino da Fiesole and Giovanni Dalmata, and for his own, which was to stand in a chapel and have a bronze monument by Antonio Pollaiuolo [146]. It seems that Sixtus had set aside the projected rebuilding of the basilica, preferring to make whatever restorations might be necessary for the present.

The successors of Sixtus IV appear to have been inspired by his example to encourage art and architecture both in the Vatican and the city of Rome, but none of them had outstanding aesthetic sensitivity.

Almost as soon as Innocent VIII (1484-1492) was elected, he conceived a plan for something quite new in the Vatican: a pavilion for his leisure hours, set among gardens, with an open gallery. It was to be something quite separate from the existing papal palace, situated to the north by the Belvedere wall of Leo IV. The plan gradually became more ambitious, so that the building eventually looked more like a Tuscan villa, crenellations giving it a somewhat military air. According to Vasari, it was built by Jacopo da Pietrasanta, who completed it in 1487. The decoration was entrusted to Pinturicchio and Bonfigli, and

finally to Mantegna, who was called to Rome to paint the frescoes in the villa's chapel between 1488 and 1490. Successive alterations to the Belvedere have destroyed all these paintings, but we know that Mantegna's work in particular was very much admired among the connoisseurs of Rome.

The accession in 1492 of the Spaniard Rodrigo Borgia, who took the name of Alexander VI, opened one of the most unfortunate chapters in the whole history of the papacy. But despite all its corruption, intrigue, and crimes both real and fictional, Alexander VI's pontificate was not without its contribution to the artistic heritage of the Vatican.

At the western end of the palace, parallel with the Sistine Chapel, Alexander built a somewhat sinister-looking fortress known as the Borgia Tower. This he had fitted out as private apartments for himself and his family, taking over at the same time the three main floor rooms of the Nicholas V wing.

The Borgia Apartments were frescoed by Pinturicchio between 1492 and 1495 with scenes from sacred history and mythology [150, 151]. The compositions show a taste for the ornate and the exotic, and for complicated, even obscure, symbolism. Pinturicchio's paintings of St Catherine of Alexandria have a fairy tale quality, though the oriental figures may well have been drawn from life: indeed the artist seems to have had in mind the sumptuous and outlandish costumes worn by the Turkish embassy which came to Rome in connection with Prince Djem, the brother of Sultan Bayezid II, who was held by

ANTONIO POLLAIUOLO  *Tomb of Innocent VIII* ▷
The pope is represented twice, lying on his sarcophagus and seated on the papal throne, where he holds the tip of Longinus's lance in his left hand (the relic itself, given to Innocent by the Turkish Sultan Bayezid II, was later enshrined by Bernini [125]). Beside the throne are reliefs of the four cardinal virtues, complemented by the three theological virtues in the lunette above.

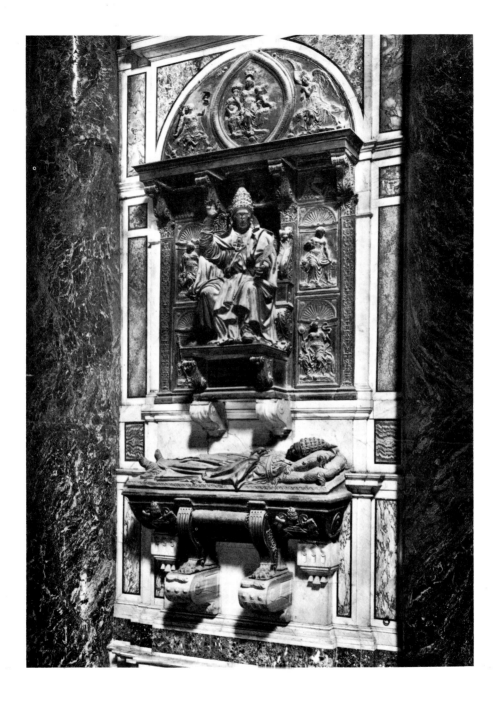

the pope. (To ensure that Innocent would keep Djem far from Turkey, where he was a threat, they brought with them money and a precious relic – the tip of the Holy Lance, with which Longinus had pierced the side of Christ.)

Pinturicchio's frescoes in the Borgia Apartments might suggest that the Vatican had temporarily lost contact with the living values of contemporary art. However, we must not forget that it was during Alexander's pontificate that a very great architect, Donato Bramante, began to work in Rome. He had arrived in the city in 1499. In 1502, at the pope's command, he built the famous Tempietto in the courtyard of the church of S. Pietro in Montorio on the Janiculum. This tiny building heralded the new and more plastic concept of architecture which was to come to fulfilment in the High Renaissance. Bramante's Tempietto already held in it the germ of the new St Peter's.

At almost the same time a young artist made his first appearance at St Peter's, with which he was to be closely connected for the rest of his life – Michelangelo. In May 1499 he completed the large marble *Pietà* commissioned twenty-one months earlier by Cardinal Jean de Bilhères de Lagraulas, the ambassador of Charles VIII [114].

By the end of the fifteenth century, two of the greatest artists of the age had become involved in what was to become the greatest centre of artistic activity in Europe.

# THE GREAT AGE:
# FROM THE PONTIFICATE OF JULIUS II
# TO THE DEATH OF MICHELANGELO

The first few years of the sixteenth century witnessed a flowering of the fine arts and all branches of learning. But for the cultivated world it was an age full of a sense of unease: the triumph of humanism brought with it a failure of nerve; it looked as though the traditional balance between faith and human wisdom had been lost. The tragedy of Savonarola may be seen as one reflection of this unease. Faced with such new intellectual challenges, religious humanists searched all the more keenly for a new harmony between faith and reason.

Rome and the Vatican were to be the focus of culture in the sixteenth century; after Florence, Rome was to be the new Athens. History provided circumstances and personalities to meet an exceptional situation. The first of these was the new pope, Cardinal Giuliano della Rovere, a nephew of Sixtus IV, who was elected towards the end of 1503 and took the name of Julius II (1503-1513).

Julius was an impetuous character who had been hardened by adversity. During the reign of Alexander VI he had lived in exile in France. Of clear and brilliant intellect, he felt it was his destiny to undertake some tremendous enterprise. He was an ideal person to be head of the Church – a politician, a great patron, and a great leader. He reorganized the papal army and the Swiss

Guards and led them himself to Bologna in order to put down the Bentivogli. He was the archetype of the Renaissance prince.

The fact that he had come to the throne at the age of over sixty seems to have increased his energy. He realized that he had no time to lose, and he wanted to leave his mark on history. He was prepared to undertake something that he would never see completed, and to oblige his successors to complete what he had begun. He realized too that he would need artists of the same stature as himself to produce the work he had in mind, and he was ready to be the sort of patron who stimulates genius rather than gives orders: thus he was able to recognize the greatness of Bramante, Michelangelo, and later of Raphael.

Only a few months after his election, Julius commissioned from Bramante buildings that would connect the papal palace to the Villa Belvedere. This was a considerable project. Its chief function was to provide a fitting approach to the Villa Belvedere where Julius' collection of antique sculpture was to be housed. Julius already possessed the *Apollo* [264], the *Venus Felix,* the famous *Torso of Hercules* by Apollonios [262], the *Meleager* [260], the *Sleeping Ariadne,* and the groups of the *Tiber* and the *Nile* [266], to which the *Laocoön* [259] was eventually added when it was discovered in 1506. This was the beginning of the Vatican Museums. Only artists and men of learning were to be allowed in to view the collection, as we gather from the Virgilian inscription: *Procul esto prophani* ('let the uninitiated keep away').

Bramante had made a careful study of the ruins of ancient Rome, and learned a great deal from them about problems of construction. For the Vatican he visualized something that would rival the most famous buildings of antiquity. There were to be two long wings or galleries – single-storeyed at the Belvedere end and three-storeyed at the palace end, since the ground sloped markedly – each covered by a terrace along which visitors could walk to the Belvedere. A large rectangular court-yard was thus formed with galleries on the long sides, and on the

short sides buildings, each with a semi-circular exedra. The centre was to be laid out as a handsome garden on three levels, linked by staircases and ramps. This courtyard was intended as the scene of theatrical performances and tournaments, to be viewed from the galleries at either side.

Bramante began the building in haste, and Vasari notes that disagreements soon broke out. Only a few years later part of the building collapsed. However, at the same time the villa was improved by a circular ramp five storeys high, with granite columns in the Tuscan, Doric, Ionic and Corinthian orders, which rises round an open centre [222]. This was sufficient to re-establish Bramante's reputation as an expert in construction, and became a model for future builders.

In March 1505, while Bramante was working at the Belvedere, Julius called Michelangelo from Florence for a work certainly no less ambitious than the one that Bramante was engaged on: the pope's own tomb. What Julius wanted, and Michelangelo set to work to design, was something which, in size alone, was to surpass any monument that had ever been erected for a pope. It was to be an enormous free-standing structure in two stages with forty statues arranged on its four sides. Michelangelo became very enthusiastic about the task, designing and re-designing the tomb, and he spent eight months in the marble quarries at Carrara to get the best possible materials.

On returning to Rome, however, Michelangelo was appalled to find that the pope had already lost interest in the colossal scheme. There was in fact no place available to contain anything so vast; even the apse of St Peter's could not have held it; and Julius was already thinking of other designs. Michelangelo was so furious that he left Rome immediately, leaving an insolent message for the pope. When Julius sent his emissaries to bring him back, Michelangelo refused to return. Even the pope's threats were unavailing. The efforts of the Florentine Signoria,

who had no wish to offend the pope on Michelangelo's account, were fruitless.

Thus from the very beginning of their relationship we can see that things were not easy for Julius II or for Michelangelo. But despite their differences, each seems to have realized that he needed the other. As personalities they were equal. A reconciliation finally took place at Bologna in 1507. Michelangelo was in tears, begging the pope's pardon on his knees. Julius, equally moved, embraced him as a brother and asked him there and then to cast a bronze statue of himself to be put up in Bologna as a reminder of the long arm of the papacy. (The statue was destroyed in 1521 when the town was recaptured by the Bentivogli.)

Michelangelo never quite gave up his great plan for Julius' tomb. The monument had to be reduced considerably, since it held little interest for Julius' successors. In 1513 – the year of Julius' death – and 1514 Michelangelo was carving the famous statues of *Slaves,* which were part of the original design. (Two of these are now in the Louvre, and four unfinished ones are in the Galleria dell'Accademia in Florence.) Also at this time Michelangelo produced his magnificent *Moses* [43], the only original piece to be installed in Julius' monument when it was finally put up in 1545 in the church of S. Pietro in Vincoli on the Esquiline.

The elaborate designs for the tomb of Julius II did however have a considerable influence on the history of St Peter's. Precisely because there was no part of the basilica large enough to contain the tomb, Julius conceived the idea of enlarging the apse. In the spring of 1505 some strengthening of the original

MICHELANGELO *Moses* Detail ▷
This famous statue, intended to be only one of forty on the grandiose tomb that was to be erected in St Peter's for Julius II, now forms the centrepiece of the pope's much-reduced tomb in S. Pietro in Vincoli in Rome.

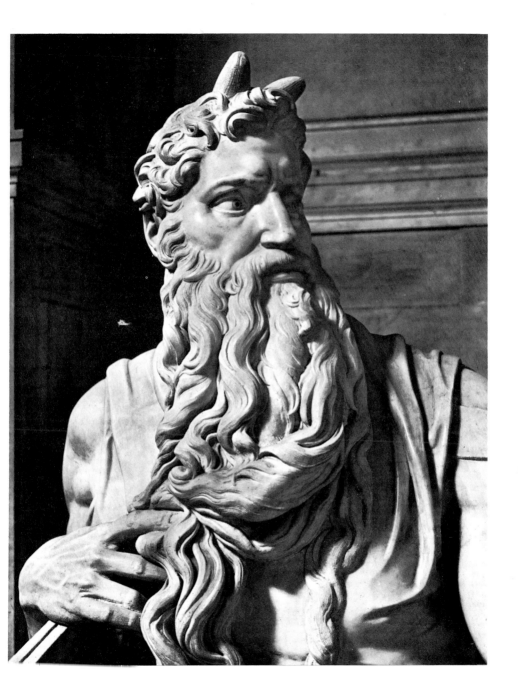

structure was undertaken with this enlargement in mind. When this proved unsuccessful, Julius began to think again of Nicholas V's project for a complete rebuilding of the basilica.

Instead of using Rossellino's design, Julius decided to get both Bramante and Giuliano da Sangallo to draw up new plans. Sangallo was an old friend, and had in fact followed Julius in exile to France. But in the event it was Bramante who was entrusted with the building.

Bramante very quickly worked out a completely new design – somewhat unfavourably received by the Curia, most of whom had strong feelings of attachment to the old basilica. From the various studies of Bramante which survive, we can see that he envisaged a building in the form of a Greek cross [46]. The four equal arms were to end in deep apses. The centre was to be covered by a completely hemispherical dome, like the one he had built for the Tempietto at S. Pietro in Montorio, but on a much larger scale. Four smaller domes were to be placed over the four corners of the building between the arms, and four towers completed the design, filling it out to a square in plan.

In this way Bramante hoped to re-create the effect of ancient Roman architecture. It was to be a synthesis of the Pantheon and the Basilica of Maxentius, and it was to be read symbolically as the spiritual unity of the Catholic Church under the vault of heaven, with the power of the papacy at the centre of the universe.

Bramante was quite prepared to move the tomb of St Peter, but the pope would not consider this. Instead Bramante was obliged to build a temporary shrine of peperino (a volcanic stone common in Latium) to protect the tomb during the alterations. This had a blind arcade of Doric columns, and was quite a fine building in its own right.

The work of rebuilding began with the demolition of every part of the old basilica where new foundations were to be laid. Much could have been saved and removed elsewhere, but in fact

nothing was kept: Bramante got the name of 'the demolisher', *il ruinante*. The old mosaics went, together with Giotto's frescoes in the apse, and the tombs of popes and martyrs, whose relics had to be transferred elsewhere.

On 18 April 1506 Julius laid the first stone of one of the great piers which were to support the dome – the pier which was later on to contain the shrine of St Veronica's Veil. In April 1507 the Archbishop of Taranto laid the foundations of the other three piers; these rose quickly, and were followed by the arches joining the piers. The choir was then laid out to the design of Rossellino.

After this enthusiastic beginning, work gradually slowed down. Although Bramante knew a great deal in theory about the problems of architectural construction, he was faced by difficulties which had not yet been solved. Finance was another problem. The pope had plenty of money at his disposal, but the project was proving extremely costly. Finally in 1513 he proclaimed that since St Peter's was to be the finest church in the world, all the faithful were called upon to subscribe to the necessary funds, in return for which indulgences would be granted. This was a dangerous step, since it gave grounds for the Protestants, especially the Lutherans, to accuse him of simony.

Now that a large part of the old basilica had been demolished, and the supports for the dome of the new church erected, there was no going back. The plan of the new building was fixed by the work that Bramante had done: whoever might come after him would have to accept it as the basis for his design.

At this moment, Julius was putting another plan into action which would have far reaching results. On 10 May 1508 he called Michelangelo in again, this time to paint in fresco the ceiling of the Sistine Chapel, which until now had been decorated with a simple design of stars [48].

At first Michelangelo was not at all enthusiastic. He considered himself primarily a sculptor, even though he had painted some

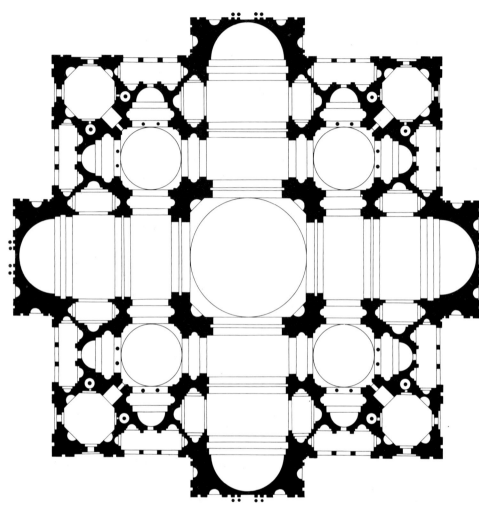

BRAMANTE    *Proposed plan of St Peter's*

pictures – such as the *Doni Tondo,* now in the Uffizi. He had never before painted in fresco. He realized that the task would be enormous; and he suspected moreover that it was a ruse on the part of Bramante to keep him from intervening in the tricky problems posed by the new basilica.

Finally Michelangelo began to respond to the challenge. Bramante had suggested that a fixed scaffolding would be best for painting the ceiling, but Michelangelo insisted on a movable one, so that he could easily change position within the chapel. His original plan was to paint within the architectural framework of the ceiling, but he abandoned this in favour of an illusionistic scheme. Moreover he decided on an iconographic programme much more complex than the one the pope had originally suggested, which was to feature only the apostles. It was Michelangelo's own idea to paint episodes from Genesis, framed by figures of prophets, sibyls and ancestors of Christ which would link up with the wall frescoes below with their scenes from the lives of Moses and Christ [164-176].

For more than four years, that is to say until October 1512, Michelangelo worked virtually without interruption. He was so absorbed in what he was doing that he would even spend his nights on the scaffolding. He had very few assistants, and he was disinclined to let anyone, even the pope, see what he was doing. In 1511 Julius II could contain his patience no longer, and had some of the scaffolding removed so that he might see at least a small part of the painting. When he presumed to offer a few suggestions, Michelangelo took offence and another quarrel began between them.

While the Sistine ceiling was being painted the Vatican's third great creative talent came on the scene. In 1508 Julius decided to commission new decorations for the state apartments on the upper floor, which had been frescoed by Andrea del Castagno, Piero della Francesca and Benedetto Bonfigli. The most famous artists of the time were summoned for the work – Sodoma,

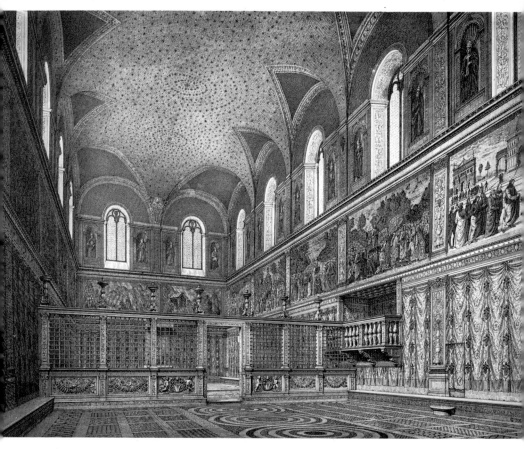

*Interior of the Sistine Chapel as it would have appeared about 1508, before Michelangelo began work on the ceiling.*

Perugino, Lorenzo Lotto, the Lombard Bramantino, Baldassare Peruzzi (who was also an architect) and the young Raphael, who so impressed the pope that he was put in charge of the work.

We may well regret that Raphael destroyed all the fifteenth-century painting in these rooms, but with his numerous assistants he produced an outstanding series of works. In the first room,

the Stanza della Segnatura, which was finished in 1511, the theme is the triumph of faith, reason, poetry and virtue – a humanists' harmony of divine mysteries, philosophy and art [193-199]. In the second room, the Stanza di Eliodoro, finished in 1514, the frescoes illustrate the action of divine providence in guiding the destiny of the Church [203-208].

It is almost inconceivable that in the ten years of Julius' pontificate so much great art should have come into being – the beginnings of the new basilica, the Belvedere courtyard, the ceiling of the Sistine Chapel, and the first of the Stanze to which, in time, Raphael was to add his paintings in the Logge [216, 217]. The Logge are themselves part of the Cortile di S. Damaso, which Bramante built up in a series of great arches supported on piers, ending in a colonnade with straight entablature [56].

It is not only the quality and the number of the works in question that is so impressive; the fact that such different personalities were all working together for the same patron almost seems to mark a turning point in the history of Western civilization.

If for a moment we think about the common characteristics of these works, we can see that they are all aiming to break away from the earlier world of humanism and to express new ideas. While Bramante, for instance, constantly looks to antiquity as his model, the ancient order is re-thought in contemporary terms. The symbolism of the new St Peter's states, as it were, a principle of authority linking traditional faith and the new culture. Michelangelo, depicting scenes from the book of Genesis, offers his prophets, sybils and *ignudi* as ideal types of humanity as a neo-Platonist would visualize them. His sense of history implies the guidance of mankind by a transcendent power towards a higher end. Even Raphael, more evidently dependent on humanist thinking, sees the union between faith and reason and between faith and poetry (in the Stanza della Segnatura) not simply as an abstract ideal, but as something that is realized in

history; and this union culminates (in the Stanza di Eliodoro) in the affirmation that divine providence alone governs the fate of the Church and of all mankind.

In Bramante, Michelangelo and Raphael we find a new attitude to the past and the present which justifies us in saying that the Vatican influenced all that was greatest and most significant in the art of the period. This implies a change in the artistic status of the Vatican itself. In the fifteenth century it had been a privileged centre which stimulated artists to produce work for it that was essentially tied to a traditional culture. Now it became the crucible for a new synthesis of cultural elements. It provided the impulse which allowed the recent past to be put into perspective, and a new beginning to be made, based on a deeper evaluation of humanism.

The ceiling of the Sistine Chapel was the only work commissioned by Julius to be finished before his death. But his successors realized that they had no alternative but to continue the process of renewal which he had begun. His successor, Leo X (1513-1521), followed his lead with enthusiasm.

Leo was a Medici, and, as one would expect, a highly cultivated man. He was elected pope as an old man, and like Julius before him he realized that he had no time to waste. There were serious obstacles in the way of further papal patronage, especially the financial difficulties which had beset Julius at the end of his reign.

One of the first things Leo did was to summon to Rome Fra Giocondo, the 69-year-old Dominican mathematician and friend of Leonardo da Vinci, who had great experience of constructional techniques. He, Bramante and Giuliano da Sangallo were to work together on St Peter's. Fra Giocondo quickly pointed out some faulty structure in Bramante's piers, and measures were taken to make them and the arches connecting them more stable. This was all that he had time to do, for both he and Bramante died in 1514. It is said that before Bramante died he

suggested to Leo that Raphael should be put in charge of St Peter's. If this is true it could well mean that Bramante wanted to ensure that work would not be handed over to Michelangelo or to Sangallo. He was more or less certain that Raphael would not modify his project in any way. Raphael was a novice in the field of architecture, having designed only one church, S. Eligio degli Orefici, built near the Via Giulia in 1514, where he had adopted Bramante's favourite plan of the Greek cross. Raphael was, moreover, indebted to Bramante for the architectural background of his *School of Athens* [196].

Raphael was put in charge of St Peter's on 1 August 1514. During the first few years of his direction, the last remnants of Constantine's basilica were demolished, and the new piers were strengthened in accordance with Fra Giocondo's recommendation. In 1516 Raphael called in a professional architect, Antonio da Sangallo the Younger, the nephew of Giuliano, to look after the technical details; and it was at this time that Raphael and Leo X together decided to change Bramante's plan by adding a nave, thus transforming the plan from a Greek to a Latin cross [52]. This gave the new basilica something more like the shape of the old, and also took into account liturgical requirements which Bramante had not sufficiently considered.

Raphael's plan remained on paper, and we only know it through a copy made by Serlio. Nothing at all is known of the proposed elevation except that it was inspired by the Roman architectural writer Vitruvius. Raphael's admiration for the severe and noble style of antiquity may have stemmed from the time when, according to one tradition, Leo commissioned him to write a report on the remains of ancient Rome. Leo, indeed, was concerned at the destruction of the ruins and interested in any new discoveries, such as that of Nero's Domus Aurea or Golden House. Raphael enjoyed the highest place in the artistic world of Rome at this time. Not only was he in charge of St Peter's, he was also continuing the building of the Belvedere

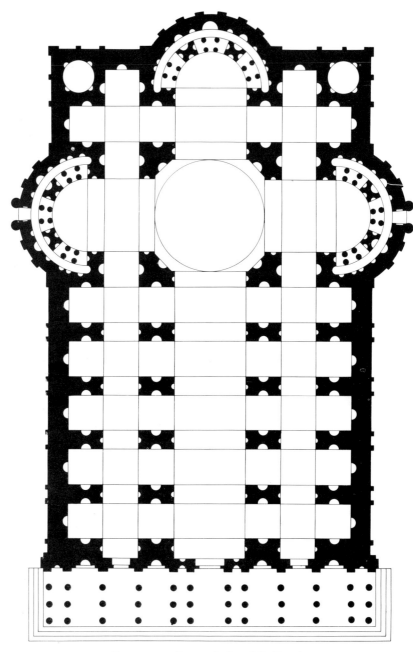

RAPHAEL    *Proposed plan of St Peter's*

wing, and finishing the third floor of the Logge. Michelangelo had for the time being returned to Florence.

During the pontificate of Leo X, Raphael finished the Stanza di Eliodoro, incorporating a portrait of the pope in the *Encounter between Attila and St Leo the Great* [212]. He also designed the decoration for the Stanza dell'Incendio di Borgo, which was painted mainly by Giulio Romano, Perino del Vaga and Penni. The Logge were painted by the same artists, plus Giovanni da Udine. The loggetta of Leo X and the bath *(stufetta)* of Cardinal Bibiena were decorated under Raphael's direction, and the latter building has exquisite mythological figures which seem to be the work of Raphael himself.

Raphael had become the leader of a group of specialized artists, whom he used with such intelligence that each retained his own individuality yet all managed to agree with his ideas. In this he was very different from Michelangelo, who always insisted on working alone. Works commissioned from Raphael were often executed by his assistants, at least in part: Raphael's is not the only hand visible in the cartoons for tapestries of the life of St Peter (now in the English Royal collection) or in the *Transfiguration* [242, 243]. Thus Raphael's untimely death in 1520, at the age of 36, did not mean the extinction of his style. In painting, at least, he left a well-trained body of successors.

The only major departure from Raphael's plans was likely to occur at St Peter's, which was now handed over to the famous Sienese architect Baldassare Peruzzi. Between 1508 and 1511 he had distinguished himself in the building of a fine villa on the banks of the Tiber for the banker Agostino Chigi. (This became known eventually as the Farnesina, when it was acquired by the Farnese family.) In it Peruzzi was inspired by Raphael, but his style was nonetheless completely personal: like his other important work, the Palazzo Massimo alle Colonne (1532-6), the Farnesina is an extremely elegant and original invention in a somewhat Mannerist style.

When Peruzzi took over the building of St Peter's, the pope was again in financial straits, and so he welcomed the idea of going back to Bramante's original plan of a Greek cross: Raphael's projected large nave was to be reduced to a short nave and a narthex. This design was less massive, with a certain sobriety and elegance of form.

During the pontificate of Adrian VI (1522-1523), who had no interest in the arts, work was suspended for two years; but with the advent of his successor Clement VII (1523-1534), a Medici like Leo X, the Vatican once more became the scene of intense industry. Under Clement, the work of consolidating the arches and piers which were to support the dome continued; and in Raphael's Stanze, Giulio Romano and Penni continued painting, especially in the Sala di Costantino.

Further work would no doubt have been undertaken had it not been for the war that now broke out between the Emperor Charles V and François I of France. Nearly the whole of Europe was involved in the struggle. The emperor's armies invaded northern Italy in 1525, and at Pavia François I was defeated and taken prisoner. The armies advanced on Rome, and with the complicity of the anti-papal Colonna faction they overcame the pope's forces – an episode graphically described in Benvenuto Cellini's *Autobiography*.

During the month of May 1527 Rome and the Vatican suffered the worst depredations they had ever experienced. The destruction and sacrilege perpetrated by the Imperial *Landsknechts* surpassed even that of the Saracens. Of all the most venerated relics, only the tomb of St Peter was spared. The pope took refuge in Castel S. Angelo and later at Orvieto.

When Charles V's mercenaries finally left, the city was in a state of total desolation. It took a long time to recover, since everyone seemed to be overcome by a sense of despair, a feeling that what was past could never be re-created, and only apprehension for the future. At the same time, the split between

Catholics and Protestants had clearly become irreparable, forcing home the fact that the old Europe belonged to the past, and that new forces were at work.

In 1527 all the artists who had worked for Raphael, and all those who had come to Rome in the preceding years, left the city to find employment elsewhere. Peruzzi went with the rest. With the Sack of Rome, the golden age of the Renaissance had come to an end, and a new age had begun, filled with anxiety.

Clement VII finally returned to Rome, a weary and embittered man. As if to commemorate the sorrows of this age, he called Michelangelo back from Florence to paint the *Last Judgment* on the end wall of the Sistine Chapel. Michelangelo arrived in Rome on 23 September 1534, and Clement died two days later.

Clement's successor was Paul III Farnese (1534-1549). The new pope confirmed Michelangelo's commission, and the *Last Judgment* was finished in 1541. A comparison between the new fresco and those on the ceiling is sufficient to demonstrate the change that had taken place [175, 178]. The ceiling frescoes offer us a vision of the potential greatness of man as he submits to the divine plan. In the *Last Judgment,* all illusions have gone and humanity is terrified by the prospect of a justice no longer tempered by any thought of mercy.

The new pope was fully aware of the unease that troubled men's minds as they sought to work out their salvation. Paul III was a very learned man and had been a disciple of Pomponius Laetus in his youth. He was a skilled diplomat, but unyielding in matters of moral principle. He rose masterfully to the challenge of the situation, and the Church owes to him the restoration of its prestige after its recent humiliations.

Paul III had to fight against a dulled and corrupted Curia that seemed to have learned nothing from its recent trials. He began a new régime of austerity, increasing the powers of the Inquisition – sometimes with unnecessary severity. Finally in 1545 he convened the Council of Trent to oppose the threat of the

Protestant Reformation and to define the Catholic Church's dogma and canon law.

Even with so much to contend with in the realm of religion and politics, Paul III gave a new impulse to artistic life in the Vatican. For him this was not a mere matter of external ornament; it was rather a question of re-affirming the prestige of the Catholic faith in the sphere of culture. While Michelangelo was completing his *Last Judgment,* the pope called in Antonio da Sangallo to rebuild the south-west wing of the papal palace, which included the Sala Ducale, Sala Regia and adjacent rooms. Here a new chapel was built, the Cappella Paolina (named after

MARTEN VAN HEEMSKERCK *Old St Peter's and the Vatican Palace c. 1533* To the left is the façade of the basilica, with the benediction loggia and campanile; in the centre rise the four storeys of Bramante's Cortile di S. Damaso (containing the Logge frescoed by Raphael), with the Sistine Chapel behind it to the left; on the right is part of the wall built by Leo IV.

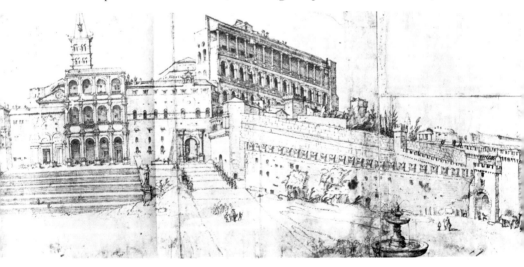

the pope), which was also decorated by Michelangelo with two impressive frescoes – the *Conversion of St Paul* and the *Crucifixion of St Peter* [187-190], two works that convey the same sense of drama and pessimism that he had already put into his *Last Judgment*. At the same time new work was undertaken in the courtyard of the Belvedere which little by little completely changed Bramante's original design.

The pope's interest in the arts was not limited to the Vatican. He had Antonio da Sangallo build the Palazzo Farnese, a typical patrician residence of the High Renaissance, later completed by Michelangelo. Titian was summoned from Venice to do several portraits of Paul III and of his entourage (now in the Museo di Capodimonte at Naples).

But Paul's chief preoccupation remained St Peter's. At the beginning of his reign, he had recalled Peruzzi from Siena, but Peruzzi died at the beginning of 1536. The work was then handed over to Antonio da Sangallo, who made a new design similar to that of Peruzzi, but even closer to the original scheme of Bramante. It included an unfortunate façade squashed between two towers, of complicated design, lacking in harmony. The pope approved these designs, despite protests from such artists as Vasari. A complete scale model in wood still survives of Sangallo's plan [60]; but in the event the work which he undertook in the basilica was structural, and in no way affected the exterior.

Antonio da Sangallo died in 1546. Paul III then turned to Giulio Romano and Sansovino, who both declined. It was at this point that the pope put the work into the hands of Michelangelo, who was by now an old, sick man, all too aware of the responsibility involved. He tried to refuse, but the pope's insistence eventually won him over. He undertook to do the work without payment. It was to be something he would do 'for the glory of God, for the honour of St Peter, and for the salvation of his soul.'

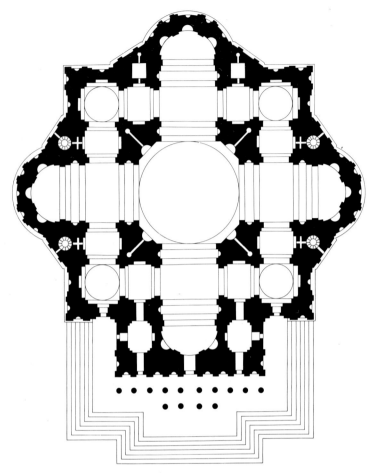

MICHELANGELO   *Proposed plan of St Peter's*

He adopted the scheme of Bramante, claiming that whoever had departed from Bramante (Sangallo, for instance) had departed from the truth. His interpretation of the design, however, had a decidedly contemporary feeling. He reduced Bramante's square plan to something more compressed, with the apses brought closer to the centre [58].

The central dome was to be enlarged, and instead of resting directly on the four piers it was to be supported on a high drum, and instead of a hemisphere it was – at first – to be a pointed dome like Brunelleschi's dome of Florence Cathedral. (Michelangelo later returned to the idea of the hemisphere.)

Bramante's design had been essentially a hemisphere placed over a cube. Michelangelo's design was altogether more dynamic, with the three apses expressing a sense of compressed force, and the magnificent thrust of the dome. In fact Michelangelo was treating the building as a sculptor would. We notice this especially in the parts that were carried out under his personal direction [103]: in the exterior of the tribune, for instance, the architectonic elements have the tension that one associates with knotted muscles. Not only was it a sculptor's building; we can even say it was a painter's building, in such features as the calculated effects of light and shade created by projecting elements in the tribune walls. The repertory of classical forms was undergoing a transformation. The traditional treatment of the orders was rejected. Cornices, entablatures, capitals, tympana, pillars and pilasters were all given qualities that borrowed something from the organic world of nature [104]. It was as if Michelangelo wanted his building to embody a transcendent vision of the order of creation.

In the course of the eighteen years he devoted to the building of St Peter's, Michelangelo evolved a new approach to architecture, renewing all the canons of the Renaissance. He had his own conception of space and of the composition of volumes, which was to have an immediate effect on architectural Mannerism, just as his *Last Judgment* had on painting and sculpture.

Michelangelo brought about something which was not merely a change of style. His innovations involve more than the architectural means of expression, more even than the intensity of feeling that can be expressed by these means. He brought about a renewal that goes right to the heart of what we

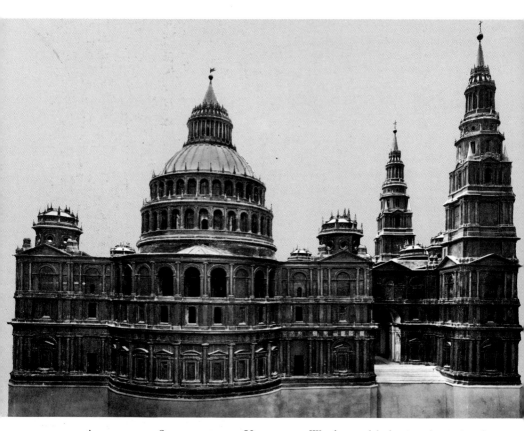

ANTONIO DA SANGALLO THE YOUNGER  *Wooden model showing the projected completion of St Peter's*  The design is obviously inspired by the superimposed classical orders of the Colosseum and the Theatre of Marcellus, but it is fragmented and lacks harmony, and attracted severe criticism from Michelangelo.

MICHELANGELO AND GIACOMO DELLA PORTA
*Wooden model of the dome of St Peter's* ▷

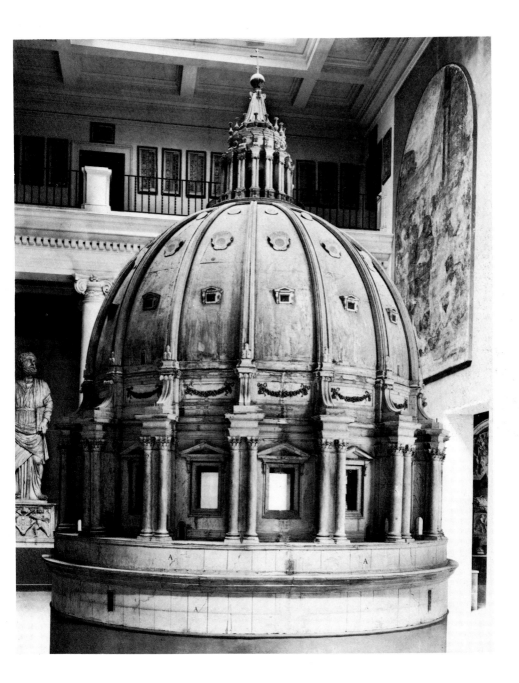

understand by architecture as space organized in a constructive manner. In Michelangelo's work, it is space that undergoes change. With him, the space contained within a building is no longer static. It becomes somehow organic. The walls and the dome no longer separate internal and external space: they link them; they 'organize' the interior and exterior simultaneously and with the same degree of expression, creating a nobler kind of aesthetic synthesis. It is with Michelangelo that modern architecture begins.

# THE LEGACY OF MICHELANGELO

During the last years of his life, Michelangelo witnessed a gradual slowing down in the building of the new basilica. To Vasari he wrote, 'Things are not going too well for me here as far as St Peter's is concerned.'

The work had progressed quickly under Paul III and during the five years of Julius III's pontificate (1550-1555). Julius was not a great pope, but that he was a man of taste who appreciated the latest developments in architecture is proved by the marvellous Villa Giulia, which he had built by Vignola and Ammanati on the Via Flaminia. (It is known to tourists today as the Museo Nazionale d'Arte Etrusca.)

Julius III gave Michelangelo more scope than his predecessor had done with regard to the building of St Peter's, and he insisted on his receiving at least a token salary of 50 scudi a month. He also gave him his favourite architect, Vignola, as assistant. Vignola had already proved his worth in the building of the Villa Farnese at Caprarola and the Villa Giulia, and had written an important treatise on architecture, the *Regola delle cinque ordini d'architettura,* inspired by Vitruvius. In designing the church of the Gesù, he had produced what was to be the type of all Jesuit churches of the Counter-Reformation.

The pontificate of Paul IV Carafa (1555-1559), a man of little culture best remembered for his zeal in stepping up the Inquisition, forms a parenthesis in the building history of St Peter's. Things improved, however, under Pius IV (1559-1565), who was well disposed towards the arts. When Michelangelo died in 1564, it was Pius who appointed Vignola and Pirro Ligorio to take over work on the basilica. But when Pius V (1566-1572) came to the throne, Ligorio was dismissed, and Vignola carried out Michelangelo's plans on his own. With the utmost loyalty to Michelangelo's intentions, he completed the north transept and almost finished the drum that was to support the dome, with its series of double columns on which colossal statues of the apostles were to stand. He was still working on plans for erecting the dome when he died in 1573.

It is in fact questionable whether Michelangelo's plan, for a perfect hemisphere surmounted by a lantern, could have been carried out. It was all very well on paper, but from the practical point of view so vast a hemispherical dome was almost an impossibility: it would have exerted such an outward thrust that it is unlikely that the drum could have taken it.

The plan certainly had to be changed somehow, and it was the Genoese architect Giacomo della Porta who found a solution. He designed a pointed dome [61], in which the mass would be lightened by the introduction of further windows; and he also increased the space between the inner and outer shells of the dome. The lantern would be much smaller than the one proposed by Michelangelo. Della Porta's design was rather similar to Sangallo's [60], but it sacrificed nothing of Michelangelo's feeling for sculptural relief, monumental mass and an exciting sense of tension.

The dome, as it finally took shape from 1585 onwards, was a compromise between Michelangelo's design and the structural exigencies resolved with such ingenuity by della Porta. The conception is still Michelangelo's, a massive yet supple covering

which would dominate the basilica internally and externally; but we must never underestimate the extreme subtlety with which della Porta translated the design, giving the dome such elegance, thrust and dynamism.

The work was nearly finished during the pontificate of Sixtus V (1585-1590), and its completion coincided with a renewed interest in the arts in Rome. Sixtus V was a strong-willed and decided character, a fitting counterpart to Julius II with whom the century had opened. Sixtus was responsible for the daring enterprise of Domenico Fontana who removed the obelisk from the Circus of Caligula and transferred it to the forecourt of the new basilica [66, 67], which was eventually to become the Piazza S. Pietro. Sixtus and Fontana also devised a new town plan for the city of Rome, with straight avenues linking the four chief basilicas (the best known of these avenues is made up of the Via Sistina and former Via Felice). Another of Fontana's important works is the completion of the Palazzo del Quirinale, begun by Gregory XIII (1572-1585) and appointed as the papal residence in Rome. He also worked on the Lateran Palace and built the Cappella Sistina in S. Maria Maggiore.

When the dome was finished, St Peter's must have looked rather odd. The obvious next step would have been to complete Michelangelo's Greek cross design by building the façade. For the moment, however, the original façade of Constantine's basilica was still standing, with its portico.

It had been thought originally that these Early Christian elements, with their Romanesque and Gothic alterations, might somehow be incorporated into the new basilica. The effect of such a hybrid would have been curious indeed, but certain influential people like Cardinal Barberini (later Pope Urban VIII) were very much attached to the remains of the original building for sentimental reasons. It was Paul V Borghese (1605-1621) who put an end to this state of indecision. He insisted that the old building was not strong enough to survive, and decreed that

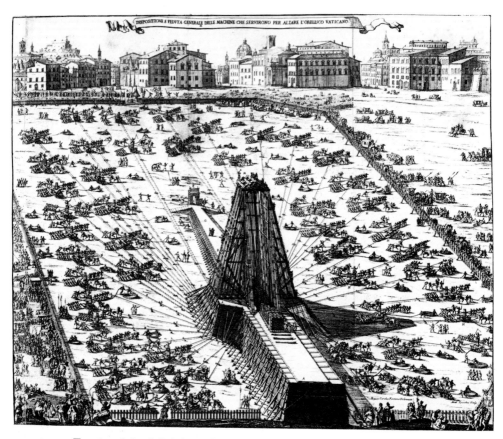

*Erection of the obelisk from the Circus of Caligula in Piazza S. Pietro in 1586*

a long nave should be added, thus turning Michelangelo's Greek cross into a Latin one.

Paul V entrusted his plan for the nave, atrium and façade to a Lombard architect, Carlo Maderno. Maderno was conscious of the responsibility involved in changing Michelangelo's plan. Work began on 8 March 1607, and although Maderno made it clear in a letter that he did not entirely agree with the

pope's plan, building progressed rapidly to produce the nave that we see today, with its arches and pilasters supporting a barrel vault, and the two side aisles with their series of chapels. The atrium, reduced to a simple narthex, was none-theless imposing, and it is to Maderno's credit that he incorporated here some of the original features, such as Filarete's doors [108] and Giotto's mosaic of the *Navicella,* by now considerably restored.

*View of Piazza S. Pietro*  In this fresco in the Vatican Library, painted in 1588, one can see the newly erected obelisk (the lions which support it are just visible) and, behind it, the old loggia, the drum of the dome of St Peter's, still under construction, and the Cortile di S. Damaso.

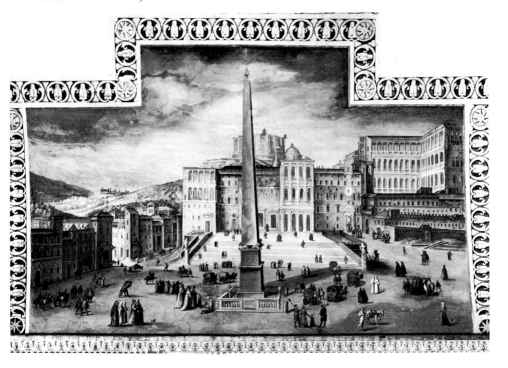

Maderno's façade was less fortunate. He finished it in 1614, and he did at least try to break up its monotonous line by accentuating the central part [97]. But the façade inevitably masks the dome at close quarters [99] and seems insignificant when seen from a distance – a fact which had not been so noticeable on paper since Maderno had originally intended to place a campanile at either end.

Throughout the second half of the sixteenth century and the first twenty years of the seventeenth century, the reconstruction of St Peter's had been the chief concern of the popes. Some of them were already providing for its interior decoration. Gregory XIII commissioned a chapel which was designed by G. Muziano and built by della Porta, and handsomely decorated with columns and precious marble facing taken from ancient monuments: it became known as the Cappella Gregoriana, and housed the famous thirteenth-century *Madonna del Soccorso* and the relics of St Gregory Nazianzus. On the opposite side of the nave a similar chapel was built, later known as the Cappella Clementina. Each chapel was covered with a dome similar to those in Michelangelo's original design, but smaller and simpler. Michelangelo had in fact intended four such small domes placed in a square round the central one.

During all this time some important new works were being undertaken in the vicinity of St Peter's. Bramante's Belvedere courtyard had already been altered before the death of Julius II, when Michelangelo had been called in to rebuild the staircase leading up to the exedra backing on to the Villa. In 1560 Pirro Ligorio, following – it is said – the advice of Michelangelo, transformed this exedra into a great niche in the Imperial Roman style [222].

It may seem surprising that the popes should sponsor anything so frankly spectacular and hedonistic in an age that was fraught with theological problems and trials for the Church. The fact remains that they never lost their taste for worldly splendour,

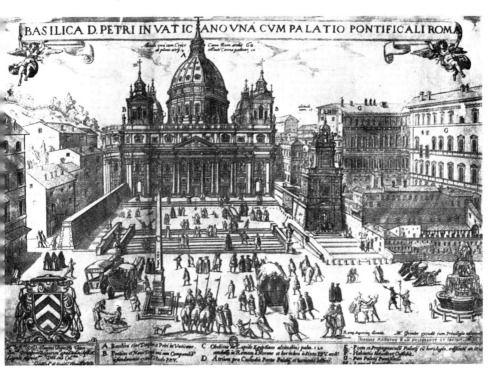

*St Peter's at the beginning of the seventeenth century, before the building of Bernini's colonnade*

as we can judge by the sumptuous joust held in the Belvedere during Carnival 1565 to celebrate the wedding of Pius IV's nephew, Annibale Altemps, to the latter's cousin Ortensia Borromeo.

After the west side of the Belvedere courtyard had been redesigned, work was begun on the east side, which backed on to the papal palace. Here again Bramante's design was modified, but its simplicity was retained so as not to detract in any way from the monumental quality of the great niche.

The courtyard was completed during the early years of Paul V's pontificate, but a somewhat questionable decision was taken to divide it into two by means of a transverse wing known

as the Braccio Nuovo. Here Sixtus V installed the Vatican Library. It meant in effect that Bramante's spacious design, which had achieved something worthy of classical antiquity, was now virtually ruined.

The charming and decorative Villa Pia, or Casino of Pius IV, which stands in the Vatican gardens, is also due to Pirro Ligorio; designed for the leisure hours of Paul IV (1555-1559), it was only completed under Pius IV. It is a gem of Mannerist architecture, and includes a loggia which faces the villa across an oval court surrounded by a low wall [71]. In the centre there is a fountain, and at the sides two arches with shell niches under pediments lead into the surrounding park. The villa itself contains little more than a large entrance *salone* and several small rooms.

The façades of the villa, the loggia and the two arched gates, as well as the inner side of the encircling wall, are covered in stucco reliefs of mythological figures and motifs which serve as a framework for antique sculptures. The interior of the villa was frescoed by the Zuccari brothers and their pupils with mythological subjects. Not only the decoration, but the villa itself with its atrium-like loggia, courtyard and rooms is inspired by the villas of Imperial Rome. However, as W. Friedländer pointed out in his important study on the Casino, the way in which the ornament is used and the way in which the various parts of the complex relate to one another make it a thoroughly unclassical work. It is indeed completely Mannerist; and the structures are so totally subordinated to decoration that it seems almost a prelude to the most exotic Rococo creations of the eighteenth century.

At the same time, painting tended towards the learned, the intellectual and the hedonistic. In this twilight period of the Renaissance, alongside of such pompous historical cycles as that in the Sala Regia, we can observe an increasing use of grotesques in ornament, and a tendency to elaborate the stylistic models left

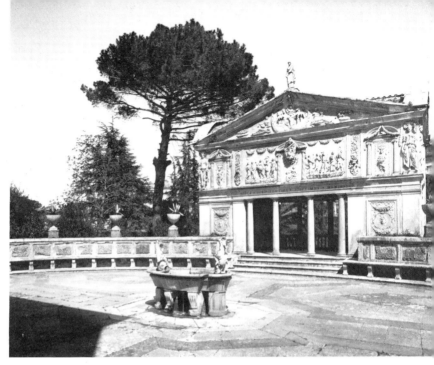

Pirro Ligorio    *Loggia and fountain of the Casino of Pius IV*

Pirro Ligorio    *Casino of Pius IV, in the Vatican gardens*

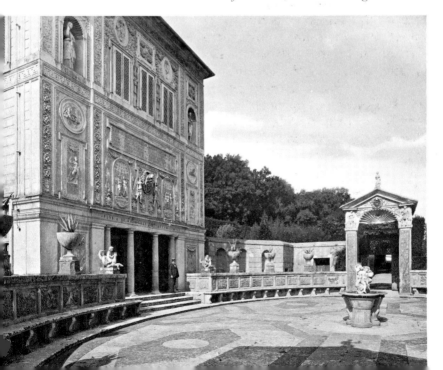

by Raphael and his school. During the pontificate of Pius IV the Loggia della Cosmografia was painted with frescoes using currently fashionable symbols from astrology and magic. The decoration of the long corridor on the third floor of the west wing of the Belvedere courtyard is rather similar. Here, under the guidance of Ignazio Danti, a group of painters including Gerolamo Muziano and Cesare Nebbia painted maps (some correct, some fantastic) of the principal regions of Italy.

This original décor fascinated everyone at the time. Montaigne in his *Journal de voyage* says that he visited the Vatican in 1581 above all to see 'les statues enfermées aux niches du Belvédère et la belle galerie où le pape dresse des peintures de toutes les parties de l'Italie, qui est bien près de sa fin.'

# THE IMPRINT OF BERNINI

During the first twenty years of the seventeenth century, the Vatican was dominated artistically by Carlo Maderno, who was at work on the nave, narthex and façade of St Peter's. But Maderno was himself still very much under the influence of sixteenth-century tradition. His Roman churches (such as S. Andrea della Valle and S. Susanna) and his aristocratic palaces (Palazzo Mattei, Palazzo Pallavicini-Rospigliosi and – begun by him – Palazzo Barberini) all have the solemn, austere and sculptural monumentality of the Cinquecento. It was Maderno's tendency to follow High Renaissance tradition that appealed to a man like Paul V, who liked fairly conventional building. The eccentricities of Pirro Ligorio with all their decorative invention were not really in the official taste.

By 1620 the papal court had removed to the Quirinal Palace; its location on a hill in the centre of the city was thought to be healthier, and more suitable from the practical point of view. The Quirinal Palace now came in for more attention, with a sumptuous entrance put up by Paul V, and a chapel, the Cappella Paolina, which was as large as the Sistine Chapel. This was decorated by Roman artists – Guido Reni, Lanfranco and Saraceni.

For the moment, then, the Vatican Palace was rather out of favour. Paul V commissioned outstanding works for the city, such as the Acqua Paola aqueduct and the fountain on the Janiculum, but in the Vatican itself little was done: minor work was carried out to complete the old palace, and Paul showed a certain interest in the construction of the Fontana delle Torri, in the gardens, and a new entrance to the Vatican to the right of the façade of St Peter's.

This entrance, which was the work of Ferabosco and Vasanzio (the Flemish architect Hans van Xanten) was destined to be short lived, for it was pulled down between 1659 and 1661 by Bernini to make room for a passage between the colonnade and the basilica. All we can gather about the original structure, from an engraving, is that it had a somewhat curious appearance: more than anything else, it resembled the kind of decorations in wood and papier maché that were put up on festive occasions. It had a heavy, military-looking base, and over the door was an open loggia. The front was built like a tower, decorated with a niche containing a mosaic, and a large clock, which gave the building its name of Porta Horaria. The whole thing was topped off with a little dome, surmounted by a cross standing on a globe.

The popes admittedly had little interest at this particular moment in what was going on in the Vatican, but this is not a sufficient explanation for the style of such buildings as Maderno's façade and the Porta Horaria. The fact is rather that the Vatican was no longer keeping up with the artistic development of Rome. It had ceased, for a time, to be the centre of culture.

Things were moving forward, however, in the Roman churches and the palaces of the aristocracy. Between the end of the sixteenth century and the beginning of the seventeenth, Caravaggio had laid the foundations of modern painting. He expressed a new morality, a new feeling about religion and about society, based on his experience of reality [246]. His *Madonna of*

*the Serpent,* painted for the chapel of the Confraternity of the Palafrenieri in St Peter's, was rejected as unsuitable: its subject was the defeat of heresy, but its treatment was thought too free, too unlike the official iconography.

At the same time Annibale Carracci was reviving the great Renaissance tradition in painting, bringing new life to something that had been all but exhausted by the Mannerists. But significantly Carracci produced nothing for the Vatican, amid all his works for Roman churches and collections, and in the magnificent gallery of the Palazzo Farnese.

The few works of 'modern' art that found their way into St Peter's are none of them very startling. Guido Reni's *Crucifixion of St Peter* [245], for instance, is a compromise between the tradition of Raphael and the dramatic chiaroscuro of Caravaggio. The Church was suspicious of much that was going on in the world of culture, not alone in the fine arts but also in science and philosophy. In 1600 Giordano Bruno was burned at the stake, and thirty-three years later Galileo was condemned and silenced.

But while the Church continued to frown on the new movements in contemporary thinking, the arts began to revive with the accession of Urban VIII (1623-1644), who, as Cardinal Barberini, had tried to preserve the last fragments of Constantine's basilica. By birth he was a Florentine, but so great was his devotion to the city of Rome – *urbs Roma* – that on his election he took the name of Urban. He was a poet, a musician, and a true lover of the arts, and it was he who had the good fortune to discover among the artists then working in Rome the very one who would be able to translate his yearning for splendour into worthy forms. The artist was Gianlorenzo Bernini.

There were at the time many other fine artists whom Urban could have favoured. There were the architects Francesco Borromini, Pietro da Cortona and Gerolamo Rainaldi. Among the painters there was again Pietro da Cortona, then Domenichino,

Giovanni Lanfranco, Poussin, and Guercino. The sculptors included Alessandro Algardi, Francesco Mochi and François Duquesnoy. But during the whole of Urban's pontificate it was Bernini who dominated the Roman scene. His imagination and his taste left a mark on the city that is with us still. Bernini and Urban VIII enjoyed much the same kind of intimate relationship and communion of ideas that we have already observed between Michelangelo and Julius II.

Bernini began work in the Vatican in 1624 with the baldacchino over the high altar [120, 122], a task which took him nine years. But even while he was engaged on this he was drawing up plans for the reliquary shrines to be built into the four great piers under the dome [125]. For one of these shrines he carved the enormous statue of Longinus with the Holy Lance [127]. Bernini worked ceaselessly not only in the Vatican but on various churches, palaces and squares in Rome and other towns. In 1628 he was preparing designs for the tomb of Urban VIII. This was not finished until 1647, after Urban's death; it was placed in one of the deep niches of the apse as a pendant to the tomb of Paul III, designed by Guglielmo della Porta [131, 132]. Between 1633 and 1637 Bernini also carved the monument to Matilda of Canossa [128].

During the pontificate of Urban's successor, Innocent X (1644-1655), Bernini's reputation suffered when one of the campaniles he had added to the façade of St Peter's proved structurally faulty and had to be taken down. However, he continued with his decoration of the piers in the nave, and designed further statues for the niches in the great crossing-piers.

With the accession of Alexander VII Chigi (1655-1667), Bernini was once again given complete control over all the work in St Peter's. He designed the 'Cathedra Petri' [129] – the Gloria with the chair of St Peter – in the apse (1656-66) and the colonnade enclosing the Piazza S. Pietro [94, 97, 99, 101]. From

1663 to 1666 he was working on the Scala Regia and the equestrian statue of Constantine, commissioned by Innocent X in 1654 [111, 112].

Under Clement IX (1667-1669), Clement X (1670-1676), and Innocent XI (1676-1689) Bernini was aided by an imposing team of assistants, pupils and workmen. In 1667 the Piazza S. Pietro, with its two fountains, was finished [99]. From 1671 to 1678 he supervised work on the tomb of Alexander VII [134], and designed the tabernacle for the Altar of the Blessed Sacrament.

When we come to consider these works individually, we shall see how each one reveals some new emphasis in Bernini's powers of expression, and in his feeling for the grand and the spectacular. The colonnade, the Cathedra Petri, everything he achieved in St Peter's has something theatrical about it, so that the basilica becomes almost a succession of tableaux. All his sculptures and decorations are eloquent in the praise of the Church Triumphant.

Bernini set the seal of the Baroque on St Peter's for all time, but in such a way as to be in perfect harmony with the imposing structure created by Michelangelo. From the moment when Bernini put up his baldacchino over the high altar, St Peter's turned into a dialogue between two great masters, each the dominating force in the art of his age. After Bernini, all the seventeenth-century additions, apart from Algardi's bas-relief of *St Leo and Attila* [135], are of small importance.

When Bernini died in 1680 at the age of eighty-two, St Peter's was virtually complete. Subsequent projects were to follow his ideas so closely that the general feeling has remained inalienably Baroque. His achievements in St Peter's came to be acknowledged as an integral part of the fascination of Rome.

When the connoisseur Charles de Brosses arrived in Rome from Dijon in 1739, he came ostensibly to view the ruins of classical antiquity; but he found – and later recorded in his

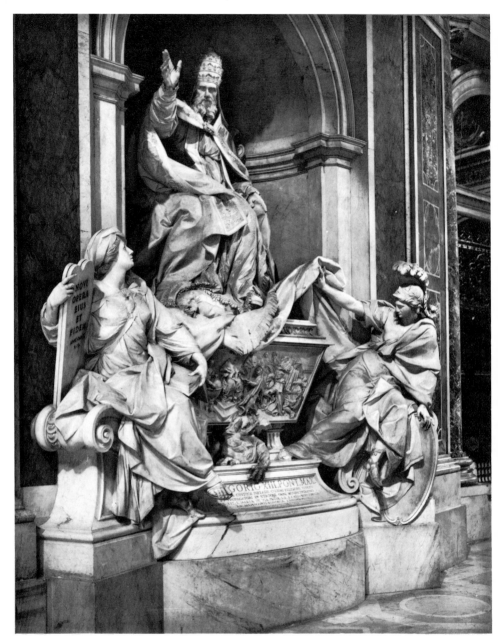

CAMILLO RUSCONI *Tomb of Gregory XIII*

*Lettres familières sur l'Italie* – that the Vatican basilica was 'the most beautiful thing in the universe'. He praised it for 'the admirable justness of its proportions': 'everything is simple, natural, august, and therefore sublime.' But his chief enthusiasm was for Bernini. 'This admirable colonnade is one of the finest monuments of modern architecture.' The baldacchino had no rival. The Cathedra Petri he called 'a wonderful work in rich and excellent taste... a prodigious and admirable work in bronze.'

Even when the Neo-classical style had supplanted the Baroque in popularity, critics such as Mengs, Milizia and Goethe still fell under the spell of Bernini, and accepted St Peter's as one of the truly great achievements of the human spirit.

Bernini's influence lasted long after his death. Indeed much of Roman art in the eighteenth century owes a great deal to his style. This is especially notable in monumental sculpture: the statues of saints in the nave of St Peter's were done by Pietro Bracci, Camillo Rusconi, Filippo della Valle, Carlo Monaldi, Bartolomeo Cavaceppi and others, but Bernini's sketches inspired them all to a greater or lesser extent. Bernini's tombs for Urban VIII and Alexander VII remained the models for this kind of monument throughout the eighteenth century, the only difference being that the style becomes lighter and more graceful under Rococo influence.

For the tomb of Gregory XIII [78], put up between 1719 and 1723, Rusconi abandoned Bernini's use of coloured marble, but his design follows Bernini closely with its seated pope, and its figures representing Religion and Wisdom. Twenty years later, in 1746, Filippo della Valle and Ferdinando Fuga adopted the same composition and used coloured marble [80]. Their figures of Charity and Justice are carved with a delicacy that is typical of the period. In 1789 Pietro Bracci designed the tomb of Benedict XIV, still following Bernini, although with the figure of the pope standing instead of sitting [82]; it is interesting to

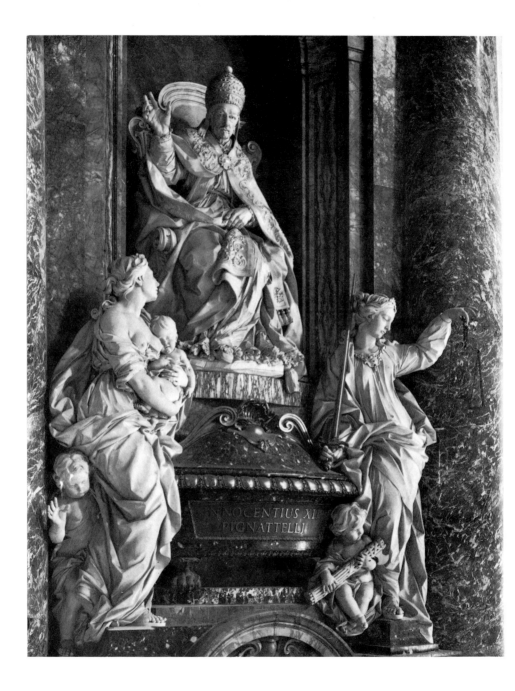

see how Bracci's personifications of Wisdom and Renunciation hark back deliberately to a seventeenth-century type. Bracci had shown himself to be a follower of Bernini as early as 1745, with the tomb of Marie Clémentine Sobieski, executed after a design by Barigioni.

Another sculpture that is very much under Bernini's influence is the equestrian statue of Charlemagne by Cornacchini, of 1725, which stands in the narthex on the left and is a servile imitation of Bernini's statue of Constantine on the right [111, 112]. Cornacchini also designed the two large holy water stoups attached to the first two piers of the nave, which were carved between 1724 and 1730 by Francesco Moderati and G. Lirone: they are so completely in the manner of Bernini that it used to be taken for granted that Bernini had actually designed them. Bernini's domination of these later artists may be said to have deprived them of originality, but within the limits that he imposed their work is vital, technically skilful and completely in harmony. The influence of Bernini in St Peter's was so strong that even Neo-classical artists submitted to it: Vanvitelli's gilded stuccoes in the semidomes of the apses, and Valadier's clock and bell towers are completely Baroque.

The last addition of all was the sacristy, built by Carlo Marchionni between 1776 and 1784. This required the demolition of one of the last of the Early Christian survivals, the church of S. Maria della Febbre. Originally supposed to be the tomb of Theodosius, it was transformed into a church at the time of Pope Symmachus; its appearance is known only from a drawing by Hubert Robert [83]. Fortunately Marchionni's sacristy is a simple building that harmonizes well with Michelangelo's tribune and apses.

◁ Filippo della Valle and Ferdinando Fuga  *Tomb of Innocent XII*

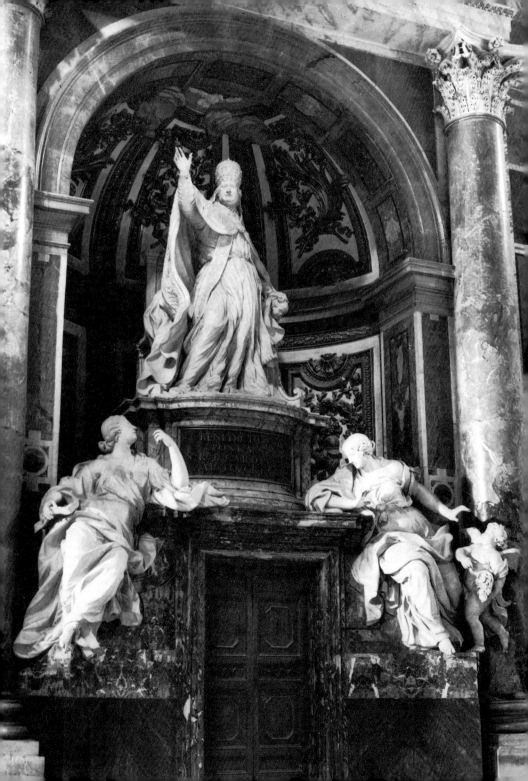

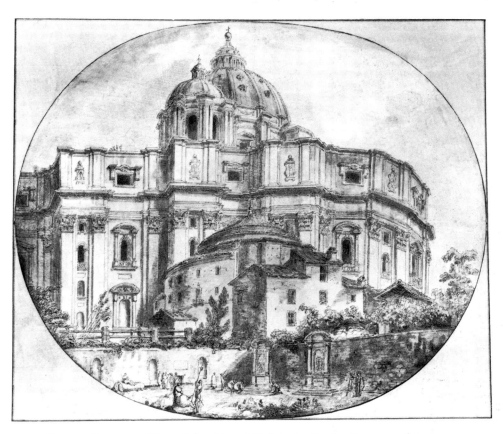

HUBERT ROBERT  *View of the Apse of St Peter's*  In the foreground is the church of S. Maria della Febbre, formerly the chapel of S. Petronilla, demolished in the late eighteenth century.

◁ PIETRO BRACCI  *Tomb of Benedict XIV*

# FROM THE AGE OF ENLIGHTENMENT
# TO THE PRESENT DAY

In many areas of culture, the eighteenth century witnessed a new approach to the past. Instead of looking back nostalgically to a remote golden age, people were beginning to be aware of the connection between past and present; the past became a legitimate subject of study, to be investigated in the light of the present, and from which one might derive lessons for the present. Eventually, in the hands of archaeologists, this attitude was itself to give rise to a new myth – that in the arts of classical antiquity modern men would find not just an ideal, but the very norm and rules of beauty.

The 'discovery' of history in the Age of Enlightenment conditioned the activities of the popes throughout the eighteenth century, and gradually led to the formation of the Vatican Museums.

When in the days of Julius II and Pius V classical sculptures were assembled in the Belvedere and the Casino of Pius IV they were admired above all as relics of antiquity. The eighteenth century required more: the collections were to be rearranged in the light of recent research, their display governed by a scientific, critical approach.

The first of the popes to be interested in a new arrangement of the Vatican collections was Clement XI (1700-1721). He

proposed that the papal palace should contain a museum of Christian antiquities. Political and economic difficulties, however, made this impossible throughout the whole term of his pontificate. The idea was taken up by his immediate successors, in particular by Clement XII (1730-1740) who founded the archaeological museum of the Capitol, in one of the buildings flanking the piazza designed by Michelangelo.

Pope Benedict XIV Lambertini (1740-1758) was extremely interested in the Vatican collections. It was he who founded the Galleria Lapidaria for antique inscriptions on stone, and the Museo Sacro, which in 1756 was put under the direction of a real authority on classical art, the distinguished collector Francesco Vettori.

More important developments came with Clement XIII (1758-1769), who acted through another great collector, the learned Cardinal Alessandro Albani, nephew of Clement XI. Cardinal Albani in turn appointed Winckelmann and Ennio Quirino Visconti to use their archaeological knowledge towards a new and scientific organization of the collections. Thus the Museo Profano was founded for classical works of art of all kinds.

Under Clement XIV (1769-1774) the collections were rearranged chronologically, and the Greek and Roman sculpture which had been kept in various parts in the Vatican was now gathered together in the Museo Pio-Clementino. The most famous pieces were set apart in the Belvedere.

The Vatican Museums were now no longer mere 'curio cabinets'. Their contents were augmented by many items: under Pope Pius VI Braschi (1775-1799) the Museo Profano acquired Cardinal Gualtieri's collection of Greek and Etruscan vases, Cardinal Albani's medals and coins, and Cardinal Carpegna's gems and cameos.

But the unfortunate Pius VI lived to see his collections ransacked by Napoleon, after the treaty of Tolentino, for the

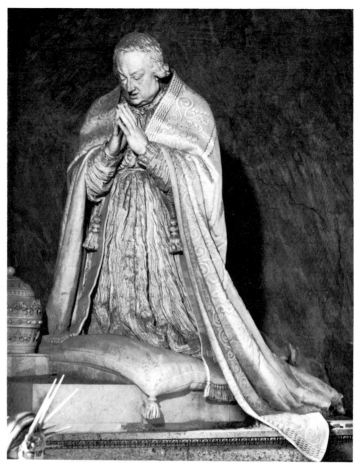

ANTONIO CANOVA    *Tomb of Clement XIII*    Detail

benefit of the Louvre. It was not until the Congress of Vienna in
1815 that the Vatican property was returned. By this time
Pius VII Chiaramonti (1800-1823) was pope, and the new direc-
tor of the Museums was none other than Antonio Canova, one
of the greatest sculptors of his time, and the most famous
exponent of Neo-classicism.

86

Canova had been working for the papacy since 1792, when he designed the tomb of Clement XIII in St Peter's [86]. He also produced the kneeling statue of Pius VI in front of the Confessio of St Peter [88]. (Pius had died in exile, but was buried here at his request.) Another of Canova's works is the monument to the Stuarts [89], carved between 1817 and 1819 – a masterpiece of formal elegance in the Neo-classical idiom.

Canova's work as director of the Vatican Museums was no less important than his work as a sculptor. To him we owe the fact that the paintings which Napoleon's army had taken from various churches and convents in the papal territories and other parts of Italy were hung in the Vatican Pinacoteca. Canova also founded the Museo Chiaramonti (named in honour of the family of Pius VII), devoted to archaeological collections. The tapestries after Raphael's famous cartoons [219], woven by Pieter van Aelst of Brussels for Leo X, were restored and hung in 1815 in the apartments of Pius V.

During the nineteenth century artistic activity in the Vatican was almost entirely limited to the arrangement of the Museums, and the acquisition of new works of art. Gregory XVI (1831-1846) founded the Etruscan and Egyptian museums. The former, inaugurated in 1837, contains objects excavated at Cerveteri in Latium and at other Etruscan sites. The second, opened in 1839, consists of Gregory's own collection with additions from other collections, and from excavations on the sites of Egyptian temples in or near Rome (the temple of Isis in the Campus Martius, and the Serapeum of Hadrian's Villa at Tivoli).

Another of Gregory XVI's foundations was the Museo Profano in the Lateran Palace, which was begun in 1844 and contains sculpture of the late Roman Empire. The Museo Cristiano at the Lateran was founded by Pius IX in 1854: it is the most complete collection of Early Christian art in existence. Both museums are at present housed in the Vatican in temporary quarters until a new building, commissioned by Paul VI,

*Confessio of St Peter*   On the left, the statue of Pius VI

Antonio Canova   *Tomb of James III, Charles III and Henry IX Stuart*
Detail: a mourning angel   ▷

88

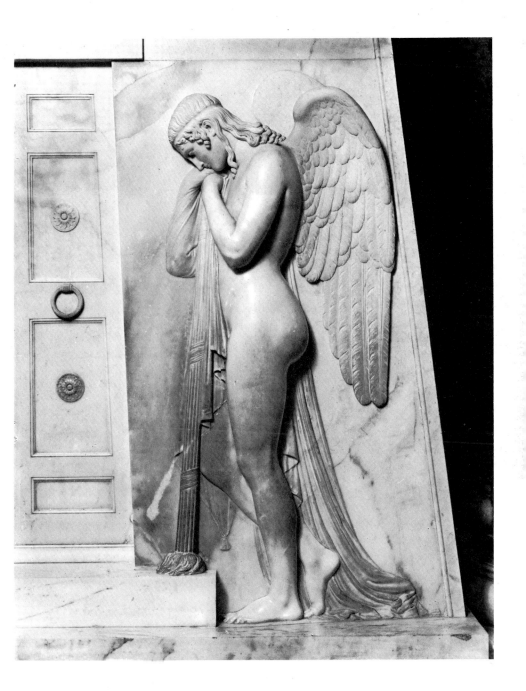

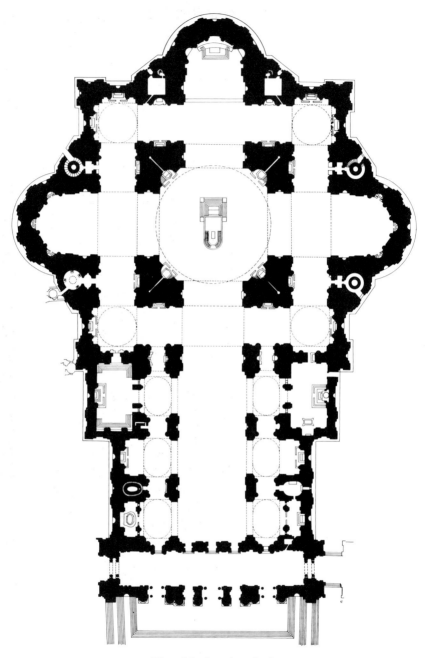

*Plan of St Peter's as built*

EMILIO GRECO
*Tomb of John XXIII*

GIACOMO MANZÙ   *Porta Nuova of St Peter's*

is completed. It is therefore only a matter of time before all the pontifical collections are accessible to the public as a unit.

When Italy was finally united under Victor Emmanuel II, the temporal power of the popes came to an end. This brought about a crisis that was both political and cultural. Rome became synonymous with reaction, publishing its syllabus of errors, and condemning so-called modernism. It is only recently that the Vatican's attitude to modern conditions has changed. Under Pius XII, the Vatican Pinacoteca was opened to the work of contemporary artists, and the nucleus of the modern collection was inaugurated by Pope John XXIII in 1960.

Recently the Vatican took a decisive step by admitting to St Peter's such fine new works as the tomb of Pope John XXIII by Emilio Greco [91] and Giacomo Manzù's new bronze doors [92]. It would thus seem that St Peter's will continue to be the living force that it has been for so many centuries in the history of Western civilization.

*Aerial view of St Peter's and the piazza*  On the right is the papal palace; in the
background, the Vatican gardens.

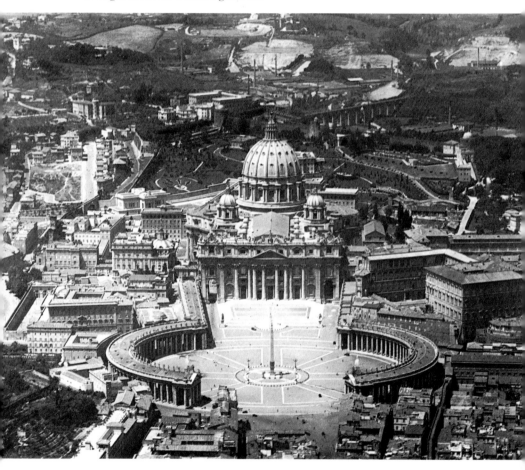

# PIAZZA S. PIETRO

While St Peter's was being built, the question naturally arose as to the best means of using the space in front of the basilica to create a worthy approach. The question had fascinated Pope Sixtus V (1585-1590), who had the idea of marking out the centre of the forecourt with the obelisk that originally stood in the Circus of Caligula. This obelisk, removed by Caligula in AD 37 from Heliopolis, where it had been erected by Caius Cornelius Gallus, had acquired Christian significance: it was a link with the place where in AD 67, according to tradition, St Peter and his companions suffered martyrdom. With the rebuilding of St Peter's it now stood awkwardly between the side of the basilica and the circular chapel of St Andrew.

Pliny in his *Natural History* (XVI, 201) had described the difficulty of transporting the obelisk to Rome, without giving any exact information about how it was done. Fifteen centuries later it was still a considerable feat of engineering to manoeuvre a heavy monolith over 83 feet high into a new position.

Sixtus began by having a scale model made in wood, which was set up in the centre of what was to become Piazza S. Pietro. He appointed Bartolomeo Ammanati to work out the problem, but when Ammanati insisted that it would take him a year, the pope decided he could not wait, and the work was passed over

to Domenico Fontana. Fontana was appalled by the idea, and seriously thought the pope had gone mad.

Fontana's plan was to build a wooden tower round the obelisk and then, by means of ropes and tackles, lift it from its plinth and gently let it down on to a platform on rollers. This platform would then be moved to the centre of the forecourt, where an inclined plane would have been set up against the new plinth, and the operation would be carried out in reverse.

All this took a considerable time. On 30 April 1586 work began on lifting the obelisk from the spot where it had stood for centuries. Fontana was so uncertain of success that he had horses kept ready to get him out of Rome as quickly as possible if anything should go wrong. The atmosphere was extremely tense, and when the obelisk finally began to come away from its base, everyone burst into loud cheers, cannon were fired in Castel S. Angelo, and all the bells were rung.

On 17 May the obelisk was lifted on to its mobile platform, and on 14 September it was ready to be re-erected [66]. The densely packed crowd had been ordered to keep absolutely silent so as not to distract those in charge of the work. Again the tension was extreme. In the immense open space the only sounds were Fontana's curt orders, the creaking of pulleys and rollers, and the panting of men and horses. Suddenly, an eye-witness reported, the silence was broken by a shout. A sailor from Liguria had noticed that the ropes were under such strain that they were about to snap; he cried out that they should be wetted in order to relax them. The workmen immediately did as he told them; and the pope forgave him for disobeying his order of silence. After many hours the operation was successfully completed, to the relief of Fontana and the unrestrained delight of the people of Rome.

Fontana eventually published an account of the technicalities involved in *Della trasportazione dell'Obelisco Vaticano* (1590), which contains a number of interesting engravings. Further

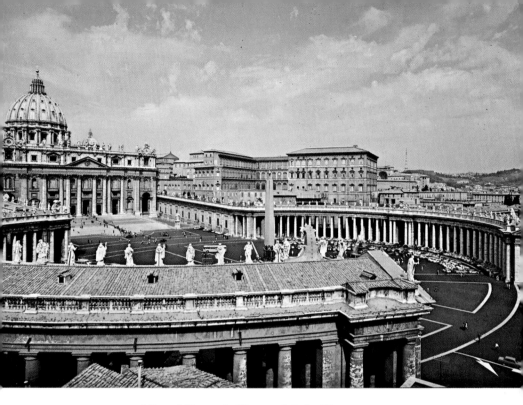

*View of Piazza S. Pietro and the basilica*

details are recorded in *Templum Vaticanum,* published in 1694 by
Carlo Fontana, a descendant of Domenico, which again contains
engravings [66].

The present base of the obelisk consists of a high plinth with
Latin inscriptions on each of its four sides, celebrating the
power of the Church over the infidels. The obelisk daringly
rests not directly on the plinth but on four bronze lions, which
symbolize the Lion of Judah. At the top, where according to
popular imagination a golden urn contained the ashes of Julius
Caesar, Alexander VII placed a reliquary containing a fragment

of the True Cross: this bears the arms of Alexander's family, the Chigi of Siena, and emblems of the Church and papacy.

After the erection of the obelisk, the next stage in creating the piazza was the provision of a façade for St Peter's, which had remained unfinished since Michelangelo's death in 1564. The presence of the dome and the scale and complexity of the building presented problems which were technical and, to an even greater extent, aesthetic. A number of architects were suggested but the choice (as we have seen) finally fell on Carlo Maderno, who was responsible for lengthening the nave.

Maderno decided on a rather conventional scheme, using a giant order across the entire width of the façade, with the centre slightly emphasized by a pediment and the use of columns rather than pilasters. He originally intended to have campanili at the ends where there are now clocks surrounded by papal arms: the design met with criticism for its heaviness, and the campanili were eliminated to lighten it. Maderno proposed to give the illusion of convexity by varying the spaces between the columns, probably with a view to linking the front more interestingly with the dome. But in the end this too was abandoned, and the final façade, consecrated in 1626, tends to look both monotonous and compressed. It has been much criticized, and although not all the criticism has been fair, it is obviously not of the same quality as the rest of the building.

When Bernini was put in charge of St Peter's in 1656, he planned to neutralize the façade by creating a more monumental structure in front of it. The present colonnade of the Piazza S. Pietro, with its elliptical plan, is the outcome of considerable study. Bernini first laid out a trapezoidal forecourt with two wings, each two storeys high, converging on the basilica. In front of this he originally proposed a circular piazza with an arcaded portico. The elliptical plan was in fact suggested by Pope Alexander VII himself. Bernini made its focal points two spectacular fountains on either side of the obelisk: one of them

CARLO MADERNO AND GIANLORENZO BERNINI
*Fountain on the north side of Piazza S. Pietro* ▷

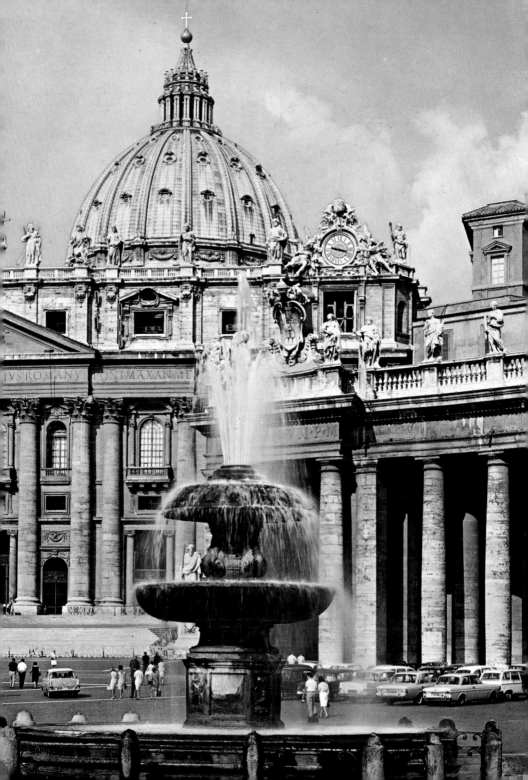

*Piazza S. Pietro*
Interior of the colonnade

*Piazza S. Pietro*
Statues over the colonnade

was by Maderno, altered by Bernini [99]; the other was executed
entirely by Bernini in 1667-77.

The two great colonnades maintain a constant depth of
nearly 56 feet, and consist of four rows of Doric columns and
pilasters of travertine (284 columns and 88 pilasters), each over
42 feet high. An entablature and parapet add another 26 feet to
the height. The whole is crowned with 96 colossal statues of
saints: while most of these were designed by Bernini, they were
carved by various assistants and not completed until 1672.

Bernini had intended to enclose the space completely, linking
the two elliptical wings by a colonnade at the entrance, which
would have concealed the façade from outside the piazza, and
was an integral part of the urban scheme. One must remember
that before the Via della Conciliazione was cut through, in this
century, the buildings of the 'Borgo' pressed up closely in front
of the piazza. Thus the seventeenth-century pilgrim coming

from Castel S. Angelo would have been suddenly and unexpect-edly confronted, on entering the piazza, with a magnificent prospect of noble proportions – surely preferable to the long dull view without surprises that the Via della Conciliazione gives us today. One can, however, recapture something of the original effect by entering the piazza from one of the sides, through the colonnade.

We have already mentioned the theatrical aspect of Baroque. In Bernini's colonnade we have, as it were, the spectacular opening scene, leading on to such sumptuous developments within the basilica as the baldacchino and the Cathedra Petri in the apse. The piazza is a preparation and an invitation to what lies beyond it. Its two arms come forward to embrace the whole of humanity into the bosom of the Church. And this symbolism is so simple, so immediately comprehensible, that those who come from all parts of the world to venerate the memory of St Peter find themselves effortlessly lifted towards the ideal they seek.

# ST PETER'S

MICHELANGELO   *The apse*

We have only to look at the plans which Bramante and Michelangelo drew up for the basilica [46, 58] to realize that although both designs make use of the Greek cross, each architect has a different conception of the use of space.

Bramante's basilica would have been a cubic mass, held down, as it were, by the drum of the dome. What Michelangelo visualized was an animated mass, with the projecting and re-entrant angles of the walls creating a sinuous movement. In Bramante's basilica, the sense of solidity would have been emphasized by the horizontal rhythm of mouldings and cornices. But Michelangelo gives these elements a vertical movement; and his dome, instead of holding the structure down, was designed to increase the upward movement.

These two forms, one static, the other dynamic, belong to two distinct phases in the development of Renaissance style. But there is more to it than that. They are the logical outcome of two different kinds of experience, and the creation of two very different artistic temperaments. The architectural language of Bramante was inspired by the principles and 'orders' of classical architecture, which he had studied thoroughly, and

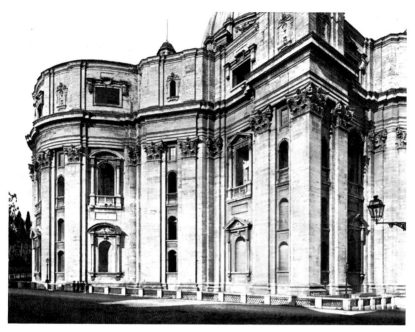

MICHELANGELO  *Apse of St Peter's*

regarded as a model of perfection. He was essentially an archi-
tect. Michelangelo, on the other hand, was a sculptor, and he
conceived architectural composition as something organic: the
vitality of the human form, which he had conveyed in his
sculpture and painting, was now to be conveyed metaphorically
in architecture as well.

Michelangelo had already demonstrated the possibilities of
this new approach to architecture in the Laurentian Library and
Medici Chapel at Florence. St Peter's gave him an opportunity
to test his principles on a much larger scale. It was a fascinating
enterprise for him to undertake, and yet at the same time a
disturbing one, since he was now an old man. Nonetheless he
did undertake it, feeling that God had given him this as a final
mission.

<span style="font-variant: small-caps">Michelangelo</span>   *Details of the apse of St Peter's*

Another way in which he differed from Bramante was in his approach to architectural tradition. As James S. Ackerman has pointed out, his attitude to antiquity was really the antithesis of that of Renaissance humanism. His contemporaries sought to copy ancient Rome, even to rival it. Michelangelo took from antiquity only the elements which suited his temperament, and whatever he took he usually transformed, in its appearance or its meaning. But he always kept some essential characteristic of his classical model, so that the spectator could recognize the source of his inspiration and at the same time admire the new qualities that Michelangelo had given it.

If we look at Michelangelo's apse, of which details are reproduced here, we have a clear illustration of what Ackerman means [103, 104]. The walls seem to have been modelled by the hand of a giant sculptor. The mouldings, cornices, pilasters and capitals create wave-like movements with their highlights and shadows. There is no break anywhere in the structure. Everything merges into an organic unity, full of life and movement.

The neo-Platonic ambition to liberate the spirit from the weight of material elements is something that we are aware of throughout Michelangelo's career, and here it reaches its climax. He sums up all that the Renaissance was trying to achieve. He makes it all his own, he surpasses it, he even contradicts it, and as Vasari said, he shows the way to all future generations.

MICHELANGELO AND GIACOMO DELLA PORTA *The dome*

Michelangelo carefully considered the problem of the relationship between the dome and the rest of the structure, and between the three elements of the dome itself. First there was the cylindrical drum with its circle of twin columns (on which statues of the apostles were to be placed): this was designed to gather into

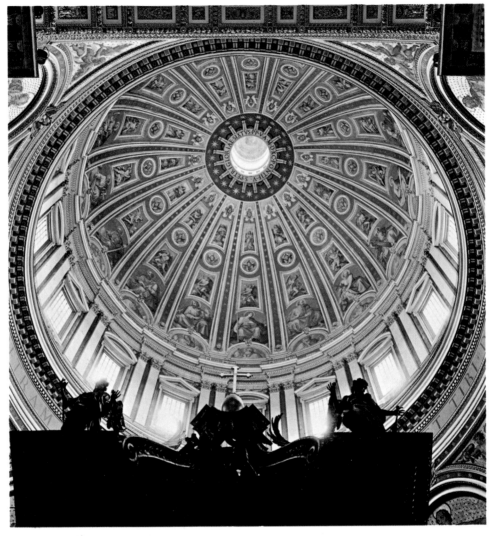

MICHELANGELO AND GIACOMO DELLA PORTA    *Dome of St Peter's*

itself all the ascending lines of the giant pilasters on the walls below. Then came the dome proper, with its sixteen ribs, in which the ascending lines were taken yet higher and converged.

This was crowned by the lantern, which echoed the form of the drum, and like a spire carried the movement up to a final point in the bronze globe surmounted by a cross.

In Michelangelo's design the dome was to consist of two separate shells and was to be hemispherical in shape. His drawings seem to indicate that he rejected the idea of a pointed dome, like Brunelleschi's in Florence, round about 1547. This was justified aesthetically by a more harmonious relationship between drum, dome, and lantern; and symbolically it was also significant, for Michelangelo saw the hemisphere as a metaphor for the vault of heaven. He took up a medieval idea and infused it with his own neo-Platonic interpretation. As Ackerman has observed, the dome would from now on play its part wherever men wanted to express civil or religious ideals. Even in Protestant countries, where it would seem unlikely that anything Roman would be imitated, the highest functions of government were to be exercised under domes that were faithful reproductions of St Peter's.

When Vignola took over from Michelangelo in 1565, he altered the relationship between the various parts of the design, and in particular reduced the height of the lantern. The structural difficulties involved in following Michelangelo's original design must already have been apparent to him. Giacomo della Porta, whose design was approved in 1586, departed from Michelangelo in giving the dome a slightly pointed shape; and while he kept to Michelangelo's general design, he made the dome ribs of equal width, altered the frames of the two upper tiers of windows, and introduced other changes in detail. A wooden model of the dome, begun to Michelangelo's design but incorporating della Porta's modifications, survives in the museum of St Peter's [61].

The resolution of the difficulties involved could have produced a hybrid, compromise design, but in fact della Porta successfully combined practical necessity and aesthetic harmony. In a *tour de*

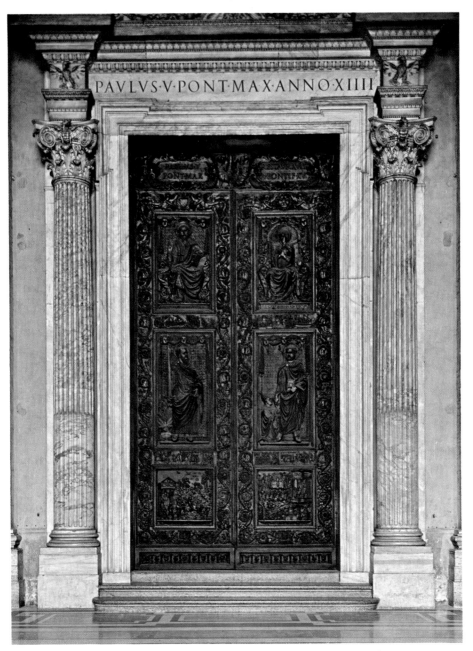

FILARETE    *Bronze doors of St Peter's*

*force* of construction, the dome was built in twenty months, from 1588 to 1590, and the lantern was complete by 1593. Michelangelo's plan lost some of its individual features, but della Porta had retained its sculptural quality and tremendous upward thrust. Above all the dome as built retained the force of Michelangelo's design and was accepted as an ideal form, an *exemplum* for domes of the Baroque and after.

FILARETE   *Bronze doors*

The bronze doors of the central entrance to St Peter's [108] were designed by the Florentine sculptor and architect Antonio Averlino, known as Filarete ('lover of excellence'). They were commissioned by Eugenius IV, and took twelve years to complete, from 1433 to 1445.

If we compare them with the bronze doors of Filarete's contemporary Ghiberti in the baptistery at Florence, especially the famous 'Gates of Paradise' of 1425-52, Filarete's work is not a masterpiece. Here we have none of Ghiberti's ideal beauty, nor his sense of space. Ghiberti belonged to the full flood of the early Renaissance, while Filarete never left behind him the traditional approach of the late medieval goldsmith. All the same, Vasari's judgment that Filarete's style was 'unfortunate' does seem rather hard.

The individual quality of Filarete's work is seen not so much in the conventional figures of the Virgin, the Saviour, St Peter and St Paul, but rather in the smaller scenes depicting events of the pontificate of Eugenius IV. These are done with a charming sense of excitement. We see Sigismund of Luxembourg being crowned emperor, the pope and the emperor riding together, the Emperor of the East arriving at the Council of Ferrara-Florence, and Abbot Andrew of Egypt receiving the declaration of faith.

These contemporary scenes are shown with all the detail of costume and ceremonial that a careful observer would note. Filarete was not insensitive, either, to the humanist culture of his time: in the decorative framework round the panels he introduces mythological subjects, such as the rape of Ganymede and the loves of Jupiter and Leda, half-hidden by rich classical foliage scrolls.

GIANLORENZO BERNINI    *The Scala Regia*

Since the end of the fifteenth century, the only direct access from the Vatican Palace to St Peter's had been by means of a long, dark and dangerous staircase, which ran from the Cappella Paolina past the Sistine Chapel to the atrium. In 1663 the pope entrusted Bernini with the task of transforming this passage, to make it not only more convenient but more imposing.

The problems which confronted Bernini were considerable: the space involved was long and narrow, wider at the bottom than at the top, and on a steep slope. Bernini's solution was brilliant [111]. He divided the slope into two consecutive flights of shallow steps, with a spacious landing between them. Each flight is lined with columns; but whereas the columns of the upper section are placed directly against the wall, those of the lower section stand away from it. All the columns gradually diminish in height as they rise up the stairs. The perspective effect of these 'shrinking' columns and the barrel vault above them creates an illusion of much greater depth than is actually the case.

The design, which derived in part from stage set architecture, is made even more theatrical by a stucco group over the entrance – two figures of Fame, by Ercole Ferrati, holding the papal arms. Two windows to the left of the landing, half way up, allow a dramatic alternation of light and shade on the stairs and columns.

GIANLORENZO BERNINI
*Scala Regia*

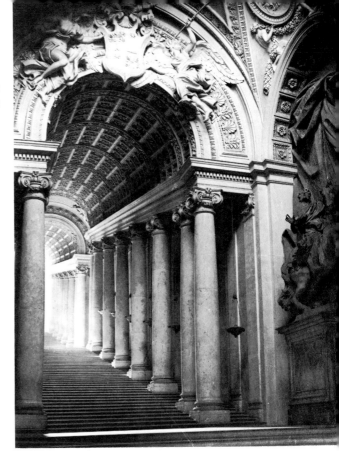

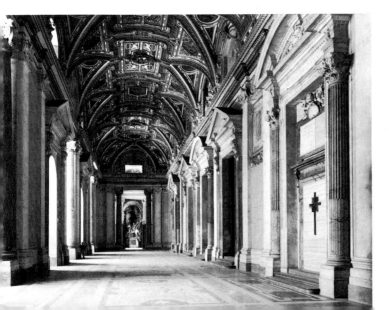

CARLO MADERNO
*Narthex of St Peter's*
Cornacchini's
equestrian statue of
Charlemagne is visible
in the distance

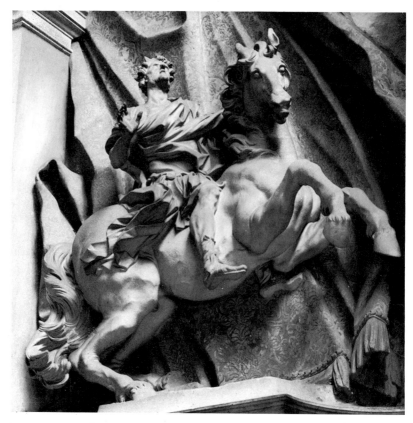

GIANLORENZO BERNINI  *Equestrian statue of Constantine*

On the landing at the point where the Scala Regia meets the
narthex, in a final imaginative flourish, Bernini placed his statue of
the Emperor Constantine [112]. The emperor is shown at the
moment of his vision of the cross (see above, p. 14). The rearing
horse, Constantine's gesture of amazement, and the billowing
curtain of stucco behind the group create an intense feeling of
drama.

The architectural part of the Scala Regia was finished by 1665.
Although the statue of Constantine was planned in 1654, it was

only completed when Bernini returned from his visit to Paris. Louis XIV was so impressed by it that he commissioned from Bernini another equestrian monument, which would stand at the top of the steps that were planned to link the Piazza di Spagna with S. Trinità dei Monti and the Villa Medici, then the French Academy in Rome. But the steps were not built (the famous Spanish Steps date from the eighteenth century), and the statue, completed in 1677, was sent to France in 1684, by which time taste had changed and it was indifferently received. It finished up in the gardens at Versailles, after having been disastrously re-worked by Girardon into a *Marcus Curtius leaping into the Abyss*.

MICHELANGELO  *Pietà*

Michelangelo was barely twenty when he came to Rome on 25 June 1496. At this time he was unknown outside the circle of artists, intellectuals and patrons associated with the Medici in Florence. In Rome he was welcomed by a small group of connoisseurs that included the banker Jacopo Galli, Cardinal Raphael Riario, and Cardinal Jean de Bilhères de Lagraulas, the French ambassador. For Galli he carved a *Bacchus,* now in the Bargello at Florence, and a *Cupid,* now lost. For the French cardinal he produced the Vatican *Pietà* [114]. These are the only works which can be dated to his first five-year stay in Rome, which he devoted mainly to study of the antique.

The *Pietà* was finished in May 1499 and placed in the former chapel of S. Petronilla, by then the church of the French clergy in Rome. Two centuries later it was transferred to its present position in St Peter's.

The group is the only work that Michelangelo signed: on the ribbon across the Virgin's breast appear the words MICHAEL-ANGELUS · BONAROTUS · FLORENTIN · FACIEBAT. It is also unusual in that it is very highly finished. The composition, in which the

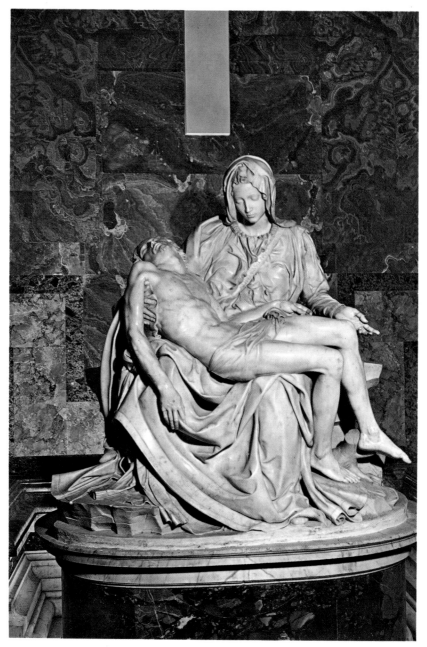

MICHELANGELO  *Pietà*

Virgin holds the dead Christ on her lap, is of a type that originated in northern Europe. Certain details recall earlier artists: the Virgin's ample drapery with deep folds suggests the work of the Sienese Renaissance sculptor Jacopo della Quercia, while the faces are clearly influenced by Leonardo da Vinci.

But despite its debt to other artists, the *Pietà* is already fully characteristic of Michelangelo in the contained strength and monumentality of the composition, and in its power to convey a sense of superhuman sorrow. Michelangelo treated the same subject again later in his life, though with very different compositions. One of these groups is the *Pietà* in Florence Cathedral, of 1553; the other is the Rondanini *Pietà* in the Museo del Castello Sforzesco in Milan of *c.* 1559-60. Both unfinished, they express a more dramatic emotion, indeed a sense of universal tragedy. But already in the Vatican *Pietà,* through a religious theme, Michelangelo expressed his vision of the poignancy of human life.

*Bronze statue of St Peter*

This statue [116, 117] has always been the subject of critical controversy. Some see it as a late Roman work of the fourth century, while others (Wickhoff, followed by A. Venturi, P. Tosca and G. de Francovich) maintain that it dates from the thirteenth century, and was designed either by Arnolfo di Cambio or by someone in his circle.

The second theory seems the more convincing. The statue is clearly based on some antique model, either Roman or Byzantine, and this has led to the suggestion that it might be a re-working of a statue of a philosopher of antiquity. But the vigorous linearity of the drapery and the expressiveness of the face and hands are Gothic qualities. Furthermore, chemical analysis has shown that the bronze is an alloy known to have been in use in the thirteenth century.

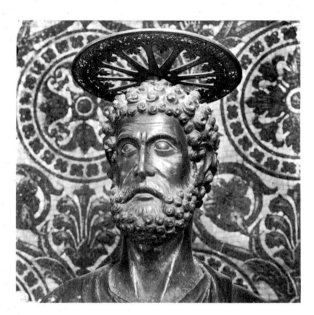

?ARNOLFO DI CAMBIO
*St Peter*
Detail

Although the attribution to Arnolfo di Cambio remains uncertain, there is no record of any other sculptor working in Rome at the time who could have produced a work as fine as this, so forceful and yet so completely in the antique tradition. Full of authority and majesty, lifelike and at the same time symbolic, the figure has been regarded with the greatest veneration since the fifteenth century. Still today, on certain major feast-days of the Church, the figure is robed with liturgical vestments and crowned with the papal tiara.

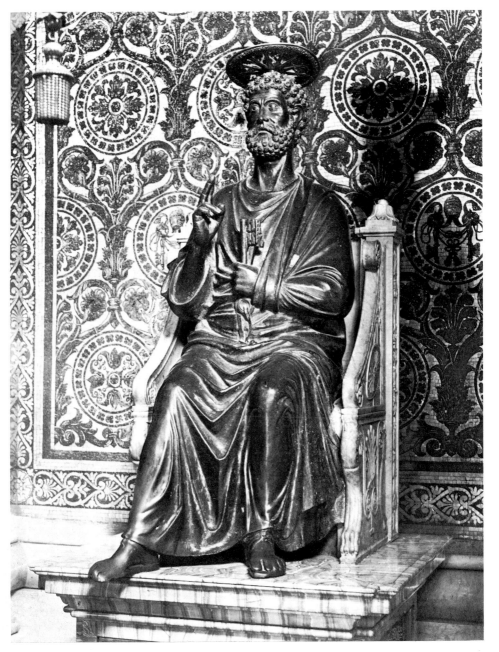

?Arnolfo di Cambio   *St Peter*

DONATELLO   *Tabernacle of the Blessed Sacrament*

This fine tabernacle [119], in which the host is reserved, was originally placed in a chapel in the Vatican Palace built by Bernardo Rossellino and Battista da Padova for Eugenius IV. When the chapel was demolished during the renovations undertaken at the time of Paul III, the tabernacle was transferred to the Cappella dei Beneficiati in St Peter's, where Vasari mentions having seen it.

Donatello worked on the commission during his brief visit to Rome in 1432-3: the bas-relief of the *Entombment* at the top is undoubtedly by him, while the architectural framework and the two groups of three angels at the bottom are attributed to Michelozzo. The whole forms one of the finest examples in Rome of the refined taste of the Florentine Renaissance.

Donatello's extraordinary ability to convey spatial depth in very low relief *(schiacciato)* appears in the *Entombment* panel: by a trick of perspective, the figures are revealed behind a curtain held aside by angels. Here too Donatello's sense of drama is manifest, in the violent gestures and distraught faces of the mourners. This is the passionate side of humanism; it represents a tendency towards intense realism that stands in sharp contrast to the sweet, conventional idealism of so many sculptures of the same moment.

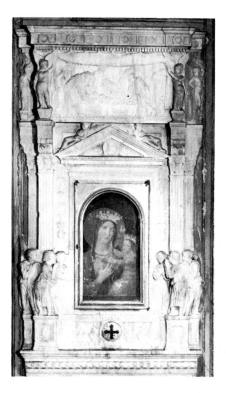

DONATELLO AND MICHELOZZO
*Tabernacle of the Blessed Sacrament*

DONATELLO
*Tabernacle of the Blessed Sacrament*
Detail: the Entombment

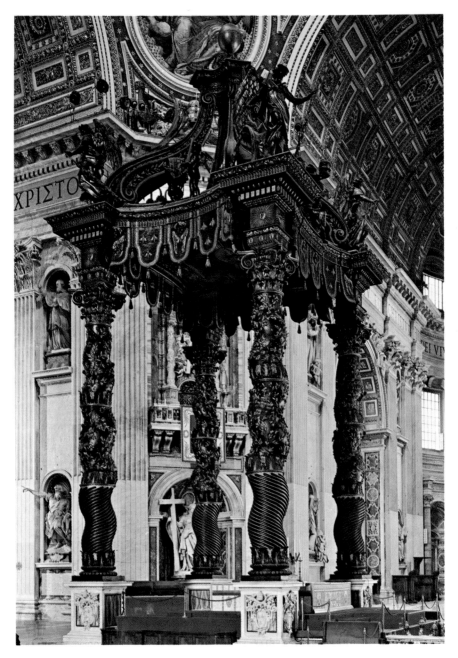

GIANLORENZO BERNINI  *The baldacchino*

GIANLORENZO BERNINI
*The baldacchino, shrines and Cathedra Petri*

When the nave, narthex and façade designed by Maderno were finally complete, the empty shell of the basilica called for some outstanding decorator who would furnish the whole of the interior according to a single plan. Filippo Baldinucci records how Annibale Carracci told his pupils and artist friends, after they had been to visit the new building, that some day a genius would arise who would create two major works of art on a sufficiently grand scale as focal points – one in the crossing, and the other in the apse. Among those present when Carracci said this was Bernini, only a boy at the time, and he is supposed to have expressed the wish that the artist might be himself.

The anecdote may or may not be true, but it is interesting in that it suggests that the artists of Rome at the beginning of the seventeenth century already felt that two major decorative elements were needed in St Peter's. These elements would provide a terminal point for the rhythm of the arcades and pilasters of the nave, and create dramatic perspectives for the entire building.

At the beginning of his pontificate, Urban VIII entrusted the young Bernini with the task of replacing the old canopy over the papal altar. This, it will be remembered, had been carefully protected by Bramante. The new canopy was to be something more in keeping with the monumentality of the new basilica.

Bernini set to work in 1624, and quickly produced a design that was completely original. The idea of a baldacchino goes back to the portable canopy used in the ancient Near East for ceremonial occasions, and as a covering above the royal throne – a tent of rich cloth resting on four or more supports. Bernini's design therefore simulated – in wood, marble and bronze – a large piece of drapery with ornate fringes, billowed out by the wind. The four supporting pillars are modelled on the twisted

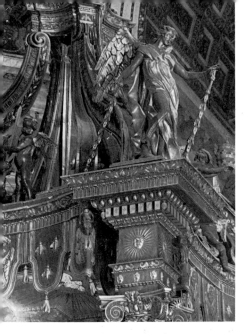

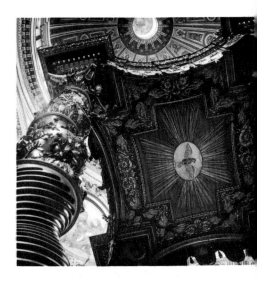

Gianlorenzo Bernini
*The baldacchino*
Details: finial
       tester
       base

columns entwined with vines in relief which, according to tradition, Constantine had brought from the ruins of the Temple of Solomon, and which decorated the altar over St Peter's tomb.

Bernini at one time intended to crown the baldacchino with a platform supporting a statue of Christ the Redeemer with his hand raised in blessing. This was changed to a dome, and eventually that was abandoned in favour of four volutes with large figures of angels [122] and a çentral pinnacle formed of the globe and cross. It was Francesco Borromini who suggested the final plan, which perfectly finishes off the spiral movement of the four columns and creates a dynamic ensemble [120]. Architecture and sculpture work together to create an impression that is almost that of painted illusionism, the colours determined by the materials used and illuminated by the profuse gilding.

The baldacchino is designed to strike the spectator on entering St Peter's with the full force of its Baroque theatricality. Ancient symbols of the faith are combined with emblems of papal splendour [122], and the twisted columns are eternal reminders of the origin of St Peter's in the Constantinian basilica, and of the origins of the Church itself.

It took Bernini and his assistants (who included not only Borromini, but Bolgi, Ferrata, Duquesnoy, Finelli, Cordier and Fancelli) ten years to erect it, so considerable were the problems involved. Not least of these problems was the casting of the four giant columns. It was difficult, in the first place, to find sufficient bronze. The roof of the Pantheon portico was pillaged, and even the covering of the dome of St Peter's. The pope's critics, alluding to Urban VIII's family name, quipped, '*Quod non fecerunt barbari, fecerunt Barberini*' – what the Barbarians had left undone the Barberini did.

While the baldacchino was splendidly proportioned for the position it was to occupy, it now became apparent that its immediate surroundings would have to be modified to suit it. The obvious solution was to create a framework for it by

remodelling the four great piers supporting the dome. Accordingly, Bernini built into each one a large niche with a balcony; by incorporating into these niches pairs of twisted columns from Constantine's basilica, he provided an aesthetic link with the baldacchino [125].

The four niches were designed to enshrine the four most precious relics that belonged to St Peter's – a fragment of the True Cross, the veil of Veronica, the tip of Longinus' lance that pierced the side of Christ, and the cross of St Andrew. Beneath each balcony was placed a statue of the saint connected with the relic it enclosed – St Helen, St Veronica, St Longinus and St Andrew [127].

Bernini carved the statue of Longinus between 1629 and 1638, and he gave some guidance to the sculptors of the other three statues. The *St Veronica* was carved by Francesco Mochi, *St Andrew* by François Duquesnoy, and *St Helen* by Andrea Bolgi. All the statues are three times life size. With their ample gestures and flowing robes, they create yet another element to coordinate the area round the baldacchino. They almost look like actors playing their parts in the drama of Christ's passion as it is re-enacted on the altar before them; and the sense that we are in a theatre, though a theatre of supernatural importance, is increased by the presence of the four balconies in the piers.

Bernini's Cathedra Petri in the apse, executed between 1656 and 1666, is focused on another famous cult object, the chair of St Peter. The bishop's throne *(cathedra)* stood traditionally in the apse, where it can still be seen in many churches in Europe and the Near East. The throne of the bishop of Rome was naturally in the cathedral of Rome, St John Lateran, but this

GIANLORENZO BERNINI  *Loggia of St Longinus* ▷

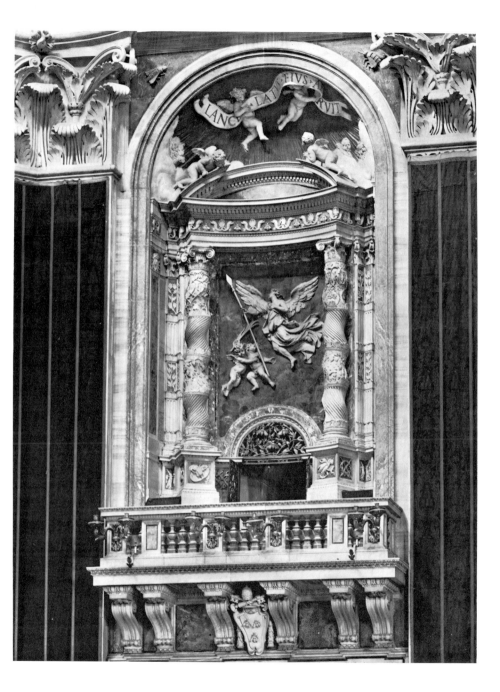

particular throne, made of wood and decorated with ivory panels of the third or fourth century, had been in the Vatican for some time. It was a venerable relic, symbolizing the bishop of Rome's authority not only over the city of Rome but over the whole Christian world.

On 3 March 1656 Alexander VII decreed that the throne should be taken from the Vatican treasury and placed in the apse of the new basilica in a suitable reliquary. Bernini designed the reliquary in the form of a magnificent throne of marble, bronze and gilt stucco, supported by figures of four Fathers of the Church [127]. Above the throne, there was to be an oval window showing the descent of the Holy Spirit in the form of a dove; this would be surrounded by a sunburst with clouds and figures of angels. The effect was to be one of golden light in which the throne appears as in a vision [129].

Thus the baldacchino surrounded by the four shrines, and the throne in a vision of glory, together produce an overwhelming suggestion of adoration and ecstasy. The idea of the Church triumphant is brilliantly conveyed, and Baroque rhetoric reaches the height of its power in art.

To create an approach to the baldacchino, Bernini had already in 1645-8 decorated the piers in the nave with polychrome marble and emblematic reliefs in white marble, with angels in pairs and medallions incorporating busts of the popes. He also designed the marble pavement, which leads the eye towards the apse from a porphyry circle marking the place of the original altar where Charlemagne was crowned Emperor by Leo III on Christmas night, in the year 800.

Other works by Bernini in St Peter's are the tombs of Urban VIII [132], Alexander VII [134], and Matilda of Canossa [128], the latter executed in 1633-7 mainly by his assistants. He also designed the tabernacle in the Chapel of the Blessed Sacrament, but this was carried out entirely by his assistants, as late as 1673-4.

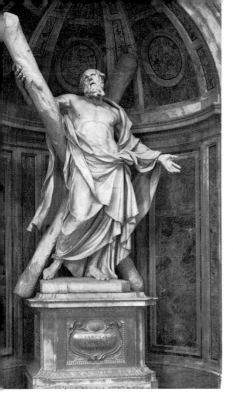

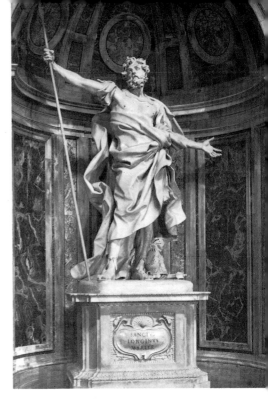

François Duquesnoy  *St Andrew*

Gianlorenzo Bernini  *St Longinus*

Gianlorenzo Bernini
*St Augustine*, on the
Cathedra Petri

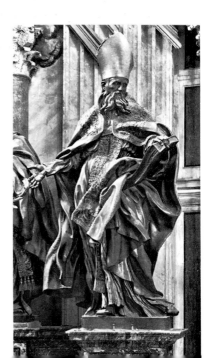

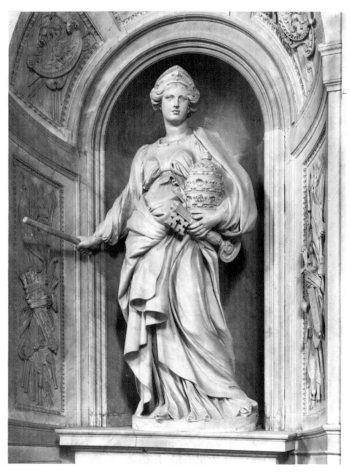

GIANLORENZO BERNINI  *Tomb of Matilda of Canossa*  Detail

GIANLORENZO BERNINI  *Cathedra Petri* ▷

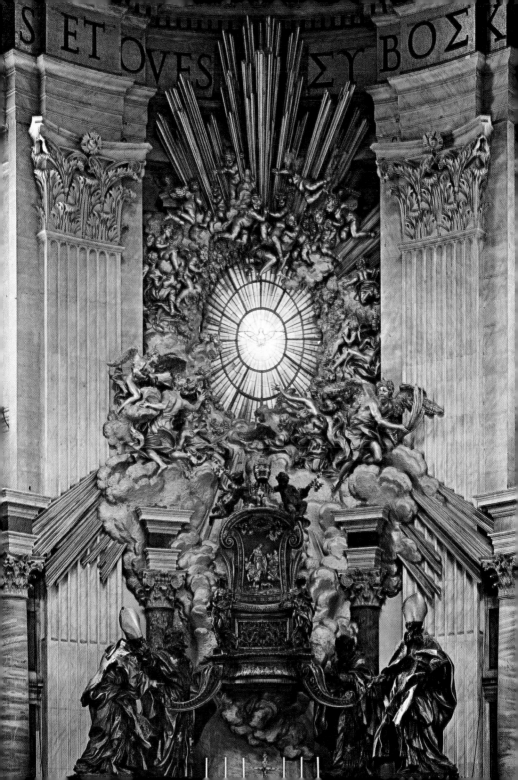

Urban VIII had been pope for only four years when, in 1628, he asked Bernini to design a tomb for him. At the time the papal tombs in St Peter's were being re-arranged, and Urban wanted his own monument to occupy one of the large niches in the apse, balancing that of Paul III (intended to be free-standing).

The tomb of Paul III was designed by Guglielmo della Porta as a free adaptation of Michelangelo's Medici tombs in S. Lorenzo at Florence. The deceased is shown in a seated position [131] above the sarcophagus, on which two allegorical figures lean. Bernini also followed this model, but he translated it into typically Baroque forms, heightening the movement, the colour and the emotional impact.

Bernini began by facing the niche with marble, and modelling the statue that was to be cast in bronze (1628-31). He had already produced several portraits of Urban VIII, successively deepening his appreciation of the pope's human qualities; but here in the tomb he tried to transcend the personality of his subject, bringing out the symbolic dignity of the papacy in the pope's vestments and gesture, and at the same time in his face showing a solemn awareness of approaching death.

After a long interruption, Bernini resumed work on the monument in 1639 and finally finished it in 1647, three years after the pope's death [132]. The group is completed by three allegorical figures – Death, who rises from the sarcophagus to write the pope's name on a tablet in letters of gold, and Charity and Justice, white marble figures standing on either side whose radiant vitality contrasts with Death and the sombre figure of the pope. This contrast lies at the heart of the work's dramatic power; it is intensified by the different colours and textures of the material and by the naturalistic treatment of such symbolic motifs as the heraldic bees of the Barberini family, scattered over the sarcophagus and plinth.

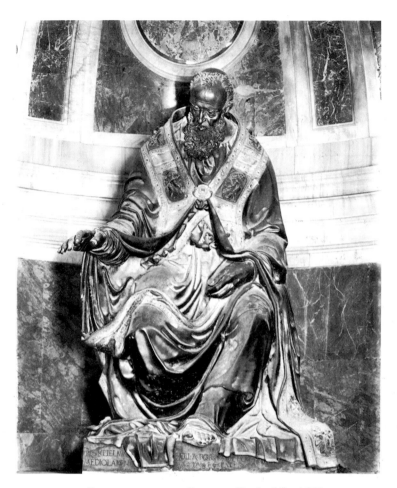

GUGLIELMO DELLA PORTA    *Tomb of Paul III*
Detail: effigy of the pope

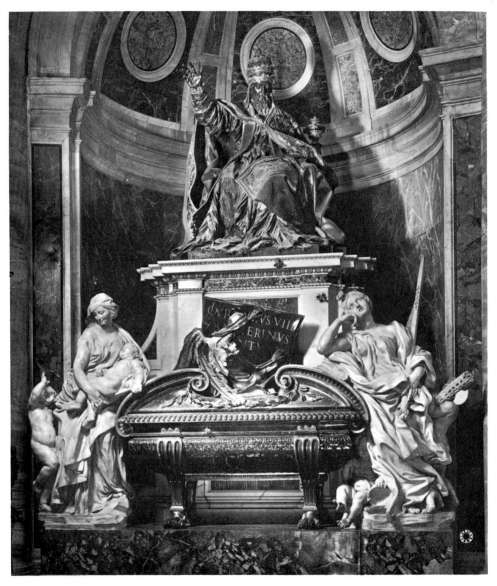

GIANLORENZO BERNINI  *Tomb of Urban VIII*  The bronze effigy of the pope was executed in 1628-31; the rest of the monument followed in 1639-47.

With this tomb, Bernini created a model that was to be imitated by a number of his contemporaries [78, 80, 82] (Algardi repeated it almost at once in his tomb of Leo XI), and to which Bernini himself was to return in later years for the tomb of Alexander VII [134].

In his life of Bernini, Baldinucci goes so far as to say that the tomb of Urban VIII in itself justifies a visit to Rome: this 'great miracle of art' has, he writes, 'qualities so unique that were it only to see it, any man of the world should go to Rome, in the certainty that his time, his money and his labour will have been well spent.' Even Innocent X, who had no great liking for Bernini, had to admit that the artist was 'a great and rare man'.

GIANLORENZO BERNINI   *Tomb of Alexander VII*

Alexander VII commissioned Bernini to design his tomb some time before 1667, but the first sketch for it dates from 1671, followed by a smaller sketch in 1672. The work was carried out entirely by Bernini's assistants: the statue of the pope was carved by Maglia, *Charity* by Mazzuoli, and *Truth* by Morelli, Baratta produced *Prudence* and Cartari *Justice,* while Lucenti cast the skeleton representing Death; various hands were involved in the decoration.

Bernini's assistants completed the work in 1678, and it is remarkable indeed that the result should be so thoroughly recognizable as a work of Bernini [134]. If we compare it with the tomb of Urban VIII [132], we can see a further development in dramatic power, in the figures of the virtues and especially in that of Death, who seems to have burst from the door below and, brandishing his hour-glass, is lifting the marble drapery. The figure of the pope is in marked contrast, kneeling in prayer

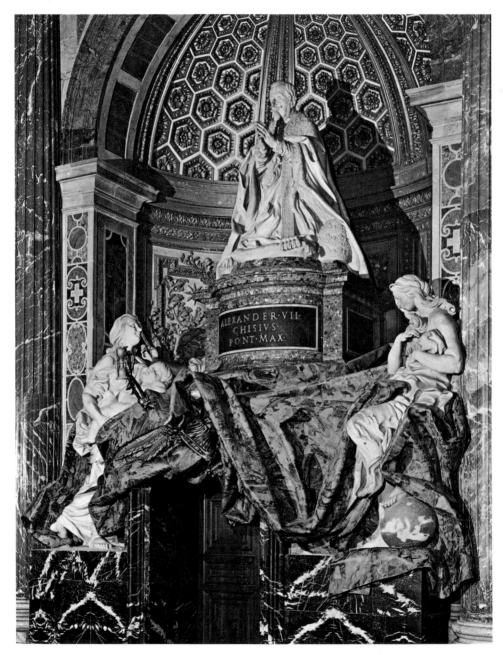

Gɪᴀɴʟᴏʀᴇɴᴢᴏ Bᴇʀɴɪɴɪ (design only)    *Tomb of Alexander VII*

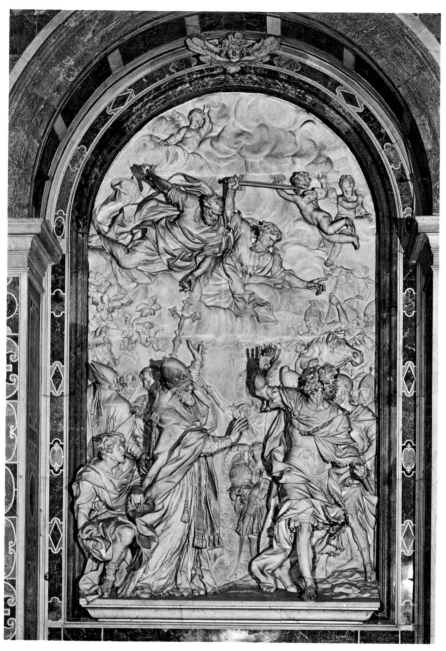

ALESSANDRO ALGARDI  *St Leo the Great confronting Attila*

with the utmost composure. We may feel that Baroque illusionism here verges on the grotesque, and that the figures have all become somewhat too conventional in their attitudes and expressions. But we cannot deny the power of dramatic illusionism in this sumptuous tableau.

ALESSANDRO ALGARDI   *St Leo the Great confronting Attila*

Algardi was the only major Italian sculptor who managed to remain relatively independent of the influence of Bernini. He was a pupil of Ludovico Carracci in his native town of Bologna, which he left for Rome at the invitation of Cardinal Ludovisi. Here, along with the Flemish sculptor François Duquesnoy (a pupil and friend of Poussin), he became an exponent of Classicism, opposed to the spectacular effects of Baroque. The papacy of Innocent X (1644-1654), who disliked Bernini, was a productive time for Algardi: among other works commissioned at this time is the great altar relief of *St Leo and Attila*.

This is one of Algardi's more dramatic works, clearly inspired by Raphael's fresco of the same subject in the Stanza dell'Incendio [212]. He concentrates on the expressions of the persons involved. The background relief is characteristically very shallow, and this gives something of a chiaroscuro effect. Bellori, a great admirer of Algardi, writes of the relief in his *Lives*: 'Great was this sculptor's skill in such a large work, in his study of nudes and drapery, and in his composition which conveys lively and beautiful movement; and equally great the ease of his masterly handling of marble, carving into depths almost forbidden to the chisel.'

The work was begun in 1646 and finished in 1653 with the assistance of Ferrata, Peroni and Guidi.

## Baptistery Chapel

As an example of the architectural decoration of St Peter's we may look at the Baptistery Chapel, the first on the left as we enter the basilica. It was built during the last years of the seventeenth century and the early years of the eighteenth, and it is faced with rich polychrome marble in a way that underlines its structure. Light enters through a small dome and gleams on the marble walls through a sort of golden haze, animating an otherwise sober and unified ensemble. There is a good reproduction in mosaic dating from 1722 of Carlo Maratta's *Baptism of Christ*, which had been painted a few years earlier specifically for this chapel. The baptismal font is a porphyry urn which originally contained the remains of Anicius Sextus Probus, Prefect of the City in the fourth century, and was later re-used for the burial of the Emperor Otto II. After 1612, Carlo Fontana designed the base on which it now stands, and added a bronze covering with the Paschal Lamb which is a typical piece of *'fin de siècle'* Roman Baroque.

## Cross of Justin II

This reliquary containing a fragment of the True Cross is one of the oldest of the treasures of St Peter's. It was presented in 570 by the Byzantine Emperor Justin II and the Empress Sophia; an inscription on it records their names and states that the cross was to be placed on the tomb of St Peter. Since its presentation it has, as if by some miracle, remained in the treasury of St Peter's undisturbed during successive plunderings. The front is decorated with precious and semi-precious stones, while on the back five medallions in repoussé silver-gilt represent God the Father,

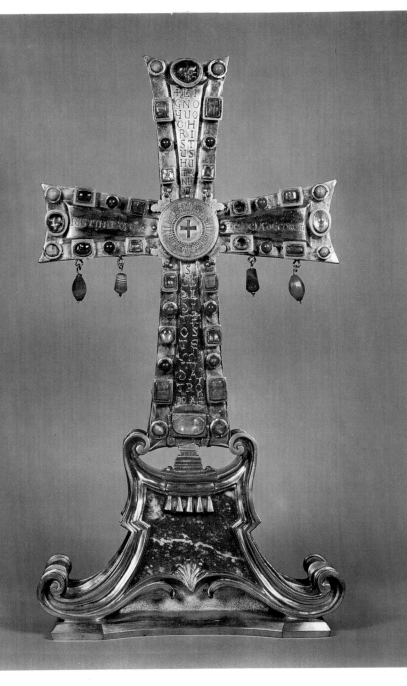

*Cross of Justin II*
Back

Christ, the Lamb of God, and the Emperor and Empress; the top was originally crowned by sixteen large pearls.

The oriental love of linear stylization, precious materials and rich polychromy are all apparent in the reliquary, which was presumably made in Constantinople. It now stands on a later base, and is carried in procession in St Peter's on Good Friday.

◁ *Cross of Justin II*  Front

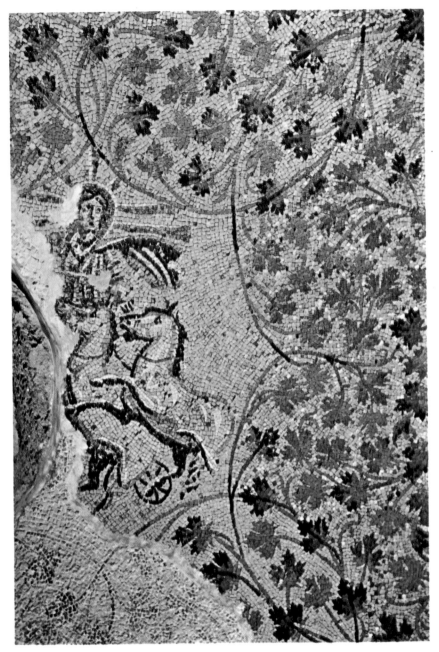

*Christ as Helios*  Detail of mosaic in the tomb of the Julii

# THE VATICAN GROTTOES

*Christ as Helios*

Recent excavations in the Vatican Grottoes, under St Peter's, have uncovered a representation of Christ that is earlier than any previously known: it pre-dates the Edict of Constantine by about a century.

The walls and ceiling of the tomb of the Julii are covered with mosaics which can be dated stylistically to the early third century AD. The scenes include Jonah emerging from the whale's mouth, the Good Shepherd, and on the highest part of the ceiling this figure of Christ ascending in a chariot, surrounded by rays of light [140]. The inspiration here is quite clearly the traditional figure of Apollo or Helios in his sun chariot. The realistic figures and the delicate design of vine scrolls on a gold background come directly from classical Roman art. The early Christians took over certain pagan images, such as that of Apollo-Helios, and applied them to Christ, giving them a new spiritual and symbolic meaning. In the same way, the figure of the Good Shepherd carrying a lamb on his shoulders is derived from Hellenistic representations of Orpheus.

## Sarcophagus of Junius Bassus

This sarcophagus [142], discovered in 1595 during works in the crypt near the Confessio of St Peter, held the remains of Junius Bassus, Prefect of the City of Rome, who died in 359 at the age of 42. The inscription shows him to have been a neophyte, converted to Christianity shortly before his death. The sarcophagus is one of the most important works of Early Christian art in Rome, both for iconographic detail and artistic excellence.

Set in an architectural framework – which includes the motif of the Paschal Lamb above the columns in the lower register – are ten scenes from the Old and New Testaments. In the upper row, from left to right, we recognize the sacrifice of Isaac, the arrest of St Peter, Christ enthroned between St Paul and St Peter, Christ led to judgment, and Pilate washing his hands. Below, we see Job on the dunghill, Adam and Eve after the Fall, Christ's entry into Jerusalem, Daniel in the lions' den, and St Paul taken to his execution.

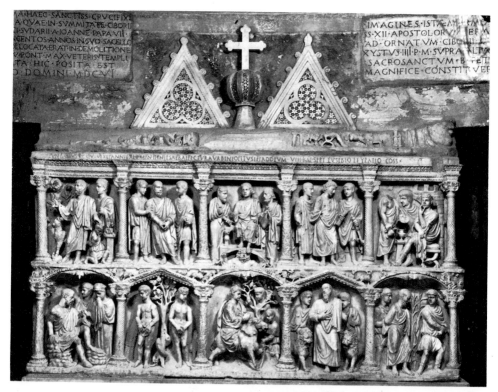

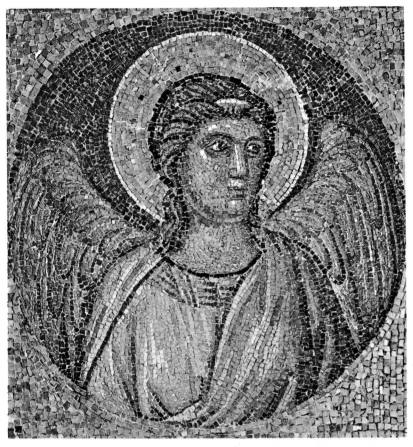

GIOTTO   *Mosaic roundel of an angel*

Artistically, the sarcophagus shows that the Hellenistic tradition was still very much alive in the fourth century AD. The scenes are treated realistically, and the impression of depth is increased by the setting, a sort of two-storeyed portico with rich ornamental detail which creates effects of light and shadow. Classical borrowings are numerous: Daniel and Job are modelled respectively on antique figures of an orator and a philosopher, and Job's wife standing next to him (covering her nose with her

robe against the smell of the dung) is clad in drapery like that of a Greek *kore,* or maiden. Adam and Eve are made to look like pagan gods, and there are Dionysiac motifs on the central colonnettes.

These classical figures are however interpreted according to a new spiritual canon. Jesus is shown beardless, handing the scrolls of divine law to his apostles: he rests his foot on a figure of Jupiter or Coelus, perhaps to signify Christianity's triumph over paganism. The solemn gravity of the biblical patriarchs and early saints, represented at the moment of their trial, already reflects an awareness of the power of divine grace.

The sarcophagus shows how successfully Christianity had been grafted on to the age-old Graeco-Roman culture: looking at it today, we are moved to see the twilight of antiquity merging into the dawn of our own civilization.

GIOTTO   *Mosaic roundel of an angel*

Only two fragments survive from Giotto's original mosaic of the *Navicella* in the atrium of Old St Peter's. This angel [143] is one, and the other is in the church of S. Pietro Ispano at Boville Ernica, near Frosinone. The subject of the *Navicella* is taken from the fourteenth chapter of St Matthew's gospel: Jesus calms the storm on lake Tiberias, saves the apostles from drowning, and calls St Peter to him. The mosaic was executed by Giotto and his pupils about 1310 at the request of Cardinal Stefaneschi; when the atrium was demolished it was taken down, then replaced in 1610 in the new narthex built by Maderno. As we see the whole mosaic today it has been so heavily restored that we can have little idea of its original appearance.

The two surviving fragments – each roundel about 2 feet in diameter – were part of the decorative frieze that framed the entire composition. Giotto's assistants have managed to convey

in mosaic the expressive intensity and monumentality that are characteristic of Giotto at the height of his mature style, after he had done the frescoes in the Scrovegni Chapel at Padua. In its iconography this angel looks back to Byzantine and even to classical models; and yet there are hints in it of an interest in the individual that looks forward to the Renaissance.

ANTONIO POLLAIUOLO    *Tomb of Sixtus IV*

The tomb of this great humanist pope was commissioned by his nephew, Giuliano della Rovere, who later became Pope Julius II and the patron of Bramante, Michelangelo and Raphael. The programme which he dictated to Antonio Pollaiuolo was highly original. Superficially the tomb would seem to conform to a traditional type, with the dead pope lying on a bier decorated with allegorical figures [146]. But the allegories in this case are meant to convey the spirit of Christian humanism. Together with the three theological virtues and the four cardinal virtues, there are the nine Muses and a personification of Perspective, the most basic principle in fifteenth-century aesthetics. This juxtaposition of sacred and secular symbolism is meant as a tribute to Sixtus IV and all that his pontificate meant to the Christian culture of his time.

Pollaiuolo's reliefs have a vibrant energy that reflects his humanist ideals, and even surpasses the antique models that inspired them. The figure of the pope is strikingly realistic, conveying the strength of Sixtus' character and at the same time the pensive quality of one already contemplating eternity. For its technical mastery alone the tomb would be remarkable. Rarely in the sixteenth century do we find bronze reliefs so intricate and yet so flowing. Pollaiuolo's pride in his achievements appears in the inscription with which he signed the work: OPUS · ANTONI · POLAIOLI / FLORENTINI · ARG · AURO · PICT · AERE · CLARI / AN ·

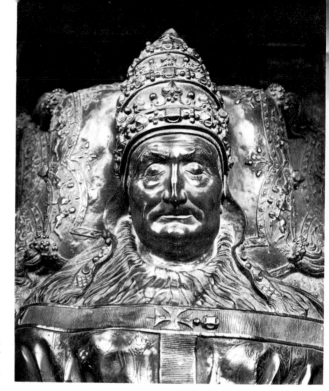

ANTONIO POLLAIUOLO
*Tomb of Sixtus IV*
Detail: the pope

ANTONIO POLLAIUOLO
*Tomb of Sixtus IV*
Detail: allegorical
figure of Philosophy

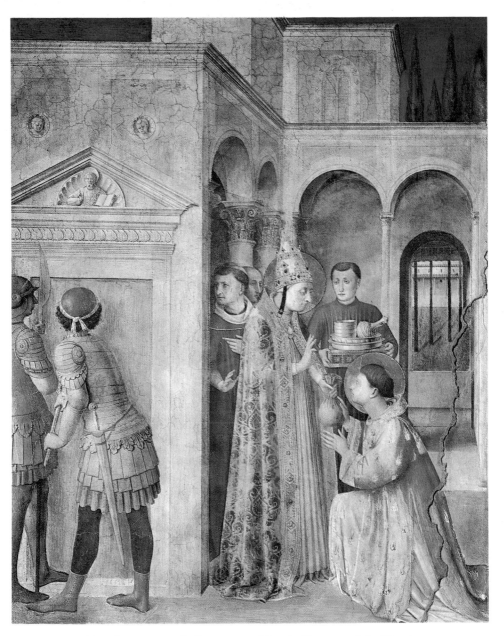

FRA ANGELICO    *St Laurence receiving the Treasures of the Church*

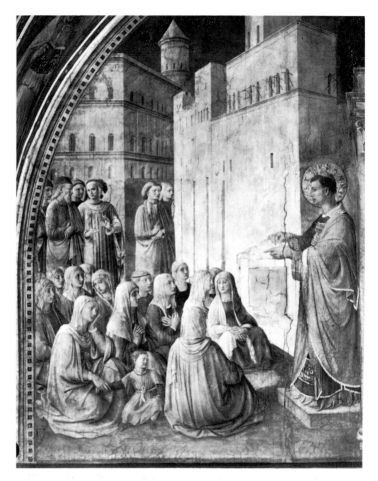

FRA ANGELICO *St Stephen preaching*

DO · MCCCCLXXXXIII – 'the work of Antonio Pollaiuolo of
Florence, famous for works in silver, gold, painting and bronze.
AD 1493'.

After its casting the tomb was placed in the Chapel of
Sixtus IV in St Peter's. It was removed early in the seventeenth
century to the old sacristy, and later to the Chapel of the Blessed
Sacrament. It has only recently been installed in the Grottoes.

# THE CHAPEL OF NICHOLAS V AND
# THE BORGIA APARTMENTS

FRA ANGELICO   *The Chapel of Nicholas V*

The frescoes which Nicholas V commissioned for the chapel of Innocent III's tower in the Vatican Palace are undoubtedly among his greatest artistic legacies. The chapel had become part of the papal residence in 1278, and had already been frescoed once before Fra Angelico came to work here, between 1447 and 1449, with Benozzo Gozzoli among his pupils.

The subjects of Fra Angelico's superb frescoes are drawn from the lives of two famous deacons, St Laurence [147] and St Stephen [149]. Recent cleaning has revealed the original colours, blue, rose, green and white, in all their delicacy. The rich architectural settings with their classical details, and the vivid and naturalistic narrative, yet retain something of the idealized character of Angelico's earlier altarpieces and frescoes in S. Marco at Florence. But their innovating tendencies and greater weight suggest that Angelico was responding to the double challenge of the setting and the patron – the Vatican, and the first pope fully committed to the Renaissance style.

The Borgia pope, Alexander VI, was notorious as a man of dissolute and cruel disposition. Although he was a lover of art, his taste tended towards the luxurious, rather than towards the formal clarity of the early Renaissance. His choice of Bernardino di Betto, known as Pinturicchio, to decorate his new apartments in the Vatican is significant. Pinturicchio came from Umbria, and had assisted Perugino on the frescoes in the Sistine Chapel, producing work that was elaborately ornamented, full of

Pinturicchio  *St Catherine of Alexandria disputing with the Philosophers*

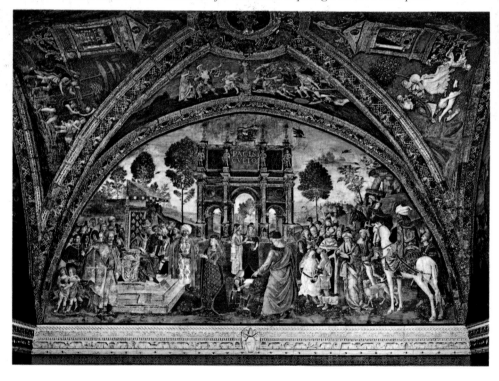

PINTURICCHIO *Sala dei Santi in the Borgia Apartments*

life and colour and minute detail. Superficially influenced by the Renaissance, his style has much more in common with the courtly art of the late Gothic period. It was precisely this kind of painting that appealed to the Spanish pope and his sinister entourage.

Pinturicchio was working in Orvieto when he was called to Rome by Alexander VI in 1494. In less than two years, with the help of a few assistants, he had painted all the rooms in the Borgia Apartments.

In the Sala dei Misteri he painted episodes from the New Testament. In the Sala dei Santi [151] he took his subjects from the lives of St Catherine of Alexandria, St Anthony, St Paul the Hermit, St Barbara, St Anne, St Sebastian, and the chaste Susanna in the Book of Daniel. In the Sala delle Arti he painted allegorical figures of Rhetoric, Geometry, Arithmetic, Music, Astronomy, Grammar and Dialectic. In the last room, the Sala delle Sibille, there are lunettes painted with pairs of those prophets and sibyls who foretold the coming of Christ – a theme which Michelangelo was later to take up in his frescoes on the Sistine Chapel ceiling.

The fresco reproduced here, in the Sala dei Santi, shows St Catherine of Alexandria disputing with the philosophers [150]. Its lively colour and narrative detail are reminiscent of a Gothic minature. Among the figures Pinturicchio has introduced actual portraits: the enthroned emperor and St Catherine are Alexander VII's children, Cesare and Lucrezia Borgia; the standing figure in pink in the left foreground, facing the spectator, is Andreas Paleologus; Antonio da Sangallo the architect is shown at the far left, wearing red and holding a set-square; and next to him Pinturicchio has represented himself. The man in the white turban standing near the throne is Prince Djem, the papal hostage, brother of the Turkish Sultan Bayezid II. The background is filled with the Arch of Constantine, a quotation from Botticelli's earlier fresco in the Sistine Chapel [161].

The ceiling of the Sala dei Santi bears the Borgia arms and complicated knot designs and also, most curiously, scenes illustrating the Egyptian myths of Isis, Osiris and the bull Apis.

# THE SISTINE CHAPEL

The Sistine Chapel was built about 1475 on the order of Sixtus IV, by whom it was dedicated to Our Lady of the Assumption (see above, pp. 32-3). The architect was in all probability Baccio Pontelli, working under the direction of the *commissario* Giovannino de' Dolci, who was in charge of all the Vatican building at the time.

The chapel was quickly decorated with frescoes [48, 154]. In 1481 four famous painters were invited to Rome from Florence – Cosimo Rosselli, Sandro Botticelli, Domenico Ghirlandaio and Pietro Perugino. On 27 October 1481 they contracted with de' Dolci to have the work finished by 15 March 1482. Their salary was to be fixed according to the merits of a fresco which each of them was to provide as a proof of his ability. The assistants they chose were Luca Signorelli, Bartolomeo della Gatta, Benedetto Ghirlandaio, Piero di Cosimo, Pinturicchio, and Fra Diamante (who contributed only a few of the papal portraits in the upper section of the design).

The subject matter chosen consisted of eight episodes from the life of Moses on one side, and eight from the life of Christ on the other, so as to create a parallel between the Old and New Testaments. The theme that the two series have in common is pastoral authority, and by referring also to the events of Sixtus'

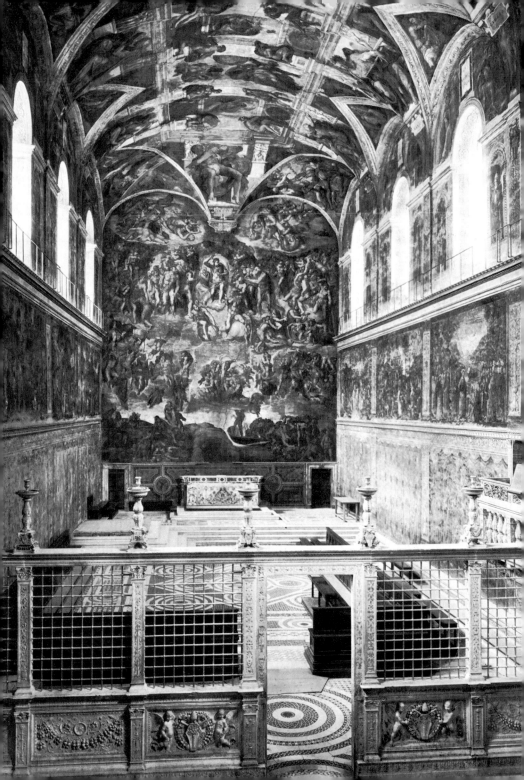

own reign, it was to be demonstrated that the Catholic Church now enjoyed the sole legitimate exercise of that authority. The message is made all the clearer by Latin inscriptions under each of the paintings.

The double cycle of frescoes originally began on the wall now occupied by Michelangelo's *Last Judgment*. There was a painting of the *Assumption* in the centre, and flanking it the *Nativity* on one side, and the *Finding of Moses* on the other. All three were the work of Perugino. All were eventually destroyed to make room for the *Last Judgment* (see below, p. 177).

The story of Moses continues with *Moses and his wife Sephora in Egypt and the Circumcision of their Sons* (by Pinturicchio and assistants), then the *Trials of Moses* (Botticelli) [158, 159], the *Crossing of the Red Sea* (Rosselli), *Moses on Mount Sinai and the Worship of the Golden Calf* (Rosselli), the *Punishment of Korah, Dathan and Abiron* (Botticelli) [161], and *Moses giving the Law, and the Death of Moses* (Signorelli and Bartolomeo della Gatta) [156]. On the entrance wall is *St Michael saving the body of Moses from the Devils*. This was painted by Signorelli, retouched by Francesco Salviati, and completely re-painted by Hendrick van der Broeck (Arrigo Fiammingo) and Matteo da Lecce during the second half of the sixteenth century, when the architrave of the entrance door collapsed and the wall was damaged.

The episodes from the life of Christ, again beginning at the altar end, are the following: the *Baptism* (Perugino and Pinturicchio), the *Cleansing of the Leper and the Temptation* (Botticelli) [160], the *Calling of SS. Peter and Andrew* (Ghirlandaio) [157], the *Sermon on the Mount* (Rosselli and Piero di Cosimo), *Christ giving the Keys to Peter* (Perugino) [163], and the *Last Supper* (Rosselli). This series finishes with a *Resurrection* by Ghirlandaio on the entrance wall, also repainted by Arrigo Fiammingo and Matteo da Lecce.

Beneath these frescoed scenes is painted a rich brocade hanging decorated with the name and the arms of Sixtus IV; it

◁ *Interior of the Sistine Chapel* (compare p. 48)

LUCA SIGNORELLI  *Moses giving the Law to the Israelites*  Detail

DOMENICO GHIRLANDAIO    *The Calling of SS. Peter and Andrew*

has been restored, but the original design has not been changed. It was for this part of the wall that Raphael's famous tapestries were woven, to be displayed on special occasions. (The tapestries are today in the Vatican [219], while Raphael's original cartoons can be seen in the Victoria and Albert Museum, London.)

The wall above the frescoes is painted with figures of the early, canonized popes (some of them, of course, were on the altar wall and disappeared when the *Last Judgment* was painted). Each of these figures, dressed in priestly vestments and wearing the papal tiara, stands in a painted niche. Various artists besides Fra Diamante were involved in painting this upper register, and although the frescoes are in rather poor condition it is possible to recognize the hand of Botticelli in the portraits of SS. Stephen I, Sixtus II and Evaristus.

157

In its original state [48], the ceiling of the chapel was decorated with a simple design of stars, the work of Pier Matteo d'Amelia. The finishing touch was provided by Mino da Fiesole's exquisite marble screen topped with candelabra [154]. Mino also designed the *cantoria,* or singing-gallery. The floor is paved with a traditional Roman design of geometrical patterns in coloured marble.

If we make the effort to visualize the chapel as it was before the advent of Michelangelo, we can appreciate it as a prefect example of fifteenth-century Tuscan art. From the very beginning it was considered to be outstanding among all the buildings in the Vatican, and thus it came to be used for the most solemn religious functions, including the conclave during which a new pope is elected.

BOTTICELLI   *The Trials of Moses*   Detail

BOTTICELLI *The Trials of Moses* Moses and the daughters of Jethro

BOTTICELLI *The Trials of Moses* and *The Punishment of Korah, Dathan and Abiron*

Botticelli was already at the height of his powers when he came to Rome to work in the Sistine Chapel. Besides a number of small portraits and paintings of saints, he had produced such complex works as the two versions of the *Adoration of the Magi* in the National Gallery, London, and the *Birth of Venus* and *Primavera* in the Uffizi, where he had used the poetry of Politian and the ideas of Marsilio Ficino to celebrate the rebirth of *Humanitas*.

He had so far painted only for a restricted circle of humanists and had had no opportunity to show what he could do in fresco on a grand scale. But now in the Sistine Chapel he saw his chance to give expression more fully to those qualities of animation, life and movement that characterize the *Primavera*. The *Trials of Moses* [158, 159] is very close in feeling to the *Primavera,* with its taut rhythms, and its elegant, sinuous lines moving through gestures and draperies to link each figure with its neighbour, and create a unity among all these rich and lively colours in an early morning landscape.

In the Sistine Chapel frescoes, Botticelli retained the medieval convention of combining a number of separate episodes in one picture. In one fresco, for instance, Moses is shown killing the Egyptian who had ill-treated an Israelite, then taking refuge in the land of Midian and coming to the assistance of Jethro's

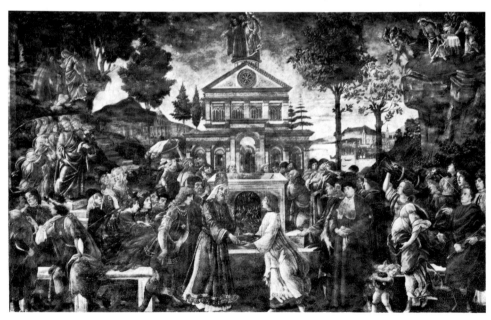

BOTTICELLI    *The Cleansing of the Leper and the Temptation of Christ*

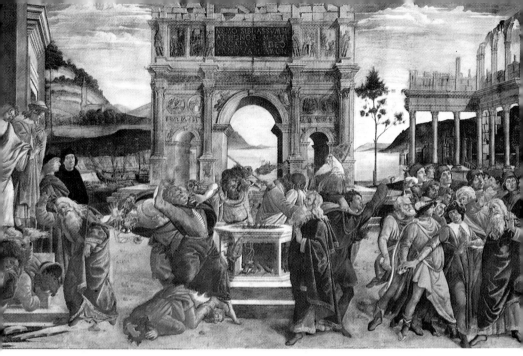

BOTTICELLI    *The Punishment of Korah, Dathan and Abiron*

daughters [158, 159]; after this he is seen speaking with God in the burning bush, and finally returning to Egypt with his family. With so many episodes in it, the scene could have been one of total confusion, but Botticelli is able to make it all perfectly clear simply through the rhythm of his composition.

The *Punishment of Korah, Dathan and Abiron* [161] has a more dramatic subject, and is neatly divided into three distinct parts. First we have the rebellion, then the sacrifice that proves God's favour towards Moses and Aaron, and finally Moses inflicting punishment. Here the linking of the three parts is done mainly by gestures, and unity is created by the landscape with the Arch of Constantine in its centre. To borrow the criteria of classical drama, Botticelli here achieves the unities of place, time and action, by compressing the biblical narrative in a wholly convincing way.

PERUGINO  *Christ giving the Keys to Peter*

For Perugino also, the Sistine Chapel was the first chance to undertake a really large work. The challenge stimulated him to develop his style to its fullest capacity, and it is indeed unfortunate that his *Assumption* and the two other frescoes on the altar wall were destroyed; particularly since the two frescoes on the side walls commissioned from him – the *Baptism* [162] and *Moses in Egypt* – were largely executed by Pinturicchio.

*Christ Giving the Keys to Peter* is one of the great masterpieces of Italian painting [163]. Its composition is quite exceptional, being set out in three parallel planes. In the foreground Peter kneels before Christ to receive the symbolic keys of the Kingdom of Heaven. They are surrounded by the apostles and a number of other characters in whom many of the artist's contemporaries may be recognized. In the middle ground are two scenes full of movement, the figures of which are reduced to small silhouettes: on the left is the story of the tribute money, and on the right the stoning of Jesus. Beyond these again, in the background, two Roman triumphal arches flank the Temple of Solomon, represented as an octagonal building with a dome and porticoes – a perfect model of Renaissance architecture.

PERUGINO AND PINTURICCHIO  *The Baptism of Christ*

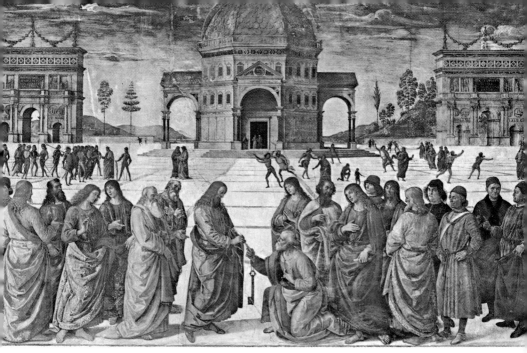

PERUGINO    *Christ giving the Keys to Peter*

Crossing these parallel planes and linking them are the lines of perspective, made visible in the patterns of the pavement and in the position and gestures of the figures. The central axis of the composition passes through the hanging key, the empty area in the middle distance, and the central portico of the Temple. Yet there is nothing rigid or artificial; everything seems to happen in the most natural way, and there is a wonderful clarity in Perugino's light that enhances the colours in the draperies and buildings. His composition shows how completely he had learned Piero della Francesca's great lesson in perspective: it is brilliantly applied here, with a poeticism that may perhaps make it more accessible than the uncompromising intellectualism of Piero.

Perugino was to attain this level of expressiveness a few times again in his long career – in the famous *Crucifixion* in the chapter-house of S. Maria Maddalena de' Pazzi in Florence, the *St Sebastian* in the Louvre, and the *Sposalizio* at Caen which inspired Raphael.

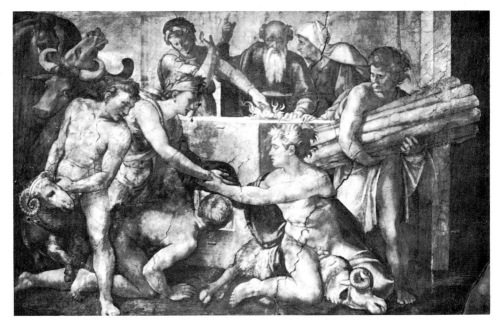

MICHELANGELO    *The Sacrifice of Noah*

## MICHELANGELO    *Ceiling of the Sistine Chapel*

We have already seen (pp. 45-7) the circumstances in which, in
1508, Michelangelo was commissioned by Julius II to paint the
Sistine ceiling. The original suggestion for twelve apostles in
*trompe l'œil* niches did not appeal to him. He called it 'a poor
thing', and quickly abandoned it for a far more ambitious
design, using episodes from Genesis, from the Creation to the
Flood. The subject was to be humanity *ante legem,* that is before
the handing down of the divine law on Mount Sinai. Thus the
ceiling would complement the wall frescoes, which dealt with
the story of Moses (humanity *sub lege*), and the life of Christ
(humanity *sub gratia*).

One should study each of the episodes of the ceiling in some
detail, so as to grasp the development of the theme. It is in any

case impossible to take in the whole cycle at a glance. The ceiling seemed to offer itself to Michelangelo as one long page, ideally designed for a narrative sequence, and he divided it lengthwise into three parallel sections [166]. The three sections are divided by *trompe l'œil* cornices which fit into the actual architecture of the spandrels and lunettes. The central section is made up of nine separate scenes whose subjects are as follows: *God separating Light from Darkness,* the *Creation of the Stars* [167], the *Separation of Earth and Water,* the *Creation of Adam* [167], the *Creation of Eve* [171], the *Fall and Expulsion from Paradise* [170], the *Sacrifice of Noah* [164], the *Flood* [174], and the *Drunkenness of Noah* [165].

There are four large scenes, alternating with five smaller ones, and each of the latter is placed in a framework incorporating

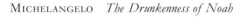

MICHELANGELO    *The Drunkenness of Noah*

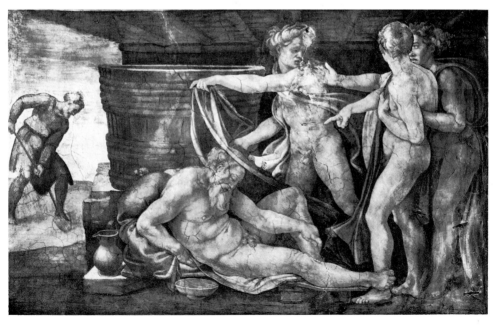

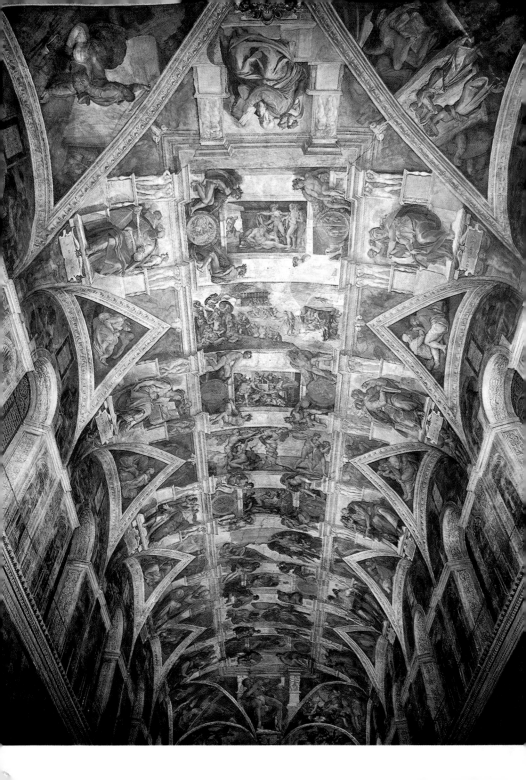

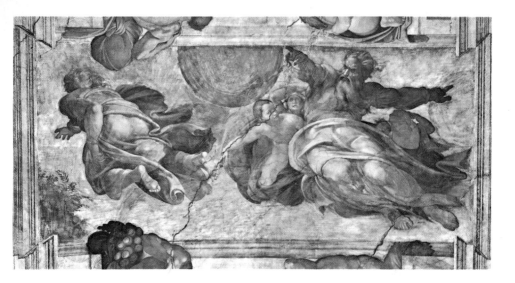

MICHELANGELO   *The Creation of the Stars*

MICHELANGELO   *The Creation of Adam*

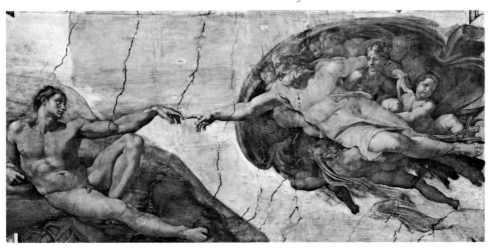

◁ MICHELANGELO   *The Sistine ceiling*

four powerfully built *ignudi,* or naked youths. These are seated on plinths, and hold a garland of oak leaves entwined round a series of bronze coloured medallions containing biblical scenes in simulated relief. Beneath each pair of *ignudi* is a throne decorated with cariatid putti: these thrones are occupied by the prophets and sybils who foretold the coming of Christ. The prophet in the central position over the entrance is Zachariah, the one above the altar is Jonah. As we stand facing the altar, the order of prophets and sibyls is as follows, beginning at the left hand side nearest the entrance: *Joel,* the *Erythrean Sibyl, Ezekiel,*

MICHELANGELO   *David and Goliath*

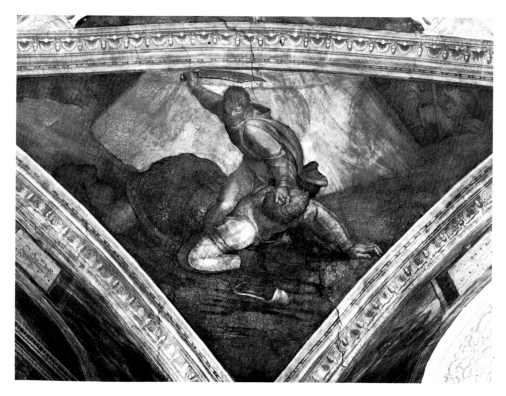

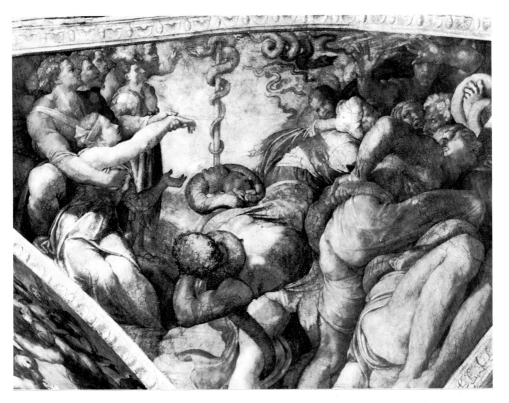

MICHELANGELO    *The Brazen Serpent*

the *Persian Sibyl,* and *Jeremiah.* On the right hand side, following the same order, we have the *Delphic Sibyl* [172], *Isaiah* [176], the *Cumaean Sibyl, Daniel,* and the *Libyan Sibyl* [173]. The triangular areas over the windows and the lunettes that surround them contain groups of the biblical ancestors of Christ. At the four corners of the ceiling are scenes that have a special reference to the deliverance of Israel: *Judith and Holofernes, David and Goliath* [168], the *Brazen Serpent* [169], and the *Punishment of Haman.*

This vast and complex narrative scheme is held together by the general composition of the ceiling, where a flowing rhythm of gestures and volumes is articulated by the shape of the vault

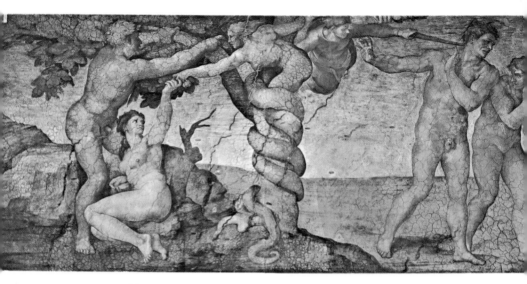

MICHELANGELO *The Fall and the Expulsion from Paradise*

itself. The biblical programme was no doubt worked out with the help of theologians in the Curia; but Michelangelo has gone beyond mere illustration, to create an epic of humanity in its progressive realization of the divine law. He introduces the *ignudi,* who seem to symbolize the endless resurgence of youth and vigour in the human race. His prophets and sibyls likewise go beyond mere representation, to become monumental figures absorbed in study or meditation, each one an embodiment of ageless wisdom. In contrast to their enlightened confidence, the ancestors of Christ below them are awed figures, enclosed in gloom and almost ghostly, whose isolation suggests the darkness of ignorance in which men lived before the revelation of the divine Word [175].

Another contrast, this time to the contemplative nature of the prophets and sibyls, is offered by the scenes in the four corner pendentives of the vault, where the value of active life is stressed in the deeds of the Israelites.

170

Michelangelo's intention to celebrate the human spirit as well as the mystery of religion seems to have grown during the four years that he worked on the ceiling, in response to the ideas of Renaissance neo-Platonism. The early scenes from Genesis – the *Drunkenness of Noah* and the *Sacrifice of Noah* – are crowded, descriptive and discursive in their treatment. But in the scenes that follow everything has been reduced to the essential [175]. Only the principal figures are shown, and these tend to become more and more monumental in scale and more interesting in their modelling, while the story line is expounded with increasing directness. Michelangelo here synthesizes all his artistic know-

MICHELANGELO    *The Creation of Eve*

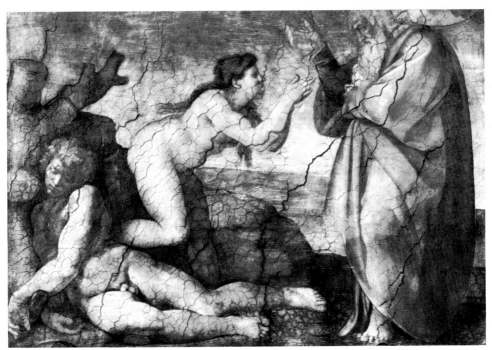

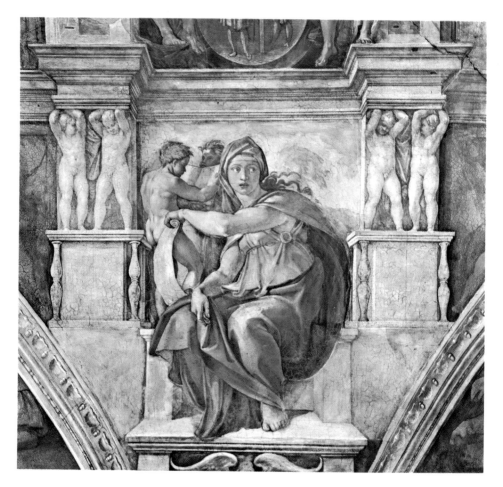

MICHELANGELO  *The Delphic Sibyl*

ledge and his previous experience as a sculptor. He was still a young man when he completed the ceiling: it marks the end of one phase of his art, and already hints at his later development.

Even when he uses classical or early Renaissance models for his figures on the ceiling, Michelangelo transforms them and gives them new meaning. In this one can already see that critical

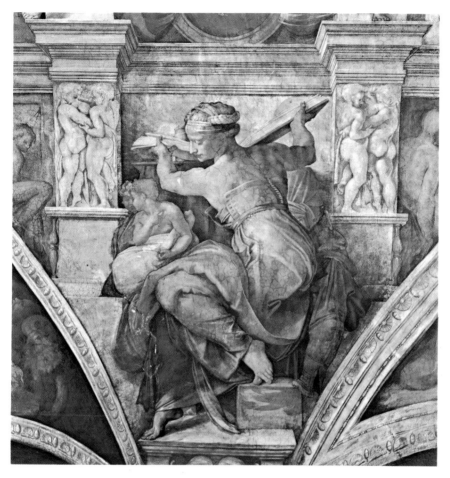

MICHELANGELO   *The Libyan Sibyl*

attitude towards his artistic inheritance that was to become yet
more marked in his later years, when he took the classical orders
of architecture and made such a personal use of them that they
issued from his hand as something new and original.

When the Sistine ceiling was revealed to the public for the
first time, its effect was shattering, and it has never ceased to

amaze succeeding generations of spectators. Among the first to praise it was Raphael, who almost at once painted a similar prophet in S. Agostino and later painted sibyls in S. Maria della Pace; and every artist of the time felt its fascination and knew that it was something they could not ignore. For Vasari, Michelangelo's work was the *nec plus ultra*: it could not be equalled, let alone surpassed. 'No painter', he wrote, 'need concern himself with new attitudes, new methods with drapery, new ways of expressing the wonderful and the terrible in art.

MICHELANGELO *The Flood*

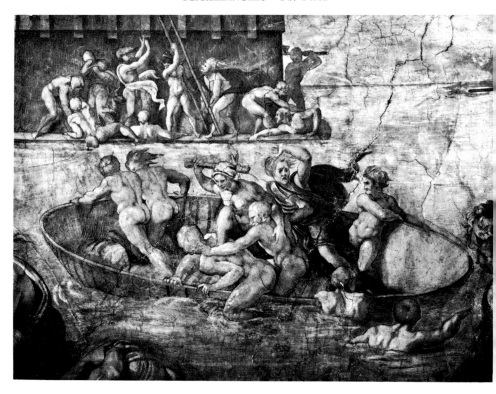

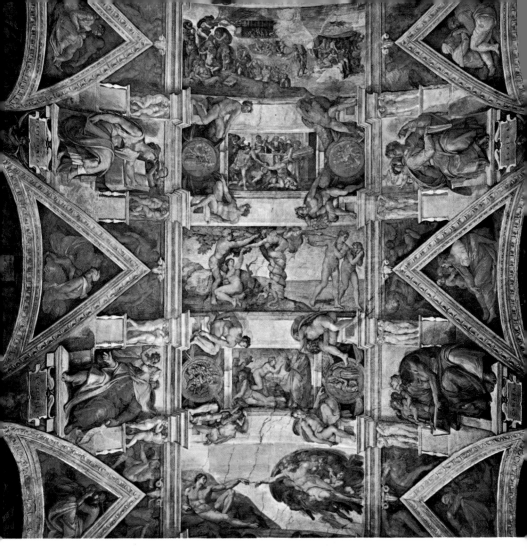

MICHELANGELO *Detail of the Sistine ceiling*   In the triangular penetrations between prophets and sibyls, left and right, are the ancestors of Christ.

You have only to look at a face painted by Michelangelo to see every conceivable perfection.' The Sistine ceiling has never ceased to inspire artists and men of culture. For the Romantics it

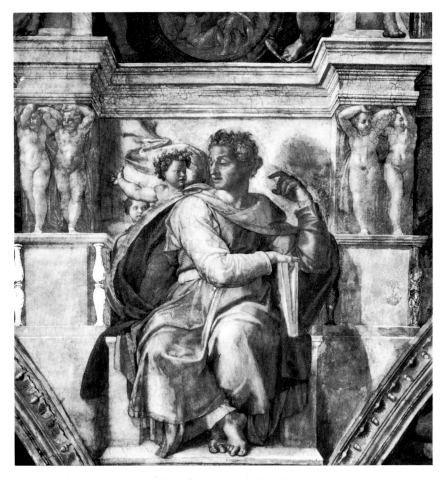

MICHELANGELO  *Isaiah*

became the textbook of the sublime, and the writer Alphonse de Lamartine, in his monumental *Cours familier de littérature,* speaks for all who have seen it: '*On commence par être troublé, on passe ensuite à l'enthousiasme, on finit par être anéanti. Michel-Ange exalte au-delà de l'Homme.*'

When the ceiling was finished, the decoration of the whole chapel might have been regarded as finished. On the end wall, as we have seen, there were already frescoes by Perugino, painted about 1481.

But Clement VII, a few months before his death, decided to alter the scheme. With his mind still preoccupied by the recent troubles of the Church, he decreed that the cycle needed for its completion a *Last Judgment* and a scene showing the punishment of the rebel angels. After the Sack of Rome in 1527, this was to provide a solemn warning to those who presumed to attack the Church. Iconographically, the Last Judgment was also the logical climax to the history of mankind represented on the side walls and on the ceiling, from the Creation to the Resurrection.

Clement's first choice of an artist fell on Sebastiano del Piombo, who proposed to paint in oils since he was unfamiliar with the technique of fresco, but the pope then changed his mind and appointed Michelangelo. The commission was confirmed by Clement's successor, Paul III, who decided to limit the subject to the Last Judgment. The scaffolding for the new fresco was put up in April 1535, and the work was finished in October 1541.

It was twenty years since Michelangelo had painted in the Sistine Chapel, and he returned to it much richer in both artistic and spiritual experience. This was the period in which he began to frequent the neo-Platonic circle of Vittoria Colonna, which had a profound effect on his mind and thought. Here the conversations turned not so much on the niceties of religious dogma as on general questions concerning man's spiritual nature and the purpose of human existence. Now he had the opportunity to sum up all that he had been trying to express in his earlier works – the *David,* the tombs for Julius II and the Medici, and the frescoes on the ceiling of the Sistine Chapel itself. Moreover, his own feelings faithfully reflected those of his age.

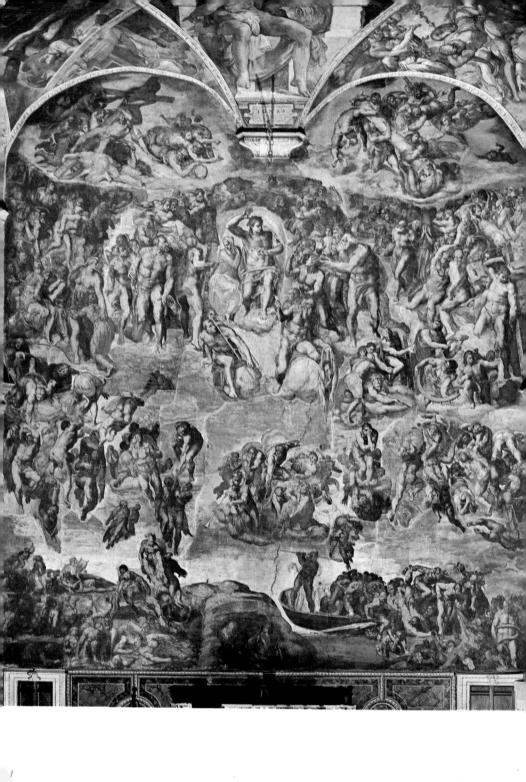

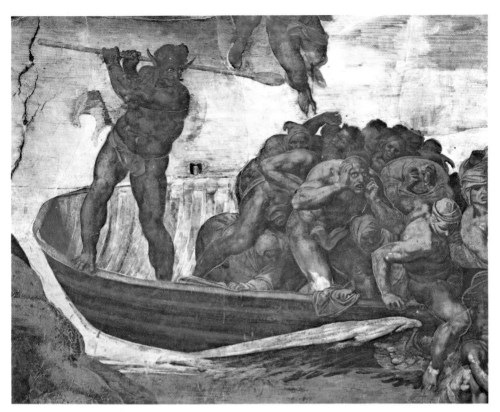

MICHELANGELO  *Charon ferrying the Damned*

With total clarity and without the least hint of pride, he could see that he was being called upon to interpret the times in which he lived.

It is certain that for the iconography of the *Last Judgment* Michelangelo studied such medieval treatments of the Apocalypse as those in the baptistery at Florence and the cathedral at Torcello, and it seems that he re-read Dante's *Divine Comedy*. But his treatment of the subject is far from medieval, and it even marks a considerable advance on his previous frescoes. We have only to compare it with these to see that his attitude to life and to

◁ MICHELANGELO  *The Last Judgment*

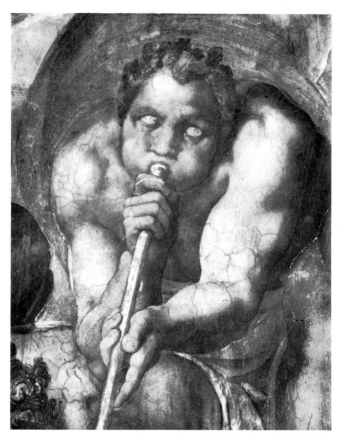

MICHELANGELO  *Trumpeting angel of the Apocalypse*

history has undergone a dramatic change. On the ceiling each character appears as a heroic figure; in the *Last Judgment* all the figures – four hundred of them – merge together in a gigantic whirlwind that swirls round the awesome figure of Christ the Judge [178]. The Virgin seated meekly beside him seems almost to have lost hope of interceding with his wrath [182].

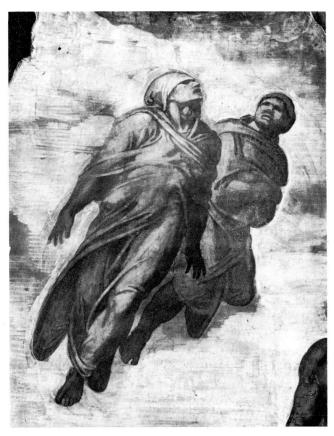

MICHELANGELO   *The Dead rising to Judgment*

Everything in this new style sets the dramatic tone: the
colours are dense and dull (admittedly more so now than
originally); the forms, although still monumental, are less mate-
rial, more evanescent; and the expressions have a *terribilità* that
is taken to its limits in the grotesque faces of the devils and the
damned [179].

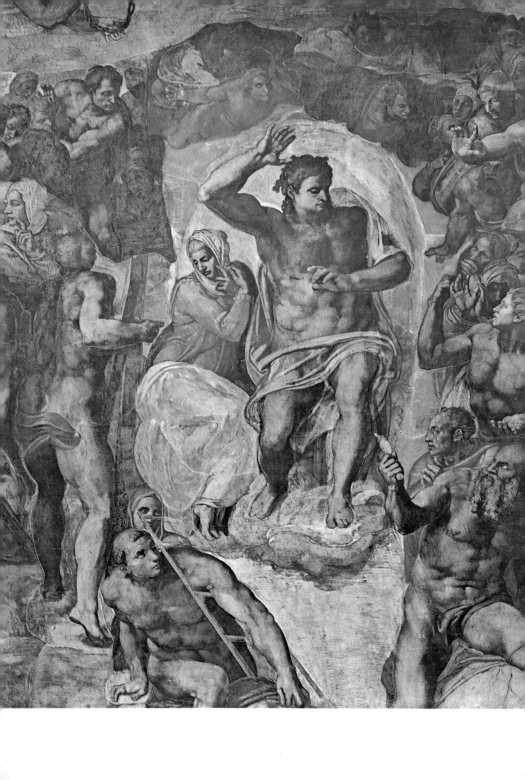

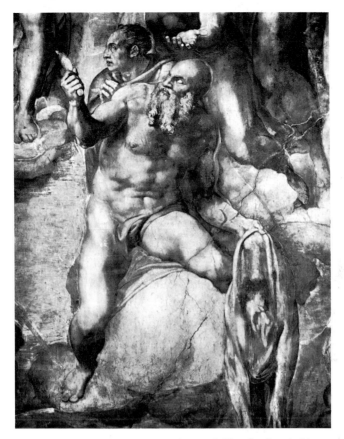

MICHELANGELO   *St Bartholomew holding his flayed skin*

The *Last Judgment* is full of bitter, ironic details. Michelangelo has painted his own portrait on the flayed skin of St Bartholomew [183], a reference to his own suffering. Charon [179] is given the head of the Constable of Bourbon, and Minos, entwined with snakes, that of the papal master of ceremonies, Biagio da Cesena, who had criticized the 'indecency' of the work while it was being painted. The completed fresco did meet with a number of criticisms. Some found the composition confused, and others

◁ MICHELANGELO   *Christ the Judge, and the Virgin*

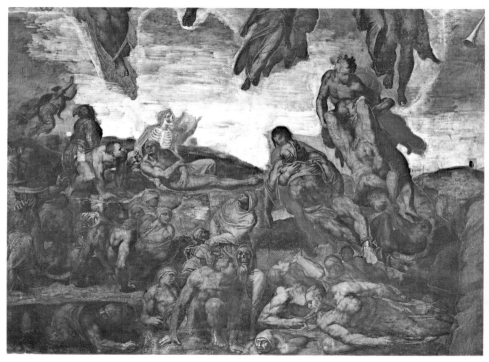

objected to the fact that all the figures were nude; paradoxically, one of the latter critics was the licentious poet Pietro Aretino. He is represented in the fresco as St Bartholomew, holding the skin that bears Michelangelo's portrait [183]. So many objections were in fact raised that Daniele da Volterra was given the task of painting draperies on the figures. This was in 1564, when Michelangelo lay dying in the house of Macel de' Corvi near the Forum. Poor Daniele da Volterra, an artist of considerable dignity, went down in popular history as *'il braghettone'* – the breeches-maker.

Among the few surviving works inspired by the original version of the *Last Judgment,* the best is that of Marcello Venusti,

done in 1549 for Cardinal Alessandro Farnese, a nephew of Paul III, and now in the Museo di Capodimonte at Naples.

Although the *Last Judgment* has often been criticized as chaotic, artificial, even blasphemous, its awesome character has never failed to make its effect. Today we are in a better position to appreciate the fresco for the spiritual anguish which it conveys, to say nothing of its powerful influence on the development of Mannerist painting.

MICHELANGELO   *Saints and Martyrs*

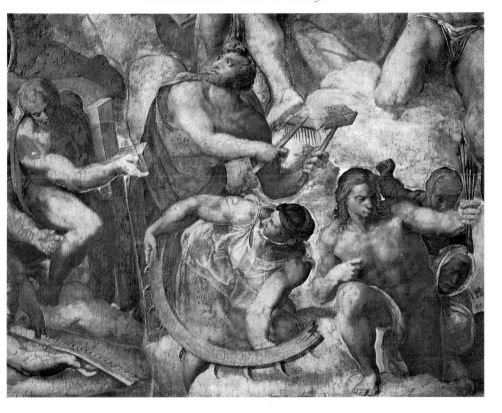

# THE CAPPELLA PAOLINA

MICHELANGELO    *The Conversion of St Paul*
                *The Crucifixion of St Peter*

A few months after the *Last Judgment* was finished, Paul III commissioned Michelangelo to paint two frescoes of the conversion of St Paul and the crucifixion of St Peter in the chapel where he had been consecrated pope in 1540. Work was begun in 1542, but it was held up several times on account of Michelangelo's ill health. The *Crucifixion of St Peter* [190] was finished in 1545, and the *Conversion of St Paul* [187] in 1549 or 1550.

These frescoes, which are Michelangelo's very last paintings, were well described by Vasari: 'Only Michelangelo has achieved... the perfection of art, for here there is no landscape, there are no trees, no houses, not even variety or beauty.' Nothing is here that might distract attention from the essential action involved in the subject. The colour is played down, the chiaroscuro and the unnatural light on the figures create a feeling as of some destiny fulfilled outside the confines of space and time.

The choice of subject matter may seem strange. Normally the pendant to a *Conversion of St Paul* would be a *Calling of St Peter,* and a *Crucifixion of St Peter* would be a companion subject to the

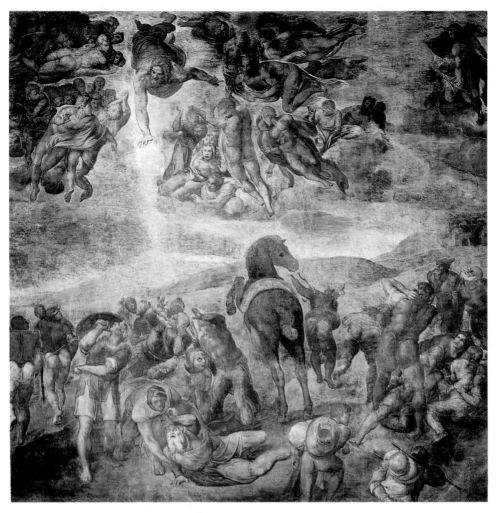

MICHELANGELO  *The Conversion of St Paul*

*Beheading of St Paul.* It has been suggested by G. C. Argan that we have here a representation of the two essential moments in the religious life, conversion and martyrdom. Each composition is organized with a diagonal movement towards the altar, itself a

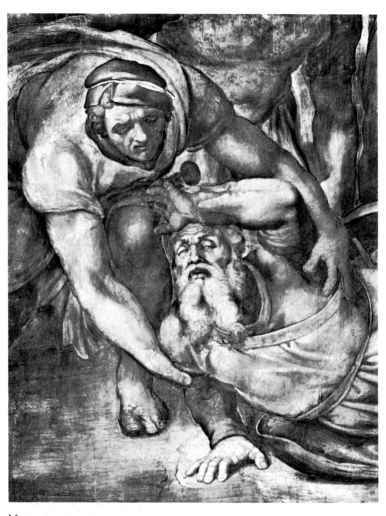

MICHELANGELO
*The Conversion of St Paul*
Detail: St Paul supported by a soldier

MICHELANGELO
Sketch for the figures of Roman soldiers
in *The Crucifixion of St Peter* ▷

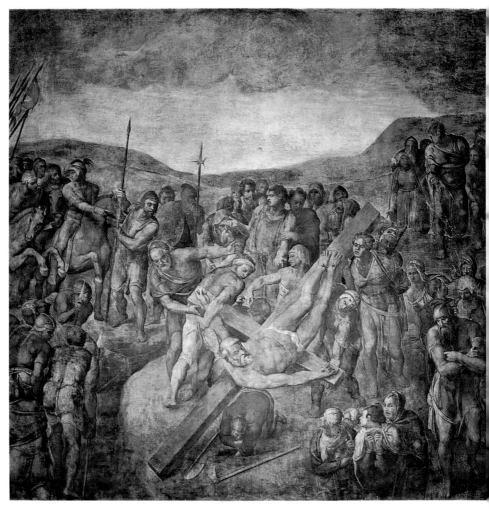

MICHELANGELO    *The Crucifixion of St Peter*

symbol of Christian sacrifice. As usual, many of the figures are drawn from classical antiquity, but their reality is now less distinct. They have become part of Michelangelo's cosmic vision.

# THE STANZE OF RAPHAEL

Raphael's Stanze consist of three rather small rooms (about 10 × 8 metres) and one larger one (15 × 10 metres) on the top floor of the building erected by Nicholas V to complete the palace built two centuries earlier under Nicholas III, on the north side of the Cortile del Papagallo.

Already in the fifteenth century the suite was used as reception rooms, and decorated by the best artists, who included Piero della Francesca, Luca Signorelli, Bartolomeo della Gatta and Bramantino. Julius II, not wanting to live in the Borgia Apartments – where, according to the contemporary chronicler Paride de Grassis, the Pinturicchio frescoes and other ornaments brought back the 'evil memory' of his predecessor Alexander VI – commissioned additional frescoes for these rooms from Perugino, Sodoma, Baldassare Peruzzi and Lorenzo Lotto. Little is known about their work, since almost all of it – except for a few fragments in the Stanza della Segnatura and Stanza dell'Incendio – was destroyed to make room for the new frescoes by Raphael, whose name was probably put forward by Bramante, another native of Urbino.

Raphael was only twenty-five, and had only just arrived in Rome from Florence, when he started work on the Stanze – at the end of 1508 or the beginning of 1509. He began with the

room which is known as the Stanza della Segnatura (which is the second room we come to if we enter from the Borgia Tower). Next he painted the Stanza di Eliodoro, and then returned to the room nearest the Borgia tower, the Stanza dell'Incendio di Borgo. The fourth and largest room, the Sala di Costantino, is entirely the work of Raphael's pupils, and was painted after his death.

The best way to follow Raphael's development is to look at the three rooms in chronological order.

*Stanza della Segnatura*

The first document dealing with Raphael's work in the Vatican is an order of payment from the pontifical treasury dated 13 January 1509, '*ad bonum computum picturae camerae ... testudinatae*', which suggests that he began with the ceiling [193]. The division of the ceiling into thirteen compartments, separated by frames painted with grotesques, pre-dates Raphael, and is part of the original decoration. The new work consists of four circular medallions containing personifications of *Theology, Law, Philosophy* and *Poetry;* in each corner of the ceiling a rectangular panel with a gold ground simulating mosaic (the subjects of these panels are *Astronomy,* the *Judgment of Solomon, Adam and Eve,* and *Apollo and Marsyas*); and small sections between the corner panels and the central octagon (bearing the papal arms), painted with scenes from Livy and Hyginus.

The figures in the medallions are certainly by Raphael, also the *Astronomy* and the *Judgment of Solomon. Adam and Eve* and *Apollo and Marsyas* are generally attributed to Sodoma, and most authorities hold that he painted the central octagon as well. (D. Redig de Campos, however, attributes the *Apollo and Marsyas* to Baldassare Peruzzi, and Venturi claims the octagon for Bramantino.)

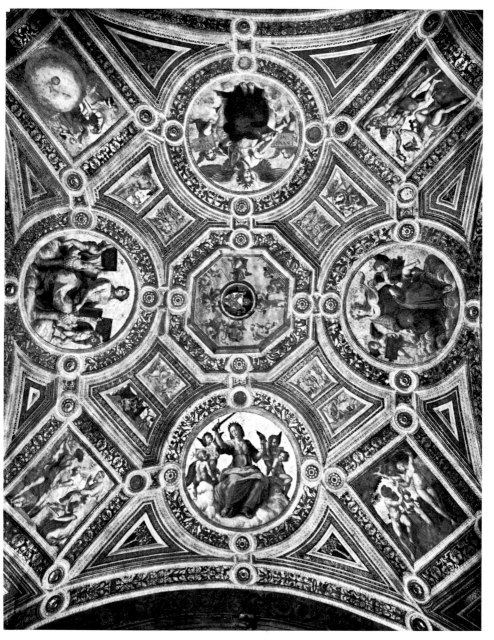

RAPHAEL  *Ceiling of the Stanza della Segnatura*

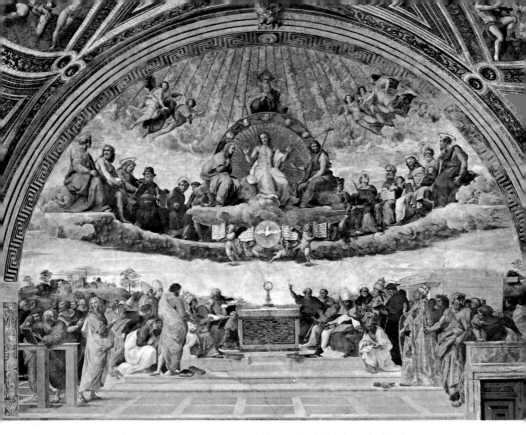

RAPHAEL  *Disputa, or Triumph of Faith in the Eucharist*

On the walls, which are in the form of lunettes, four scenes correspond to the four allegorical figures on the ceiling. The so-called *Disputa del Sacramento* [194] is linked with *Theology*; the *Parnassus* [197] illustrates *Poetry*; and the *School of Athens* [196], *Philosophy*. A fresco illustrating the three other cardinal virtues, *Fortitude*, *Temperance* and *Prudence*, complements the *Law*.

Four scenes on the window wall complete the design. These show *Augustus preventing Virgil's Executors from burning the Manuscript of the Aeneid*, *Alexander the Great ordering a copy of Homer's poems to be buried in the tomb of Achilles*, *Tribonianus handing the 'Pandects' to Justinian*, and *Gregory IX receiving the*

*'Decretals'*. These frescoes were certainly designed by Raphael, but carried out by his pupils.

The lower part of the wall was originally covered with inlaid wood panelling by Fra Giovanni da Verona, begun in 1508. This was replaced during the pontificate of Paul III by the monochrome frescoes we see today, which are the work of Perino del Vaga.

In order to understand the meaning of all these varied subjects, both sacred and secular, and to appreciate them better as works of art, it is of course necessary to know something about the general programme that links them all together.

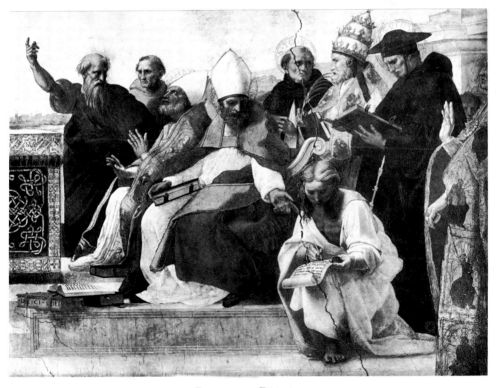

RAPHAEL   *Disputa*
Detail: Innocent III with SS. Ambrose, Augustine, Thomas Aquinas and Bonaventura

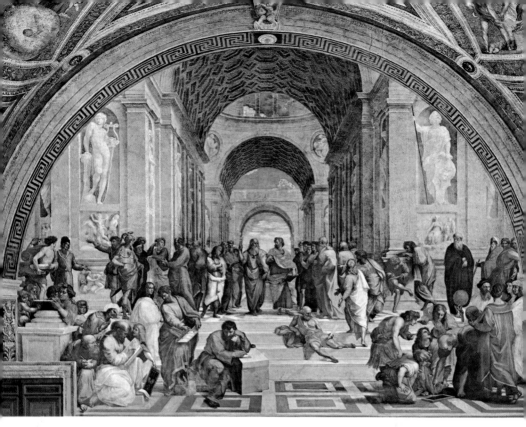

RAPHAEL   *The School of Athens*

The iconography of the Stanza della Segnatura was suggested
by Julius II himself – *'ad praescriptum Julii Pontificis'*, as Paolo
Giovio puts it in his life of Raphael. Its theme is the unity of
theological and philosophical thought, as the neo-Platonists
understood it at the time. The three principal ideas involved are
those of Truth, Beauty and Goodness. Truth revealed by God is
symbolized by the figure of *Theology,* and by the scene of the
*Disputa,* or *Triumph of Faith in the Eucharist* (its usual title,
*Disputa del Sacramento,* goes back to a misinterpretation of a
passage in Vasari). Truth revealed by Nature is the subject of
*Philosophy* and the *School of Athens.* Goodness is represented in
the paintings of the virtues, the figure of *Law,* and the scenes

196

involving Justinian and Gregory IX. Beauty is symbolized in the *Parnassus,* the figure of *Poetry,* and the scenes showing Augustus and Alexander the Great.

The humanists' ideal, in Raphael's time, involved a perfect fusion of Christian faith with the culture of antiquity, and it implied that ethics and aesthetics were brought into harmony. André Chastel has described the phenomenon: 'the wisdom of the ancients is seen not as inferior to revelation, but as adding something to it. Poetry is considered to be one of the highest powers of the human spirit. Law, or Justice, instead of being merely one of the cardinal virtues, is put on the level that Plato claimed for it, at the very top of the hierarchy of moral values...

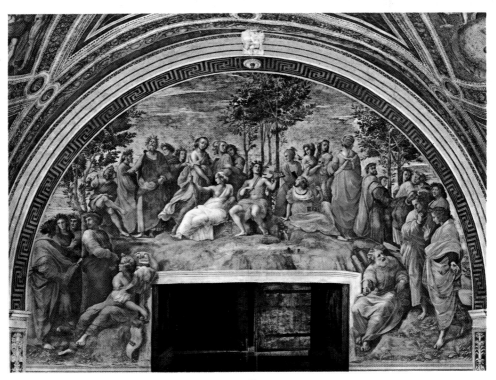

RAPHAEL  *Parnassus*

and there is thus complete harmony between Christian spirituality and the world of antiquity.'

Any other artist might have reduced such a programme as Julius II prescribed to an array of allegories and conventional symbols, or some dull exposition of abstract ideas. Or it might have been a pretext for a nostalgic evocation of the golden age, and an exercise in pure imagination. Raphael, however, in the Stanza della Segnatura, used the commission to make a personal statement of faith in the ideals of Renaissance culture. He felt them, as a painter, and accepted their guidance, and they have here inspired him to produce something which is among the highest achievements of Western art. He had an exceptional gift for combining disparate elements. His images express his meaning with the utmost clarity, his forms are perfect, and there is an almost miraculous sense of balance that makes his vision of the Renaissance synthesis totally convincing.

It is this sense of serenity in Raphael that marks the profound difference between him and Michelangelo, who was working at the time on the Sistine ceiling. They shared the same feelings about the Renaissance ideal, but interpreted them differently. Michelangelo seems to have been obsessed by the tension involved in the combination of Christian and pagan values, and this gives rise to the sense of struggle, the need to overcome obstacles, that is so characteristic of him. With his existential awareness of the present moment, Michelangelo stands at the opposite pole from Raphael, whose serenity seems timeless.

The ideas that permeated the cultural climate of Rome stimulated Raphael, and had the effect of speeding up his development as an artist, a process which can be traced in the drawings and paintings he produced at this time.

In the Stanza della Segnatura the allegorical figures in the roundels and the two scenes of *Astronomy* and the *Judgment of Solomon* still have something of Perugino about them. But the *Disputa,* painted soon afterwards in 1509, is already fully mature,

RAPHAEL *Parnassus* Detail: Dante, Homer and Virgil ▷

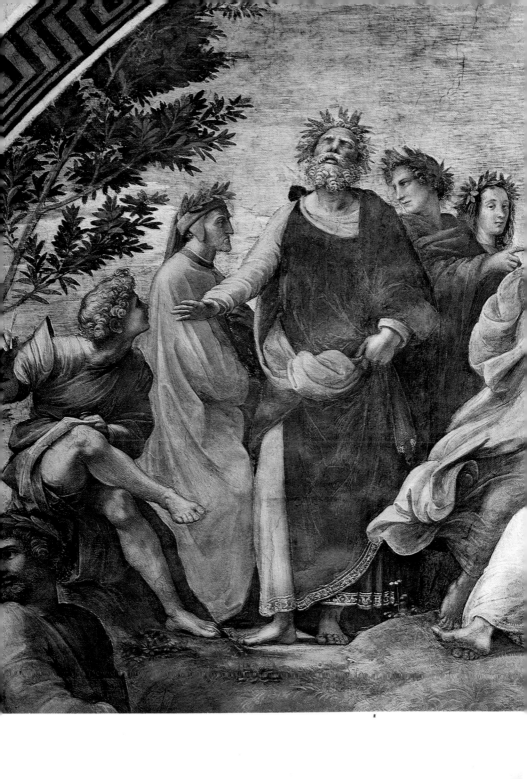

with every figure vividly realized on a monumental scale [194, 195]. The composition in its several layers is traditional enough, and Perugino's use of clear space is faithfully followed. Certain faces and certain gestures show that Raphael had been studying Leonardo carefully. What is new and original is the splendid ordering, the solemn rhythm with which this large group is organized round the central line formed by the Trinity group and the monstrance on the altar. Among the faces of those portrayed one can identify Dante and Savonarola, and Julius II as Gregory VII. Bramante leans forward on the balustrade at the left, next to the youthful Francesco Maria della Rovere, who stands facing the spectator. Heaven and earth seem here to be linked as in a vision. Raphael, with his other-wordly light, has created a miraculous moment and preserved it forever.

As soon as he had finished the *Disputa* Raphael began the painting on the opposite wall, the *School of Athens,* which was finished in 1510 [196]. This was to be such an evocation of the spirit of antiquity as would fittingly balance his vision of the Trinity and the saints. The monumental scale is emphasized here by the architectural background, which at once recalls the ruins of the Basilica of Maxentius and the contemporary designs of Bramante. It may not be true that Bramante actually provided Raphael with the sketch, as Vasari claims, but it is evident that Raphael was inspired by the plans for the new St Peter's. The architecture is no longer merely antique: it shows in fact how ancient forms were being reinterpreted and created afresh in the early sixteenth century.

The great arches in the centre of the scene form a sort of niche for the two figures of Plato and Aristotle, and the motif is taken up on either side with niches for statues of Apollo and Minerva. Plato is holding his *Timaeus* and pointing upward to heaven. Aristotle, holding his *Ethics,* points to the earth. In this way Raphael represents the two poles of philosophical speculation, the ideal and the empirical. The groups of figures on either side

continue the rhythm set up by the architectural forms, and have the effect of carrying it beyond the visible framework of the picture.

All the great thinkers of antiquity are gathered here: Socrates is involved in a discussion with Xenophon, Alcibiades and Alexander the Great (the young man in armour below the statue of Apollo). Zeno and Epicurus lean against the plinth in the foreground to the left. Pythagoras sits writing alongside them, and Averroës, in a white turban, is looking over his shoulder. Heraclitus is represented leaning against a block of marble in the centre foreground. The figure tracing geometrical designs on the ground to the right is of course Euclid; in the group round him are Zoroaster, holding a globe covered with stars, and Ptolemy, wearing a crown and facing him. The figure reclining on the steps in front of Aristotle is Diogenes.

Some of the heads, for instance that of Socrates, are taken from the antique sculptures in Julius II's collection in the Belvedere. Others are drawn from life. Plato is given the head of Leonardo da Vinci, Euclid is Bramante, and Zoroaster is very recognizable as Pietro Bembo; Francesco Maria della Rovere, dressed in white, stands behind Zeno and Epicurus, while Raphael himself and Sodoma appear on the far right.

The *School of Athens* was nearly finished in 1511, when the scaffolding was taken down from the finished part of the Sistine ceiling. Raphael was so excited by it that he could not resist adding, at this point, the figure of Michelangelo as Heraclitus (it does not appear in the original cartoon, now in the Pinacoteca Ambrosiana at Milan).

In giving the philosophers of antiquity the faces of his contemporaries, Raphael was doing something more than paying them a compliment. His purpose was in fact to point out that the wisdom of antiquity had come to life again in work produced in his own day; even to suggest that Roman culture in the age of Julius II was in fact a new School of Athens.

This association of antiquity with the great men of Renaissance Italy is again made in the idyllic *Parnassus* [197, 199], painted in 1511, as we read in the inscription near the window. Some of the representations are purely imaginative (Alceus, Anacreon, Sappho, Tibullus, and Ovid), some are taken from classical sculpture (Homer and Virgil), some from familiar portraits (Dante, Petrarch, Boccaccio, Sannazzaro), and others, such as Ariosto and Castiglione, drawn from life. Here, as in the *School of Athens*, Raphael's intention was to show the spiritual continuity between antiquity and the present – to celebrate the true 'rebirth' of classical culture.

The decoration of the Stanza della Segnatura has given rise to some speculation about what the room was used for, since it would almost seem to have been designed as an exquisite shrine to theology and philosophy. Some scholars, including Wickhoff, have suggested that it must have been Julius II's private library, but others, notably André Chastel, have rightly pointed out that the original inlaid dado argues against the presence of shelves. The room's function was most probably purely ceremonial. Its present name of Stanza della Segnatura is in any case later: it derives from the room's subsequent use by the canonical tribunal known as the Signatura Gratiae.

## Stanza di Eliodoro

Raphael began the decoration of this second room for Julius II in 1512. When he finished it, in 1514, Julius was dead, and the new pope was Leo X. As in the Stanza della Segnatura, the design was no doubt conceived by Julius II: its theme is God's intervention on behalf of the Church.

Theology in the Stanza della Segnatura had been treated in its ideal and cultural aspects. Here the theme is closely connected with the actual events of the pontificate of Julius II, and the

subjects allude to Julius' energetic re-affirmation of papal author-
ity and his insistence on the dogmas of religion.

The ceiling is divided into four parts by a charming frame-
work, probably designed by Peruzzi. These compartments, each
painted to simulate a tapestry, combine to form an oval, with the
arms of Julius II in the centre. The subjects all relate to divine
intervention on behalf of the people of Israel: *Moses and the
Burning Bush, Jacob's dream, God appearing to Moses,* and the
*Sacrifice of Abraham* [205]. These scenes were certainly designed
by Raphael, but the actual painting is either by Peruzzi or (more
probably, according to Venturi) Guglielmo di Marcillat.

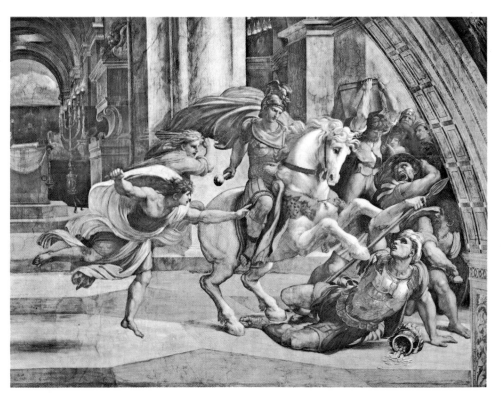

RAPHAEL   *The Expulsion of Heliodorus*   Detail

RAPHAEL  *The Expulsion of Heliodorus*

The four episodes painted on the walls correspond to the four on the ceiling. The one that gives its name to the room shows the *Expulsion of Heliodorus from the Temple* [204], and refers to the defeat of an attempt made at the Council of Pisa in 1512 to bring about a schism. The *Mass of Bolsena* [207] tells the story of a Bohemian priest who doubted the real presence of Christ in the sacrament while he was celebrating mass: the consecrated host miraculously bled. (The corporal on which the mass was celebrated was kept as a relic in Orvieto Cathedral.) The *Liberation of St Peter* [208], the first Vicar of Christ on earth, is used to show that the pope enjoys special protection from God. Finally the fresco of *St Leo the Great stopping Attila at the gates of Rome* [212] represents the pope defending the Church against all unbelievers. The lower parts of the walls are decorated with allegorical figures and views of papal estates painted by Perino del Vaga and possibly also by Peruzzi.

Each of the major frescoes celebrates a particularly dramatic event connected with the history of the Church. Raphael's style,

accordingly, begins noticeably to change. Everything in the Stanza della Segnatura had been in some way ideal and timeless. But in the Stanza di Eliodoro we are caught up in actual moments of history, and sense their strongly emotive quality. Julius II is portrayed in the *Expulsion of Heliodorus* and in the *Mass of Bolsena* (he also appeared as Leo the Great confronting Attila, but after his death the portrait was changed to that of Leo X); but the purpose is quite different from that of the contemporary portraits introduced into the *Parnassus* and the *School of Athens*. There, modern figures were elevated by being placed with the great men of antiquity: here, past events are updated to underline momentous events in the contemporary history of the Church.

RAPHAEL AND ASSISTANTS   *Ceiling of the Stanza di Eliodoro* Detail: the sacrifice of Abraham

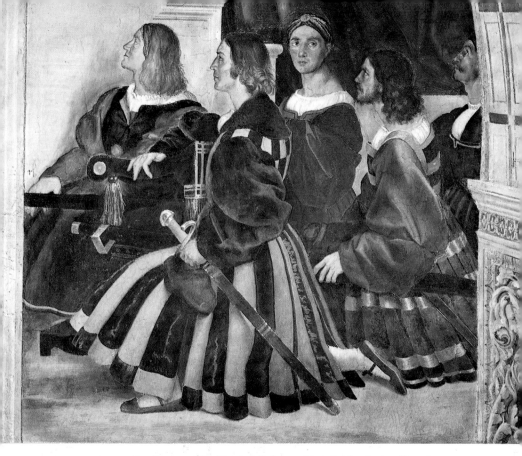

RAPHAEL   *The Mass of Bolsena*   Detail: the Swiss Guards

The parallel between the *School of Athens* [196] and the *Expulsion of Heliodorus from the Temple* [204] is extremely instructive, since the two architectural backgrounds are very similar. But whereas the rhythm of the *School of Athens* is balanced and tranquil, the *Heliodorus* scene is one of wild disturbance. Instead of the noble gravity of philosophers we have the agitated gestures of avengers, victims and onlookers. Where earlier the light had been clear and evenly diffused, here flaring torches on the walls create sharp contrasts of light and shadow. In the *Expulsion of Heliodorus* the influence of Michelangelo is apparent:

there is a more vigorous plasticity in the drawing of the figures, and the emotions are more intensely characterized.

But there is another development in Raphael's style which can hardly be explained by the influence of Michelangelo, and that is his new feeling for colour as it was being used by the Venetian painters. Roberto Longhi has even suggested that the figures of the Swiss Guards in the *Mass of Bolsena* [206] are to be attributed to Lorenzo Lotto. While this is unlikely, it is certainly true that in this fresco the relationship between light and colour is more naturalistic, full of interesting transitions, and orchestrated in broad masses that emphasize the monumentality of the figures.

RAPHAEL    *The Mass of Bolsena*

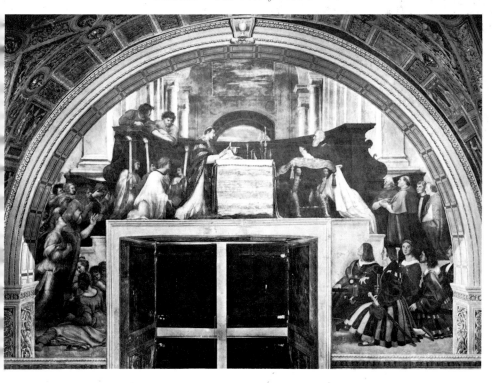

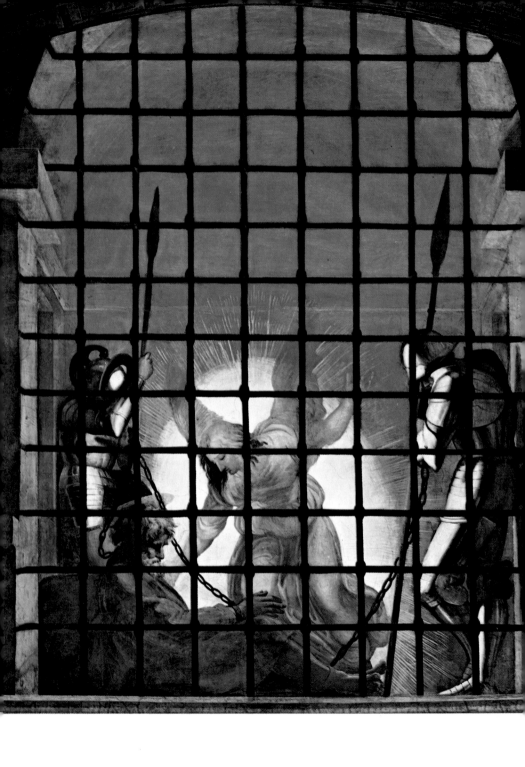

The *Liberation of St Peter* is immediately striking on account of its bold effects of light in darkness. Inside the prison cell, the angel's halo reflects on the armour of the guards [208]; outside to the left, the moon shows through a break in the clouds. There is such a fusion of natural and supernatural, of magic and nature, that the nearest parallel would be the most lyrical verses of *Orlando Furioso,* by Raphael's contemporary Ariosto.

The scene of *St Leo the Great stopping Attila at the gates of Rome* [212] is descriptive and didactic in character. It was painted mainly by Raphael's assistants, who probably included Giulio Romano. There is something rather forced and rhetorical about the division into distinct episodes, with the figures of St Peter and St Paul above the papal cortège; but there is genuine poetic feeling in details such as the Roman landscape.

Taken as a whole, the Stanza di Eliodoro represents a crucial moment in the cultural history of Rome. It would seem that around 1510 the idealistic phase of neo-Platonic culture was already fading. Symptoms of crisis began to be apparent. First Michelangelo and then Raphael felt bound to convey a certain sense of apprehension, soon to be shared by everyone.

## Stanza dell' Incendio di Borgo

This room is the first we come to if we approach the Stanze from the Borgia tower.

Raphael left the ceiling as he found it, with four roundels painted with religious subjects by his master, Perugino. The wall frescoes were painted between 1514 and 1517. Each one illustrates an event connected with one of the two ninth-century popes called Leo, thus complimenting the reigning pontiff, Leo X.

The fire in the Borgo – the fresco of which gave the room its name – occurred in 847, and was miraculously extinguished when Leo IV gave the papal blessing from the benediction loggia of St Peter's. The fresco showing the *Battle of Ostia*

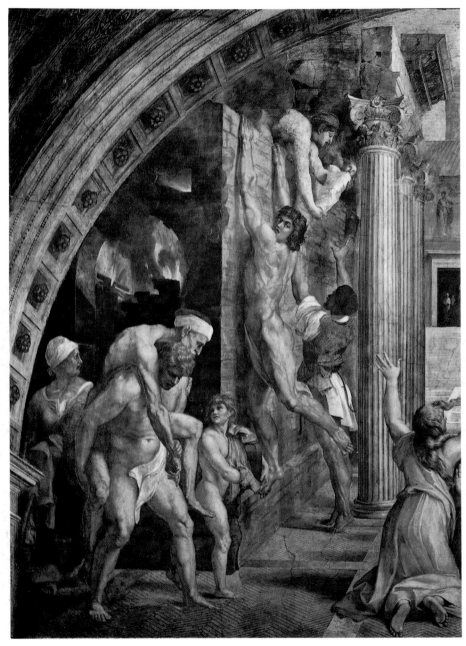

RAPHAEL AND ASSISTANTS   *The Fire in the Borgo*   Detail

commemorates the victory of Leo IV's fleet over the Arab fleet in 849. The other two frescoes concern Leo III – first the *Crowning of Charlemagne,* which took place in 800, and then the less familiar episode of *Leo III justifying his Authority.* Being accused of usurpation by the nephews of Pope Adrian I, he proclaimed that the Roman pontiff was responsible only to God: '*Dei, non hominum est episcopos judicare*'. Leo X himself, in 1516, re-affirmed the claim to supreme spiritual authority made by Boniface VIII in his bull *Unam Sanctam.*

The frescoes are largely workshop products. Raphael was by now an impresario, providing designs and supervising their execution by others.

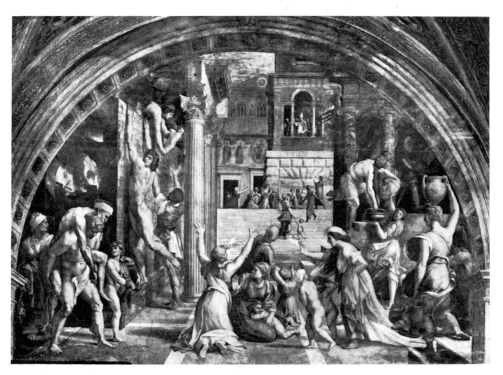

RAPHAEL AND ASSISTANTS   *The Fire in the Borgo*

There is, however, a marked difference between the first fresco and the other three. In the *Fire in the Borgo* [210, 211] we can see Raphael unifying his various researches into a dramatic and vigorous style of representation. Though at first it seems confused, the composition is in fact as highly calculated and balanced as a speech from an antique tragedy.

The historical event is carefully portrayed in the background, where Leo IV appears in the benediction loggia (the façade of Old St Peter's is just visible to the left). But the action in the foreground is what matters most. The burning of these poor Roman houses (in the old quarter in front of St Peter's; see p. 100) is raised to the epic level of the fall of Troy; and on the left Raphael has introduced a group that clearly alludes to Aeneas carrying his father Anchises on his shoulders from the flames of Troy.

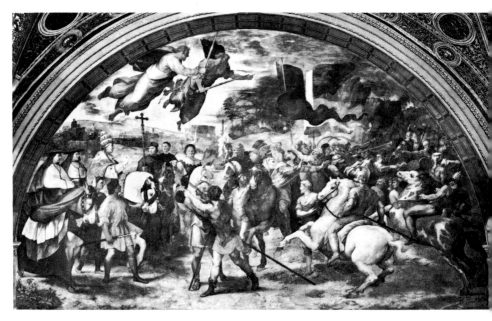

RAPHAEL AND ASSISTANTS   *St Leo the Great stopping Attila at the gates of Rome*

In the Stanza dell'Incendio one can recognize many classical borrowings from Roman paintings and reliefs; and it is interesting to see how they are assimilated and transformed with an elegance that is already Mannerist. Much of this transformation is due to Raphael's assistants, and particularly to Giulio Romano, who painted the large monochrome figures of *Charlemagne, Astolf, Godefroy de Bouillon, Lothair I* and *Ferdinand the Catholic* on the lower part of the wall. But we may be certain that Raphael intended this development, for he wanted above all to create a new style out of the synthesis of inherited traditions: at the very least, according to S. Ortolani, he was making 'an experiment in the expressive power of the historical language of art'.

The other three frescoes in the Stanza dell'Incendio, especially those which concern Leo III, are minutely, even pedantically descriptive; more like careful chronicles of liturgical ceremonies. Where the *Fire in the Borgo* had been elegant and lively, in these the colour is dull, and the treatment ponderous and static; where it was dramatic, they are lifeless. This is the degenerate side of Mannerism, when pupils use their master's models as formulas.

## Sala di Costantino

The decoration of the fourth and largest of the Stanze was ordered by Leo X in 1517. Raphael worked out a general plan for four large frescoes dealing with events in the life of the Emperor Constantine, and did some drawings for the *Battle at the Milvian Bridge*. After Raphael's death, Sebastiano del Piombo tried to get the commission, but Raphael's assistants protested, claiming that they had already been entrusted with the preparatory designs. They made their point, and their work was finished in 1520-21.

There is little trace here of Raphael's influence. Giulio Romano was chiefly responsible for the work, together with Penni and

Perino del Vaga. These three painters already belonged to a new generation, and their art tends to use Raphael's forms in an eclectic manner, combining them with borrowings from Michelangelo and other contemporary artists and close imitations of classical models. Even when Raphael wanted to convey the extremes of pathos, he managed to keep his subject within an ideal world. His followers, however, sacrificed his poetry in favour of emphasizing the descriptive element in their work.

Contemporary opinion about these frescoes is interesting: Leonardo Sellaio described them to Michelangelo as *'chosa ribalda'* – a coarse kind of work. Castiglione, writing to Federico Gonzaga in 1521, was full of praise for them. To the taste of our time they seem heavy and complicated, but they are invaluable examples of the tendencies of early sixteenth-century Mannerism.

The four episodes from the life of Constantine are painted in imitation of tapestries. The first one, the *Vision of the Cross,* shows Constantine haranguing his soldiers as the fateful sign, *'In hoc signo vinces'*, appears in the sky. The *Battle at the Milvian Bridge* is an enormous and crowded composition, full of reminiscences of Imperial Roman sarcophagus reliefs. The *Baptism of Constantine* is set in a hexagonal building with columns which recalls the Lateran Baptistery. The *Donation of Constantine* illustrates the legend of his bequest of the city of Rome to the Church. (The Donation had in fact been exposed as a piece of papal propaganda by Lorenzo Valla in the fifteenth century.)

These scenes, like those in the Stanza di Eliodoro and the Stanza dell'Incendio, are all in one way or another designed to stress the authority of the Church. The room is completed by allegorical figures of *Justice* and *Meekness* – which look as though they were executed directly from designs by Raphael – and portraits of popes. On the lower part of the walls, placed between cariatids bearing the Medici arms, are further scenes from Constantine's life painted in a bronze monochrome that gives the effect of bas-relief.

# RAPHAEL'S LOGGE AND TAPESTRIES

*The Logge*

The gallery decorated by Raphael and his school lies on the west side of the Cortile di S. Damaso, which Julius II had added on to the old palace of Nicholas III [56]; begun by Bramante in 1514, the Cortile was finished by Raphael. The gallery is 65 metres long and 4 metres wide, and is divided into thirteen vaulted bays *(logge)*. Raphael worked out a general scheme for the decoration in 1517 or 1518, but left the execution entirely to his workshop.

Pilasters and arches are covered with decoration of the kind known as *grottesche* or 'grotesques', which was copied from the recently discovered ruins of the Golden House of Nero – thought to be 'grottoes', since the rooms were underground. Even the technique is faithfully copied, with its reliefs in white or partially painted stucco. The grotesques serve as a framework for roundels and panels of different shapes painted with scenes from mythology, small allegorical figures, reproductions of famous works of classical sculpture and architecture, and episodes from the life and pontificate of Leo X [217]. Giovanni da Udine was a specialist in this sort of work, which aimed to copy antiquity as faithfully as possible. The result is very typical of Renaissance taste, being delicate and at the same time extra-

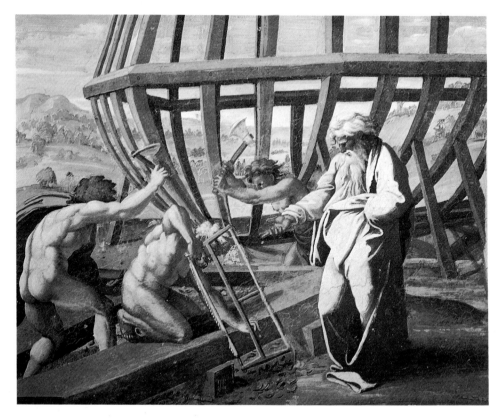

RAPHAEL AND ASSISTANTS  *The Building of the Ark*

vagant, full of humour and with a great feeling for nature. Giovanni's chief collaborator here was Perino del Vaga.

The vault of each of the thirteen bays is divided into four sections. In all but one of the bays the subject matter of the paintings is taken from the Old Testament. The last bay deals with the New Testament. The sequence begins with Genesis, and works through the stories of Adam and Eve, Noah [216], Abraham and Lot, Isaac and Jacob, Joseph, Moses, Moses and Joshua together, Joshua, David and Solomon, and finally the life of Christ. The lower part of the wall is also painted with scenes

216

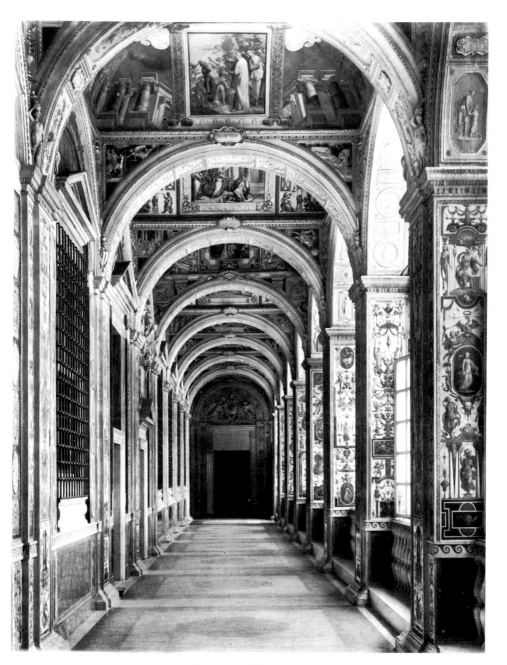

*The Logge of Raphael*

from scripture in monochrome. The whole is often referred to as 'Raphael's Bible'.

In the frescoes the hand of Giulio Romano is very much in evidence, assisted by Perino del Vaga, Penni, the young Polidoro da Caravaggio and others. The narrative is lively, the form elegant; and the paint is applied in brief, sketchy strokes that remind one of the style of antique Roman painting, and seem almost to herald Impressionism. The Logge gave Raphael's pupils more scope to express themselves than they had had in painting the large rhetorical subjects in the Stanza dell'Incendio and the Sala di Costantino.

## The Tapestries

In 1515 Pope Leo X ordered a set of tapestries for the Sistine Chapel. These were to cover the lower part of the walls, from ground level up to the bottom of the fifteenth-century frescoes, and were to be brought out for the most solemn liturgical ceremonies. The subject matter was to be taken from the Gospels and the Acts of the Apostles, with special emphasis on the miracles of Peter and Paul. There were to be ten scenes in all, composing a historical cycle that should emphasize the spiritual authority of the Church.

Raphael was commissioned to execute cartoons for the tapestries: he worked on them during the year 1516 with the help of G. F. Penni, Perino del Vaga, Giulio Romano, Giovanni da Udine and others. There were no tapestry weavers in Italy who could undertake work on this scale, and so the cartoons were sent to the Brussels workshop of Pieter van Aelst, who had already produced fine works for Philip the Fair and Joan the Mad.

The tapestries were finished in 1519, and they were hung in the Sistine Chapel for the first time on 26 December of that year.

RAPHAEL   *The Miraculous Draught of Fishes*   Detail of tapestry ▷

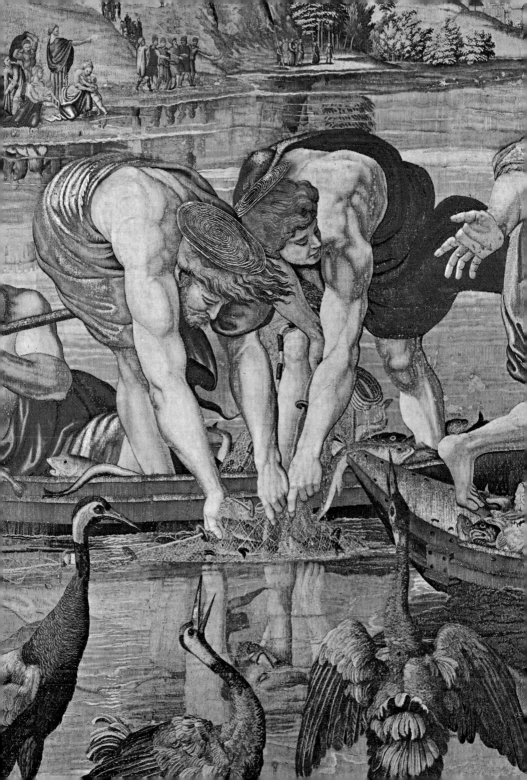

They were greatly admired. Only a few criticisms were voiced (the critics included the Venetian Sebastiano del Piombo, a great admirer of Michelangelo who never missed an opportunity to belittle the achievements of Raphael and his school). Pieter van Aelst was required to produce copies of the tapestries for Henry VIII and the Duke of Mantua, and five more sets were woven at a later date.

In 1815 the Sistine Chapel tapestries, much worn and faded, were restored under the direction of Canova, and installed in rooms specially designed for them in the apartments of Pius V. Although much of the original colour has gone, we can still appreciate the high quality of the weaving and the amazing way in which the weavers translated the characteristic features of Raphael's art.

Raphael's seven original cartoons were eventually acquired by Charles I for about £700, and they are at present on loan from the Royal Collection to the Victoria and Albert Museum in London.

The designs, which are contemporary with the frescoes in the Stanza di Eliodoro, are a milestone in Raphael's development. Under the influence of Michelangelo his compositions become larger in scale, with more movement and drama. It is true that much of this new manner must be attributed to his workshop, but it is equally certain that Raphael himself was experimenting in what were for him new directions. In this detail of the tapestry of the *Miraculous Draught of Fishes* [219], the monumental design of the apostles could only be by Raphael, and we can be sure that his was the coordinating and directing mind which created such a fusion of new tendencies.

# THE BELVEDERE

We have already seen how in 1503 Julius II commissioned Bramante to link the papal palace with the Villa Belvedere, to the north (above, pp. 40-41). This he did by means of two wings, framing a long open space on three levels, and ending at the villa in a terrace and an exedra, or semi-circular recess. This was one of the favourite architectural devices of ancient Rome, and it was chosen here both for dramatic effect and for its appropriateness as a setting for Julius II's collection of classical sculpture. In a tower in the Belvedere, Bramante provided a remarkable spiral ramp coiling round an open well [222], which was much admired and imitated.

Michelangelo was the first to modify Bramante's design. He built steps from the terrace to the exedra, and may also have had the idea of carrying the exedra upwards to form a great niche, creating as it were an apse to the courtyard.

It was not until 1560 that Pirro Ligorio put the idea into practice. Setting aside the taste for fanciful decoration that he had indulged in the Casino of Pius IV, he studied the great Roman niche in the stadium on the Palatine and produced at the Belvedere an impressively cavernous structure [222].

In 1618 the enormous bronze pine cone was installed in the centre of the niche. It had come from a fountain in the atrium of

BRAMANTE
*Spiral ramp
in the Belvedere*

BRAMANTE AND PIRRO LIGORIO
*Great niche and pine cone in
the Belvedere courtyard*

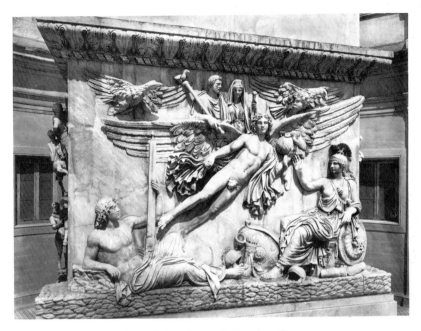

*Base of the column of Antoninus Pius*

Old St Peter's (above, pp. 17-18): Dante had seen it there, some three hundred years earlier, and used it as an image in the *Inferno* (Canto XXXI, 58) to suggest the size of a giant's head.

Later, the base of the column of Antoninus Pius [223] was also placed in the niche. It was discovered in 1703, and bears reliefs celebrating the exploits and triumph of the emperor. Thus in the course of time a remarkably harmonious group of antiquities has been gathered together within a framework – itself antique in inspiration – which does them full justice.

The new wing built by Sixtus V for the Vatican Library has disastrously cut Bramante's courtyard in two, so that it is no longer possible to see the great niche from the low, distant viewpoint that Ligorio intended. But the niche itself, undoubtedly the most famous work by this Neapolitan architectural fantasist, retains its fascination.

# THE VATICAN PINACOTECA

GIOTTO AND ASSISTANTS  *Stefaneschi Triptych*

Cardinal Stefaneschi commissioned Giotto to paint this triptych about 1330, after he had done the mosaic of the *Navicella*. It is thus one of Giotto's later works, in which he leaned heavily on the assistance of his pupils. Most critics now agree that Giotto was responsible for the general design and for certain portions of the triptych, which include the central panel of *Christ in Majesty* [225]. No other artist of the time could have treated the subject in this way. The conventional perspective of medieval painting has gone, and depth is suggested (by such devices as the pillars of the throne canopy, which pass in front of four angels' heads), thereby emphasizing the monumentality of the figure of Christ. Cardinal Stefaneschi himself is represented kneeling at the left at the foot of the throne, and the realism of the small portrait is another authentic touch of Giotto.

For a long time the triptych was on the high altar of St Peter's, which was free-standing in the apse. All three panels are painted on both sides. On the front [226], the panels flanking *Christ in Majesty* show the crucifixion of St Peter and the beheading of St Paul, while the predella bears the Virgin enthroned between two angels and two saints, and the twelve

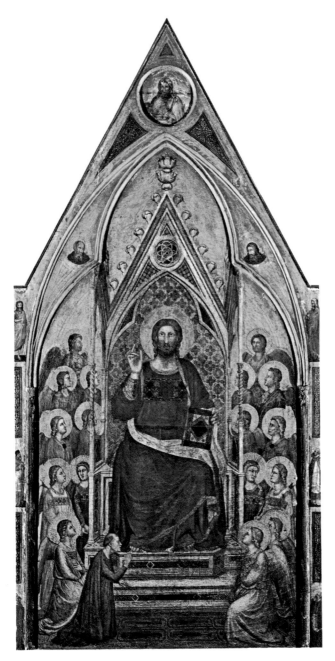

GIOTTO AND ASSISTANTS  *Stefaneschi Triptych*
Central panel: *Christ in Majesty*

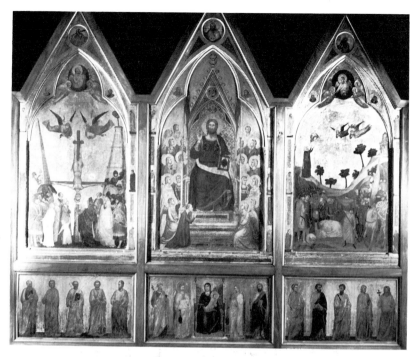

GIOTTO AND ASSISTANTS  *Stefaneschi Triptych*

apostles. On the back of the central panel is St Peter enthroned, with Cardinal Stefaneschi at his feet; the reverse of the other two panels is painted with standing saints, but all that is left of the back of the predella is the central panel with three busts of saints.

The small figures on the predella and in the framework of the triptych are by one of Giotto's pupils, who combined the style of his master with that of the contemporary Sienese school.

During the fourteenth century Giotto's influence was considerable, not only on his own pupils, but on many artists of the generations that followed. Painters in Florence, Assisi, Rome, Rimini, Bologna, Padua and Naples were all 'Giotteschi', yet they managed to combine the lessons learnt from him with their own distinct local style.

226

GENTILE DA FABRIANO  *St Nicholas of Bari raising the Three Children* and *The Birth of St Nicholas*

These exquisite little panels [227, 228] once formed part of an altarpiece painted by Gentile da Fabriano in May 1425 for the Quaratesi family, which was originally placed in a chapel in S. Niccolò d'Oltrarno at Florence. The central panel, showing the Virgin and Child with angels, is now in the National Gallery in London, while the side panels which depict the Magdalen, St John the Baptist, St Nicholas of Bari and St George are in the

GENTILE DA FABRIANO
*St Nicholas of Bari raising the Three Children*

GENTILE DA FABRIANO *The Birth of St Nicholas*

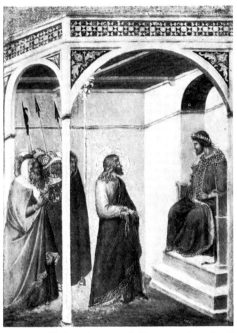

in character. Gentile, on the other hand, still favoured the late Gothic style, with its pathos

PIETRO LORENZETTI *Christ before Pilate*
Part of the predella of a polyptych, this little panel is extremely characteristic of Lorenzetti, who added to the humanity and monumentality of Duccio and Giotto a lively sense of the dramatic.

VITALE DA BOLOGNA *Virgin and Child*
Vitale is the outstanding artist of the fourteenth-century Emilian School. The influence of Giotto is evident in his attempts at realism, such as the monks kneeling to receive the Child's blessing.

Uffizi. The predella consisted of five small pictures illustrating incidents from the life of St Nicholas. Besides the two reproduced here, there are two others in the Vatican Pinacoteca, and a fifth (showing pilgrims and invalids at the saint's tomb) in the National Gallery at Washington.

Gentile da Fabriano painted the *Quaratesi Altarpiece* when the first stirrings of the Renaissance were being felt in Florence. Masaccio was painting in the Brancacci Chapel in S. Maria del Carmine, and Brunelleschi and Donatello were both engaged in work that was impressively new

and tenderness of expression, courtly unreality, and detailed secular ornament. Nonetheless his treatment is precise enough in its realism to make an old legend accessible to fifteenth-century taste. These small pictures belong to a moment of transition between the medieval world and a new age.

LEONARDO DA VINCI  *St Jerome*

This masterpiece has a somewhat strange history. Instead of coming, as one would expect, from one of the great Vatican collections, it was discovered by Cardinal Fesch about 1820 in a junkdealer's shop. The area surrounding St Jerome's head had been cut out, and though it has been restored the joins are still very evident.

The painting has remained at the stage of a monochrome sketch. It can be dated, on account of its affinity with the *Adoration of the Magi* in the Uffizi (begun in 1481 and left unfinished), to the last months of Leonardo's stay in Florence, before he left for Milan in 1482.

Like the *Adoration of the Magi*, the *St Jerome* shows Leonardo's preoccupation with chiaroscuro and sfumato to convey atmosphere, the movement of light and the living quality of nature. The picture also looks forward to Leonardo's more mature work in the *Virgin of the Rocks* and the *Last Supper*. Here, as in his most famous portraits, Leonardo is intensely interested in the psychology of his subject, with a serious and almost pessimistic approach that led La Fontaine, thinking of him, to speak of the *'sombre plaisir d'un cœur mélancolique'*.

Leonardo was in Rome in 1492, and again from 1513 to 1516, during the pontificate of Leo X. He stayed at the Belvedere, and seems to have been engaged exclusively on military engineering; in any case none of his paintings is dateable to his two periods in Rome.

LEONARDO DA VINCI  *St Jerome*

It is quite possible, however, that Leonardo's influence in Rome during his second visit may have been greater than contemporary records suggest. By 1513-16 the Sistine ceiling was finished, as were most of Raphael's Stanze, and the great building of St Peter's had begun. At this crucial moment in the history of art, Leonardo's painting and his aesthetic theories may well have helped the cultivated élite of Rome to grasp the ideal value of art, and to understand the link between the visual arts – painting, sculpture and architecture – and poetry, literature and all the other activities of the human spirit.

FRANCESCO DI GENTILE
*Virgin and Child*
*( Madonna of the Butterfly )*
A native of Fabriano, active during the second half of the fifteenth century, this artist drew inspiration from the contemporary paintings of the Bellini family.

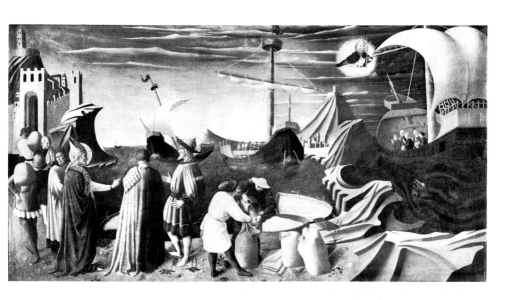

FRA ANGELICO  *St Nicholas of Bari meeting Emperor's Emissary and preventing a Shipwreck*

This is one of the predella panels from a polyptych which Fra Angelico painted about 1437 for the church of S. Domenico at Perugia. The Vatican Pinacoteca owns another predella panel, but the central panel, showing the Virgin and Child with SS. Dominic, Nicholas of Bari, John the Baptist, and Catherine of Alexandria, is in the Galleria Nazionale dell'Umbria at Perugia.

The altarpiece was painted shortly before Angelico began his famous series of frescoes in the Dominican convent of S. Marco in Florence, and some ten years before he came to Rome to work in the Chapel of Nicholas V [147, 149]. The sea and rocky landscape are extremely stylized, and the episode is depicted in a way that shows how a painter who belonged to the world of the Renaissance could still look back nostalgically at the imaginative world of Gothic art.

MELOZZO DA FORLI
*Sixtus IV appointing the humanist Bartolomeo Sacchi,
known as Platina, Prefect of the Vatican Library* ▷

FRA FILIPPO LIPPI
*Coronation of the Virgin, with Saints and Donors*

Of all the great Florentine painters of the early Renaissance,
Filippo Lippi was perhaps the most successful in synthesizing
the new tendencies, combining Masaccio's realism with that love
of ideal beauty which was to be the mark of Botticelli.

In this triptych the influence of Fra Angelico is apparent, but
there is also a balanced and solid spatial construction, most
marked in the figures at the sides, whose monumentality gives
them an almost architectural character.

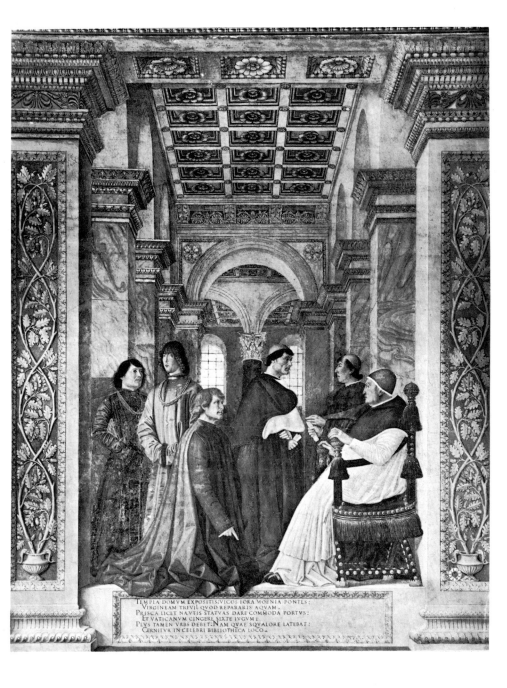

TEMPLA DOMVM EXPOSITIS·VICOS FORA MOENIA PONTES·
VIRGINEAM TRIVII QVOD REPARARIS AQVAM·
PRISCA LICET NAVTIS STATVAS DARE COMMODA PORTVS·
ET VATICANVM CINGERE SIXTE IVGVM·
PLVS TAMEN VRBS DEBET·NAM QVAE SQVALORE LATEBAT·
CERNITVR IN CELEBRI BIBLIOTHECA LOCO·

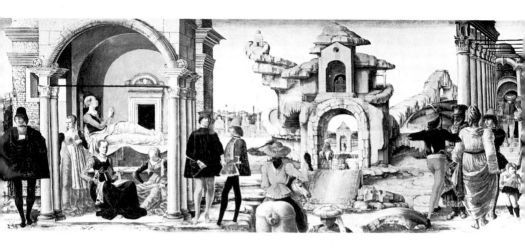

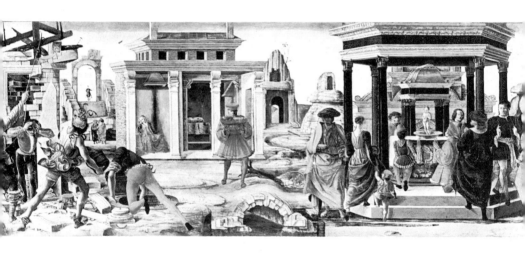

ERCOLE ROBERTI    *The Legend of St Vincent Ferrer*

The altarpiece of the Griffoni Chapel in S. Petronio at Bologna was begun by the Ferrarese painter Francesco del Cossa about 1470-75, and finished by Ercole Roberti in 1477. Art historians

are agreed that its predella, now in the Vatican Pinacoteca [236, 237], should be attributed to Roberti, whose narrative compositions are tighter and more dramatic, though they retain Cossa's solemnity and severity. Roberti has a sensitivity that one associates with Northern painters; his metallic figures move in an almost magical world of hard rocks and equally hard architectural forms. These panels are among the greatest achievements of the fifteenth-century school of Ferrara, and they show the extreme refinement and intellectuality of Italian art at that time.

ERCOLE ROBERTI   *The Legend of St Vincent Ferrer*   Detail

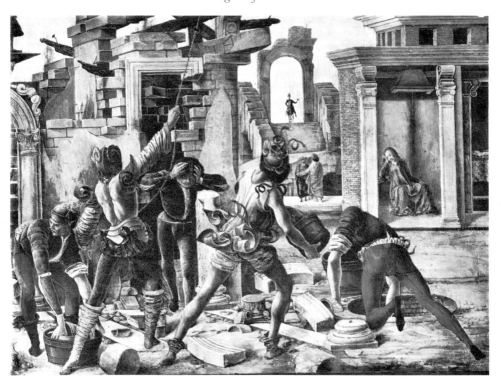

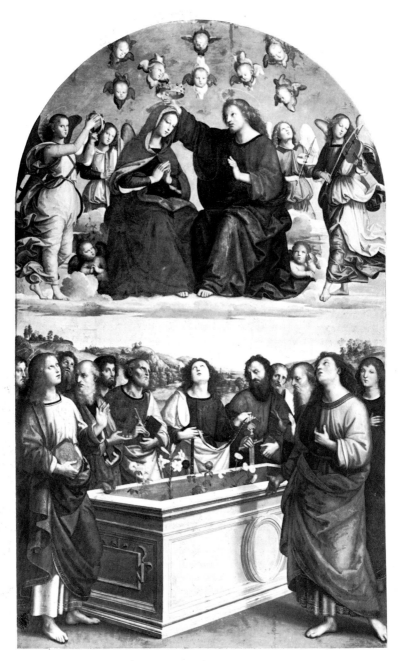

RAPHAEL  *The Coronation of the Virgin (Oddi Altarpiece)*

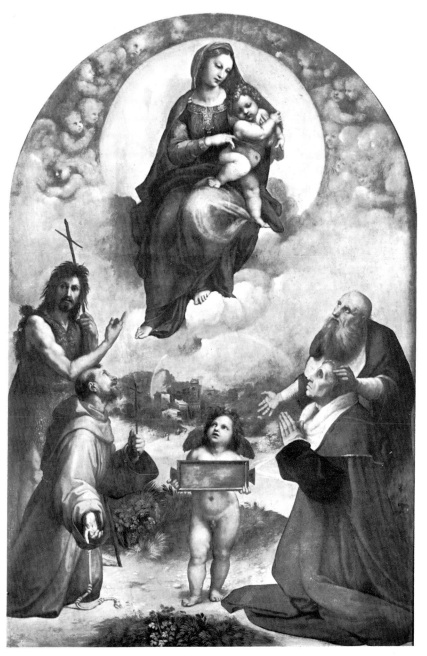

RAPHAEL  *Madonna di Foligno*

## RAPHAEL  *Madonna di Foligno*

This famous picture [239] was commissioned as a thank offering to the Virgin by Sigismondo de' Conti, of Foligno in the Marche, after a meteorite had fallen on the town during a storm and miraculously missed his house. The event is recorded in the background of the painting [241]: here the landscape that emerges from storm clouds has an almost unearthly phosphorescent beauty. Raphael had never attempted anything of the kind before. Some authorities maintain that the landscape must have been painted by one of Raphael's assistants, possibly Dosso Dossi. But it is much more likely that it comes from Raphael's hand, since we know how ready he was to learn from other artists working in Rome at the time.

The *Madonna* was probably painted in 1511 or 1512, while Raphael was working on the frescoes of the Stanza della Segnatura: it was first placed in S. Maria in Aracoeli, on the Capitol, and from there it was transferred to the church of S. Anna at Foligno by a niece of Sigismondo de' Conti. The Vatican Pinacoteca acquired it early in the nineteenth century.

Sigismondo de' Conti himself is shown kneeling on the right, being presented to the Virgin and Child by St Jerome: his face, so lacking in beauty and yet so full of expression, reveals Raphael's outstanding gifts as a portrait painter. Opposite him, also kneeling, is St Francis. A cherub in the centre holds a tablet, almost certainly intended for a votive inscription.

A comparison between Raphael's early *Coronation of the Virgin* [238], commissioned by Maddalena degli Oddi in 1502 for S. Francesco at Perugia, and the *Madonna di Foligno,* shows how far by 1511-12 he had developed beyond the influence of Perugino.

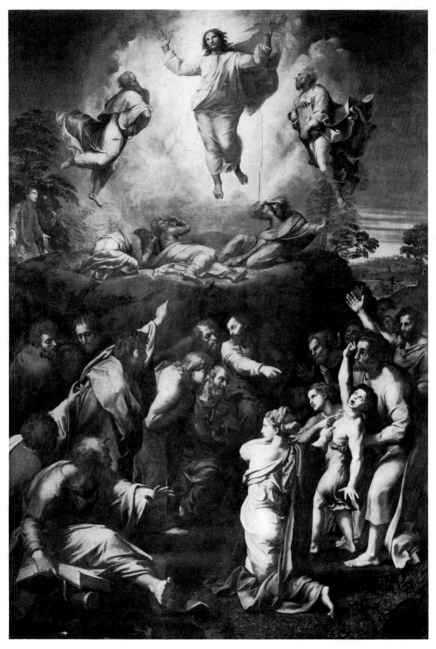

RAPHAEL AND ASSISTANTS  *The Transfiguration*

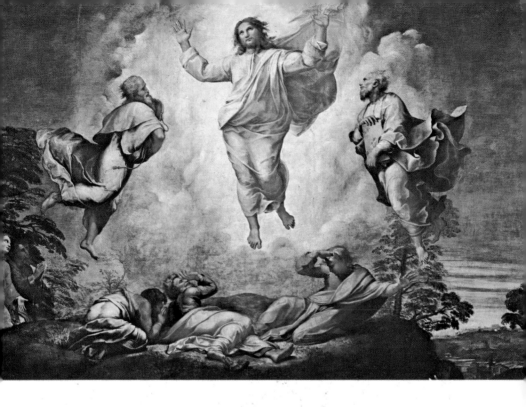

RAPHAEL AND ASSISTANTS   *The Transfiguration*

In 1517 Cardinal Giuliano de' Medici commissioned Raphael to paint a *Transfiguration* for the cathedral at Narbonne, of which he was bishop. At the same time he commissioned from Sebastiano del Piombo a *Resurrection of Lazarus*, to act as a pendant to Raphael's painting. Both artists felt challenged: Sebastiano confided to his friend Michelangelo that he was not pleased at the thought of competing with Raphael, while Raphael himself seems to have tried to get the commission taken away from Sebastiano.

The *Transfiguration* was still unfinished at Raphael's death, and was eventually placed in S. Pietro in Montorio. The upper part [243] was painted by Raphael with the assistance of his pupils, notably Penni. The lower part, which shows the miraculous cure

of a child possessed by the devil – an event associated with the Transfiguration in Matthew 17: 1-20 – is the work of Giulio Romano, who painted it between 1520 and 1522, modifying Raphael's design to a certain extent.

The difference between the two parts of the picture is striking [242]. The upper section is characteristic of Raphael's later work: the composition is carefully planned and balanced, and the emotion controlled. But in the lower half all is excitement and extravagant gesture, with strong contrasts of light and dense colouring. The classical figure of the kneeling woman in the foreground and the head of St John in profile in the centre follow Raphael's design, but the attitudes of the other figures herald the sophisticated poses of Mannerism.

### CARAVAGGIO   *The Deposition*

This is one of the masterpieces of Caravaggio's maturity [246]. It was painted between 1602 and 1604 for the chapel of the Vittrice family in S. Maria in Vallicella, the 'Chiesa Nuova' of the Filippini order.

All Caravaggio's characteristic features are present. There is a sense of drama slowly developing against a background so dark that it seems limitless. Almost the whole of the picture is occupied by the six figures: the space in which they stand is suggested by the angle of the tombstone jutting out into the foreground. The group is caught in a brilliant light which emphasizes the colours, intensifies each gesture and expression, and creates sharp contrasts and shadows. These are real, not idealized people. They have an everyday look about them, and the faces are probably drawn from life. And yet at the same time there is great dignity in their attitudes, such as that of Mary the wife of Cleophas (on the extreme right, with hands upraised), who is reminiscent of the famous Hellenistic sculptural group of Niobe with her children.

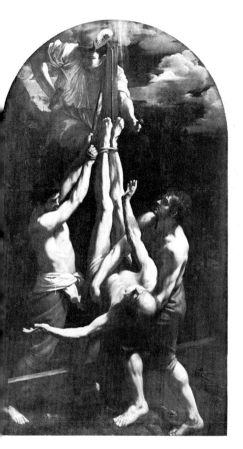

GUIDO RENI
*The Crucifixion of St Peter*
A work of Reni's youth, painted in
1600-1603 at the request of Cardinal
Pietro Aldobrandini for the church
of the 'Tre Fontane'. Reni's
use of chiaroscuro here is close
to that of Caravaggio.

PIETRO DA CORTONA
*David and the Lion*
One of a series of scenes from the
life of David (of which another is in
the Vatican Pinacoteca, and two are
in the Palazzo del Quirinale),
painted by Pietro da Cortona late
in life; they reproduce frescoes,
now destroyed, which he had
executed as a young man in the
Marchese Sacchetti's Villa
del Pigneto in Rome.

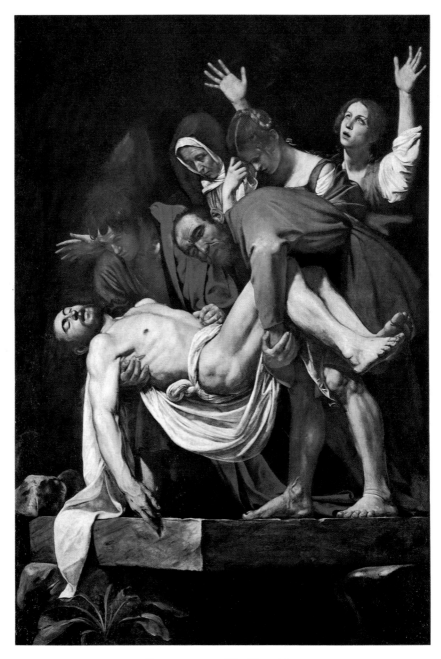

CARAVAGGIO  *The Deposition*

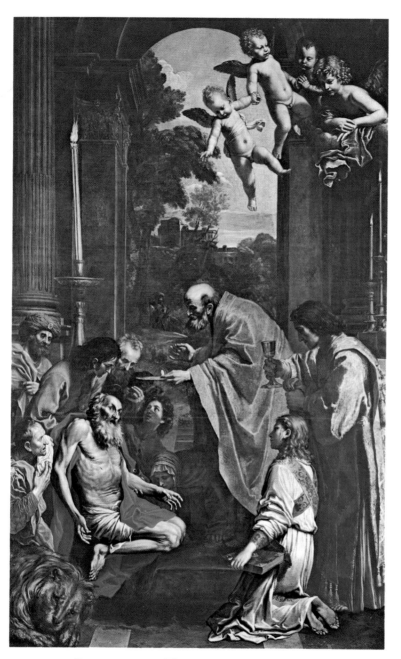

DOMENICHINO  *The Last Communion of St Jerome*

The drama is human before it is religious; but in Caravaggio's vision the very fact of human life is of religious significance. His attitude was not shared by many ecclesiastics of his day, some of whom refused to allow his pictures into their churches, judging them too 'vulgar'. But Caravaggio's concentration on human figures and human emotions did appeal to other artists: his paintings were copied by such diverse personalities as Rubens, Valentin, Fragonard, Géricault and Cézanne; and they are accepted today as the true expression of religious feeling.

### DOMENICHINO    *The Last Communion of St Jerome*

Domenico Zampieri, known as Domenichino, was one of the greatest classical painters of the seventeenth century. His style is less intellectual and more emotional than that of Poussin, more in the tradition of sixteenth-century Italian painters, from Raphael to Titian.

The *Last Communion of St Jerome* [247] is signed and dated 1614. It was commissioned three years earlier by Cardinal Aldobrandini, protector of the convent of S. Gerolamo della Carità in Rome, and there it remained until the early years of the nineteenth century, when it passed into the Vatican Pinacoteca.

The painting was generally received with enthusiasm by Domenichino's contemporaries. It was criticized by Baroque artists such as Pietro da Cortona and Lanfranco, and the painter was accused of copying Carracci's treatment of the same subject in a picture executed a few years earlier for the Certosa at Bologna. But other painters, who included Poussin, judged it to be one of the finest paintings in Rome. The great art critic of the time, G. P. Bellori, wrote of it in his *Lives* of contemporary artists: 'Each one of the figures seems to live and breathe. Even when one admits that Domenico has surpassed himself, it is still amazing how he manages to bring all the parts together, each area of light and shade, every colour and half tone enhancing the

rest, each one merging into the other without violent contrast, diffusing an airy quality throughout... in the languishing body of St Jerome the whole of nature seems to languish.'

The picture may seem conventional and contrived today, but it must be recognized that its fine composition and warm colouring make it a major achievement of seventeenth-century painting; and in the landscape and the kneeling figure of the deacon in the foreground there is a genuine poetic quality.

NICOLAS POUSSIN *The Martyrdom of St Erasmus*

The passionate realism of Caravaggio is at one pole of seventeenth-century art: at the other is the rational classicism of Poussin. Between these two approaches, which imply two different concepts of history and two distinct forms of moral engagement, there is the Baroque as exemplified by Bernini, with all its splendour and rhetoric, and its metaphorical use of nature.

Poussin spent most of his life in Rome, painting for his own circle of Italian and French clients. He produced very few works for churches. He was young when he painted his *St Erasmus* [250], in 1628 or 1629, and very conscious of the honour of painting a picture to hang in St Peter's.

His early style still shows the influence of the Venetian painters, especially Titian. An additional influence in the *St Erasmus* is that of Pietro da Cortona, who had originally been commissioned to do the work, and whose sketches Poussin used; however, when Poussin's painting is compared with these sketches (in the Uffizi and at Windsor Castle), it clearly shows his modification of the Baroque approach. The particularly cruel martyrdom of St Erasmus called for a dramatic treatment and the depiction of a great variety of emotions. Poussin accepted this, but he maintained an emotional balance through the calculated rhythm of the composition, and the firm, clear light.

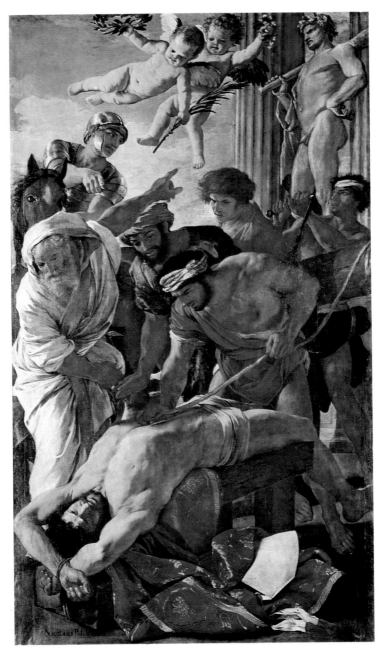

NICOLAS POUSSIN   *The Martyrdom of St Erasmus*

These qualities were not widely appreciated in Poussin's lifetime, when most people were fascinated by the fire and colour of Baroque art. It is not therefore surprising that his *St Erasmus* aroused little attention, although it was a major landmark in the development of his style.

It is interesting to compare the works of Poussin, Caravaggio and the 'Caravaggeschi', which hang in the same room in the Vatican Gallery. The classical ideal to which Poussin aspired does not neglect the strong forces of nature; it tries rather to establish a harmony between them and the order that rules them. Nature is ruled by reason, and seen in a historical context.

SIR THOMAS LAWRENCE
*King George IV of England*
This elegant portrait was presented by George IV to Pius VII in 1819, when Lawrence visited Rome. It is an outstanding example of the painter's work, in which the eighteenth-century English tradition of portraiture is combined with the grand manner Lawrence had learnt from the Venetians and Velasquez. A portrait of Pius VII, which Lawrence painted during his stay in Rome, now hangs in Windsor Castle.

*The Mars of Todi*

# THE VATICAN MUSEUMS

*The Mars of Todi*

This Etruscan bronze sculpture of the fourth century BC [252] was discovered at Todi, a town in Umbria on the edge of Etruscan territory, and its hieratic character makes it not surprising that it was called the *Mars of Todi*. It is, however, more likely to be the votive figure of a soldier than Mars or the Etruscan war god: an inscription engraved on the border of the cuirass reads *Ahal Trutitis dunum dede* – Ahal Trutitius gave this as a gift.

It is a magnificent work, and of the greatest interest in revealing the technical perfection that the Etruscans had achieved in bronze-casting. The statue was made in five parts, clearly and concisely modelled and forming a completely convincing three-dimensional whole. It also provides a fascinating link between the art of the Etruscans and the aesthetic ideal of the Greco-Roman world, since it is clearly influenced by Archaic Greek art, with its feeling for pure forms and idealized nature, while at the same time it seems to have a mysterious, metaphysical quality particular to the Etruscans, much of whose art was preoccupied with the cult of the dead.

## The Aldobrandini Wedding

A Roman fresco of the first century BC, uncovered in 1605 near the Arch of Gallienus on the Esquiline, this fragment [255] takes its name from the Aldobrandini (the family of Pope Clement VIII), in whose villa it was long preserved.

At the time of its discovery, the only painting known to have survived from antiquity was the decoration of the Domus Aurea or Golden House of Nero, which was of the type known as 'grotesque'. It is not therefore surprising that the fragment aroused great enthusiasm, since it seemed to be a unique record of what people looked like in classical times. It had all the perfection one might expect, and exactly the right note of sobriety in its colouring. The Neo-classical critics of the early nineteenth century saw its formal beauty as the highest possible achievement in art.

We now have a greater knowledge of Roman painting, thanks to the excavations at Pompeii, Herculaneum, Piazza Armerina and Rome, and we can see the *Aldobrandini Wedding* more clearly in its artistic context. It is in fact typical of a certain eclectic and academic, even 'purist', tendency which appeared in Roman art at the end of the first century BC, in contrast to the extreme realism and expressiveness of contemporary monumental sculpture and portraiture [267]. It has been heavily and not skilfully restored. But it is still of great interest today for the influence which it exerted on the classicizing painters of the seventeenth and eighteenth centuries; and, not least, for the picture it gives of the customs and family life of ancient Rome.

The subject may be the marriage of Peleus and Thetis, or of Alexander the Great and Roxana. In the fresco the artist has combined a purely realistic illustration of the wedding ceremonial of his time with poetic elements such as the figure of Peitho or Aphrodite, who, seated on the marriage-bed at the right, comforts the pensive bride in her white robe.

*The Aldobrandini Wedding*

## ATHENODORUS, AGESANDER AND POLYDORUS  *Laocoön*

This is probably the most famous of the many masterpieces in the archaeological collections of the Vatican. It was discovered on 14 January 1506, almost by accident, by a certain Felice de' Freddi who was digging in his vineyard and came upon the ruins of the so-called Baths of Titus.

The group was found in seven pieces, and the inscription on the base, bearing the name of Athenodorus, son of Agesander, immediately identified it as the group mentioned by Pliny as the work of Athenodorus, Polydorus, and their father Agesander, of the second century BC.

The sculpture was greatly admired, and Pope Julius II soon acquired it for his collection in the Villa Belvedere. The frag-

*Stele of an athlete*
Greek funerary relief of the
mid-fourth century BC,
showing a young athlete
and his attendant.

*Running girl*
Marble copy of a
Peloponesian bronze of
the fifth century BC.

*Oedipus and the Sphinx*
Painting in red on a black ground
inside a large pottery *kylix*
from Athens, of the fifth
or fourth century BC.

*The Amazon of Ephesus*
Roman copy of a figure carved by
Phidias for the temple
of Artemis at Ephesus.
The statue came to the Vatican
from the Villa Mattei in Rome;
restorations include the head,
taken from another statue.

ments were quickly put together by G. A. Montorsoli, but in a somewhat arbitrary fashion; and it was not until the twentieth century, when a further fragment was discovered, that Montorsoli's reconstruction was corrected.

The subject comes from the *Iliad*. The priest Laocoön had tried to warn the Trojans not to let the wooden horse into their city: Apollo, who favoured the Greeks, punished him by calling from the sea two enormous serpents, who crushed the priest and his two sons to death while the terrified Trojans looked on. The face of Laocoön conveys the fortitude of a martyr struggling with inexorable fate.

Michelangelo was extremely impressed by the *Laocoön*, in which he discovered the same ideals that inspired his own art. Later artists returned to it for its suggestive power; and it is known that Bernini had it in mind during his studies in the expression of emotive and energetic movement.

The critic and antiquarian J. J. Winckelmann included memorable discussions of the *Laocoön* in his *Studies in Antique Art* (1764), stressing the perfection of its style and its profound spiritual significance. Somewhat later Burckhardt, in his more systematic and rational way, wrote in his *Cicerone* that 'self-control in adversity is based here on moral as well as on aesthetic grounds.' In the Neo-classical age when art was dominated by the search for 'rules', this provided the noblest model, signposted by Winckelmann: 'The *Laocoön* remains today what it was for the artists of ancient Rome – the rule of Polycletus, which is the rule of perfect art' (*Thoughts on Imitation in Greek Painting and Sculpture*, 1755).

ATHENODORUS, AGESANDER AND POLYDORUS *Laocoön* ▷

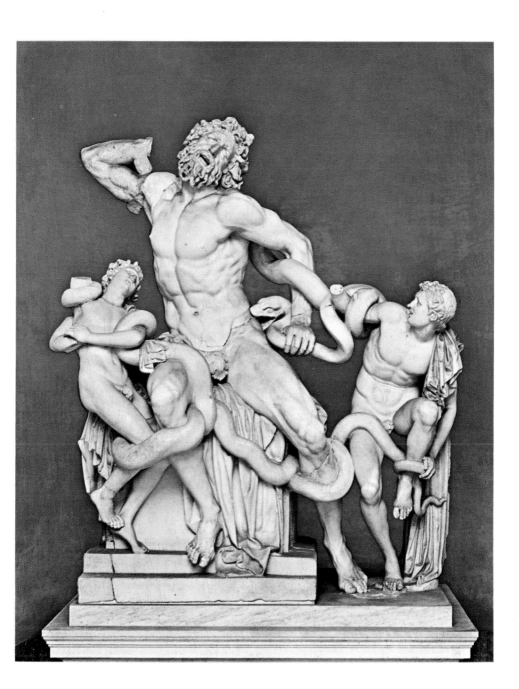

*Meleager* Detail
One of the finest works
in the Vatican Museum,
a Hellenistic copy
of a statue by Scopas
of the fourth century BC.

*Cnidian Venus*
Antique copy of the famous *Aphrodite*
of Praxiteles, of the fourth
century BC: the goddess
is represented naturalistically,
about to enter the bath.

*Apollo Sauroctonos*
(the Lizard-Killer)
Roman copy in marble of an original
bronze statue by Praxiteles,
of the fourth century BC.
The lizard appears on the
tree trunk next to Apollo.

*Antinoüs*
Roman copy, of the Hadrianic period,
of a Greek original by Praxiteles
of the fourth century BC.
The statue probably represents
not Antinoüs but Hermes,
in his role as *Psychopompos*
or conductor of souls
to the underworld.

APOLLONIUS  *The Belvedere Torso*

Like the *Laocoön,* the *Belvedere Torso* has inspired artists from the
Renaissance onwards, and has always been cited by art historians
as an outstanding example of Hellenistic sculpture.

The fragment of a statue which probably represented Hercu-
les, it is signed by Apollonius son of Nestor, an Athenian
sculptor living in Rome at the end of the Republic (first century
BC). Another work of his is the bronze *Boxer* in the Museo
Nazionale Romano. Apollonius almost certainly modelled the
figure on an earlier Greek work of the fourth century BC, but it is
restated with a sculptural emphasis, in the prominent muscles
and the twist of the body, which is typical of Hellenistic
eclecticism.

The *Torso* was discovered at the beginning of the fifteenth
century, and later acquired by Julius II. Michelangelo was
among the first to study it. The great excitement – even
veneration – which he felt has been recorded: it could also be
guessed from the 'quotations' of the fragment in his work [167
below, 183]. Again as in the case of the *Laocoön,* some of the
most enthusiastic and pertinent critical comments are those of
Winckelmann; and a number of sculptures by Canova testify to
the *Torso*'s continued popularity in the Neo-classsical period.
Unlike the *Laocoön,* however, the *Belvedere Torso* inspired Ro-
mantic artists, like Rodin, who found in it a monumental energy
that transcends all abstract rules of formal perfection.

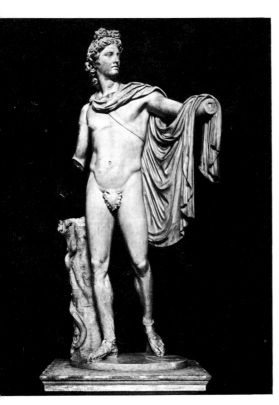

*Apollo Belvedere*
This extremely famous sculpture
is a copy of a Greek original,
possibly in bronze, attributed
to Leochares (fourth century BC).
It was found at Grottaferrata,
and was the ideal of Neo-classical
artists and critics. Apollo
is shown the moment after releasing
an arrow from his bow.

*Apoxyomenos*
The figure represents a victorious
athlete after the contest
scraping his arm with a strigil
(*Apoxyomenos* means 'one who uses
a strigil'). It is the only surviving
copy of a statue by Lysippus of
*c.* 320 BC, which existed in Rome
and is mentioned by Pliny
in his *Natural History* (XXXIV, 19).

*Jupiter of Otricoli*
The classic representation of
the Father of the Gods, copied from
a Greek original by Briassides
(fourth century BC). The head was
found during excavations in the
Roman baths of Otricoli in Latium.

*Silenus holding the Infant Bacchus*
Detail
Hellenistic or Roman copy of
a statue attributed to Lysippus,
of the fourth century BC.

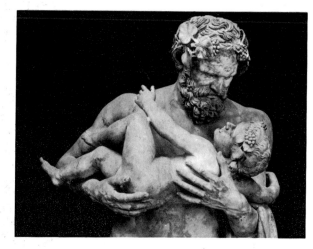

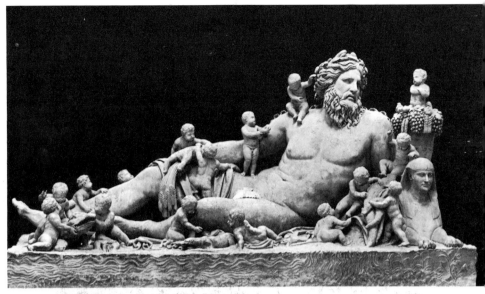

*The Nile*
Hellenistic sculpture of the second
century BC, from the temple of Isis
in the Campus Martius in Rome.
A companion figure representing
the Tiber is in the Louvre.

*Barberini Candelabrum*
One of a series of elegant ornamental
candelabra of the late Hellenistic
period, possibly of the second
century AD, which formed part of the
decoration of Hadrian's Villa at Tivoli.

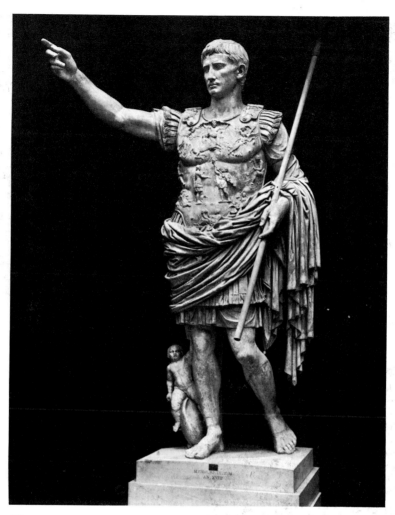

*The Emperor Augustus*
One of the best known examples of monumental sculpture of the
Imperial period (first century BC), discovered at Primaporta near Rome.
The details of the ornate cuirass and drapery and the forceful expression
of the emperor's face are rendered with astonishing realism.

*Sarcophagus of St Constantia*

This imperial sarcophagus of porphyry was made in Alexandria in the fourth century to hold the bodies of Constantine's children. Originally in the circular mausoleum of Constantine's daughter Constantia (converted in the thirteenth century into the church of S. Costanza), it is carved with Christian symbols which include the peacock and the lamb.

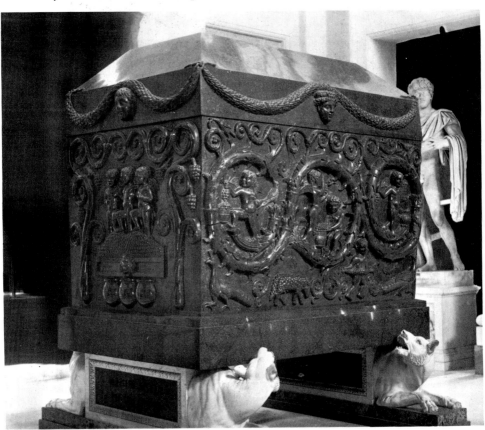

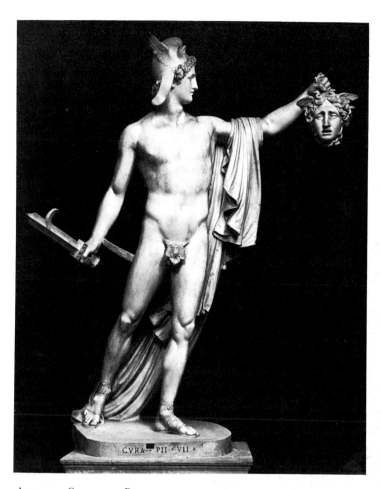

ANTONIO CANOVA  *Perseus*

This statue, executed in 1800, shows the Venetian Canova adhering completely to the canons and models of antiquity. It now stands in the Belvedere, next to the most famous examples of classical sculpture.

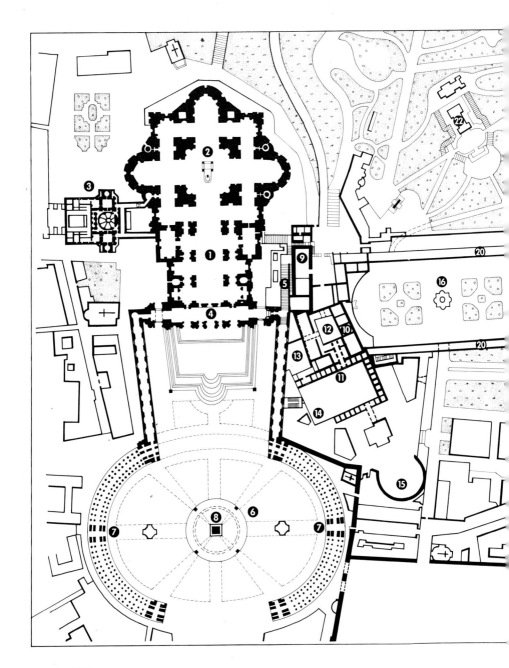

PLAN OF THE VATICAN CITY

1. St Peter's
2. Confessio
3. Sacristy
4. Narthex
5. Scala Regia (to the left, Cappella Paolina)
6. Piazza of St Peter's
7. Colonnade
8. Obelisk
9. Sistine Chapel (below, Sala Regia)
10. Raphael Stanze, above Borgia Apartments
11. Raphael Logge
12. Cortile del Papagallo
13. Court of the Sentinel (to the right, Sala Ducale)
14. Cortile di S. Damaso
15. Tower of Nicholas V
16. Belvedere courtyard
17. Giardino della Pigna
18. Belvedere niche
19. Villa Belvedere
20. Museo Chiaramonti
21. Pinacoteca
22. Casino of Pius IV

## Sources of illustrations

# LIST OF ILLUSTRATIONS

*Page numbers in italics indicate colour plates*

282

# INDEX

*References to illustrations are italicized*